MANGA
magic

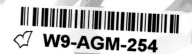
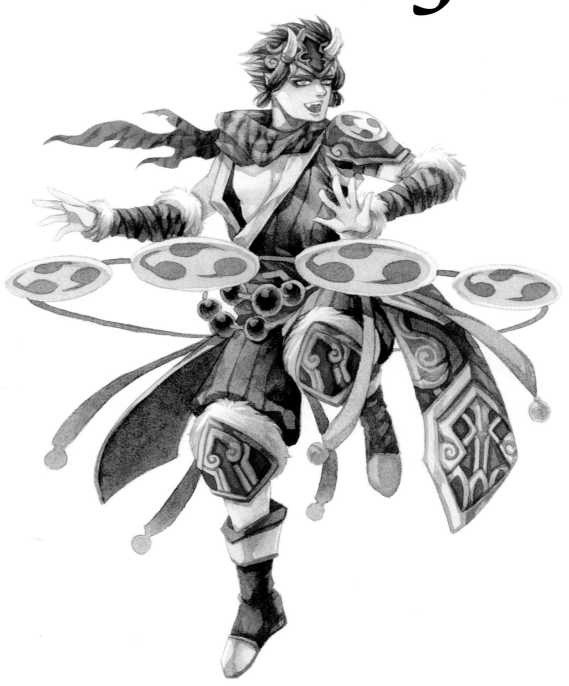

MANGA
magic

How to Draw and Color
Mythical and Fantasy Characters

Supittha "Annie" Bunyapen

IMPACT
CINCINNATI, OHIO
impact-books.com

Contents

What You Need

SURFACE
140-lb. (300gsm) cold-pressed watercolor paper
cardstock paper, at least 110-lb. (230gsm) thickness

PENS + PENCILS
blue pencil (such as Prismacolor Col-Erase)
graphite and mechanical pencils with harder leads
technical pens
watercolor pencils
white gel pen
brush pens (such as Pentel Color Brush)

WATERCOLOR PAINTS
tubes, cakes or liquid watercolors (see sidebar for my
standard palette)

BRUSHES AND WATERCOLOR TOOLS
assorted round brushes nos. 0 to 12
1-inch (25mm) and ¾-inch (19mm) flats
worn or inexpensive round
mop and script brushes
water brush
wooden nib

MARKERS
Copic brand in assorted colors including 0-Colorless Blender
other suggested brands: Neopiko, Prismacolor, Crayola

TEXTURE TOOLS
rubbing alcohol
plastic or bubble wrap
masking fluid (also called liquid frisket)
paper towels
salt
sponge

MISCELLANEOUS
white vinyl or rubber eraser
low-adhesive artist tape
white acrylic paint
magazines or photos for reference and inspiration

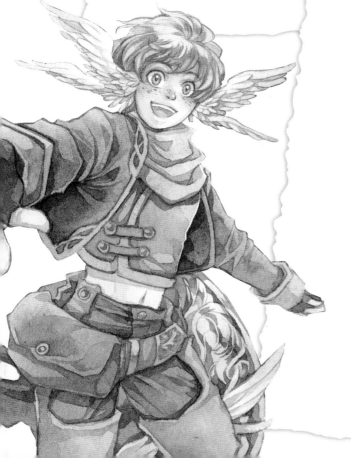

Annie's Watercolor Palette

Antwerp Blue
Blue Apatite
Brown Madder
Burnt Sienna
Cadmium Orange
Cadmium Red
Cadmium Yellow
Cerulean Blue
Cobalt Blue
Cobalt Turquoise
Green Gold
Indigo
Lilac
Manganese Violet
Mauve
Naples Yellow
Olive Green

Payne's Gray
Peacock Blue
Permanent Carmine
Perylene Green
Perylene Maroon
Perylene Violet
Phthalo Blue
Potter Pink
Quinacridone Rust
Raw Umber
Sap Green
Terra Rosa
Translucent Brown
Van Dyke Brown
Verditer Blue
Viridian
Yellow Ochre

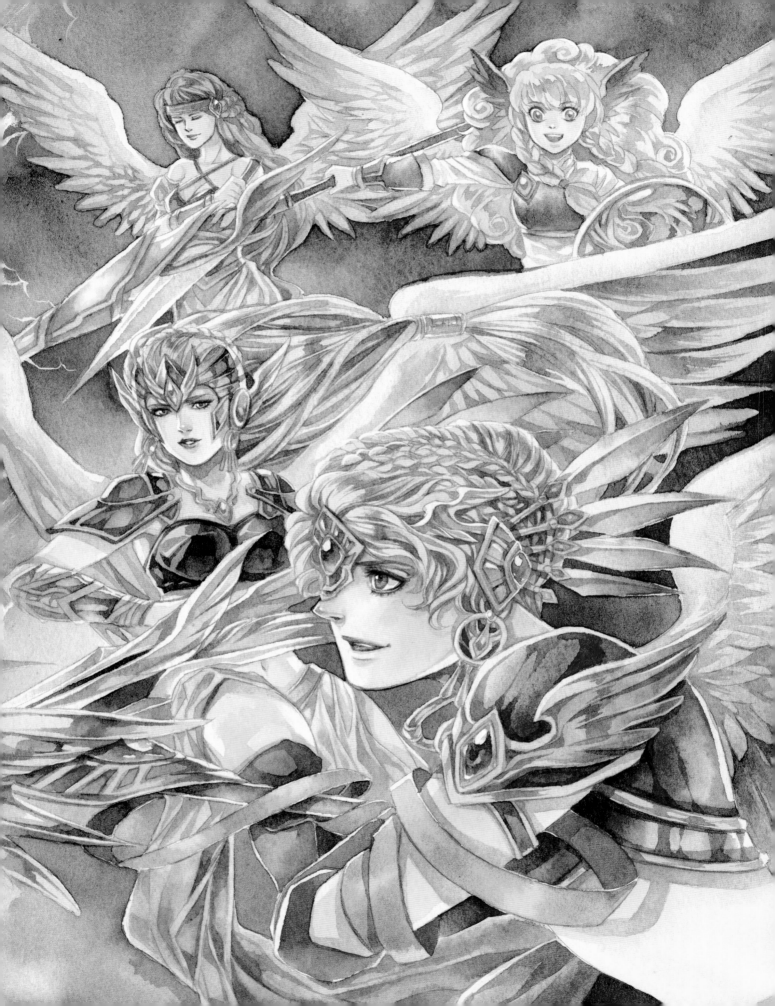

Introduction

Mythology is as much known for the immortal gods and goddesses who populate the stories as for its fairies, creatures and even spirits. These ancient legends are deeply rooted in the various histories and cultures of the world from East to West. For hundreds of years, these colorful characters and magical stories of myth have been a great source of inspiration for artists.

Whether you wish to create characters directly from the legends or combine elements of many characters into one, the creative possibilities are endless when using mythology as a foundation. The goal of this book is to give you the fundamentals for designing unique mythological characters in a manga style. The basics of anatomy can be varied as much as costumes and accessories to illustrate the personalities and histories of your characters. The primary coloring medium of the demonstrations is watercolor though we will discuss the basics of markers and colored pencils as well. But no matter what you draw and paint, the most important tool is your imagination. So open your mind to the legends of lore, and let's dive in and have fun!

Supittha "Annie" Bunyapen

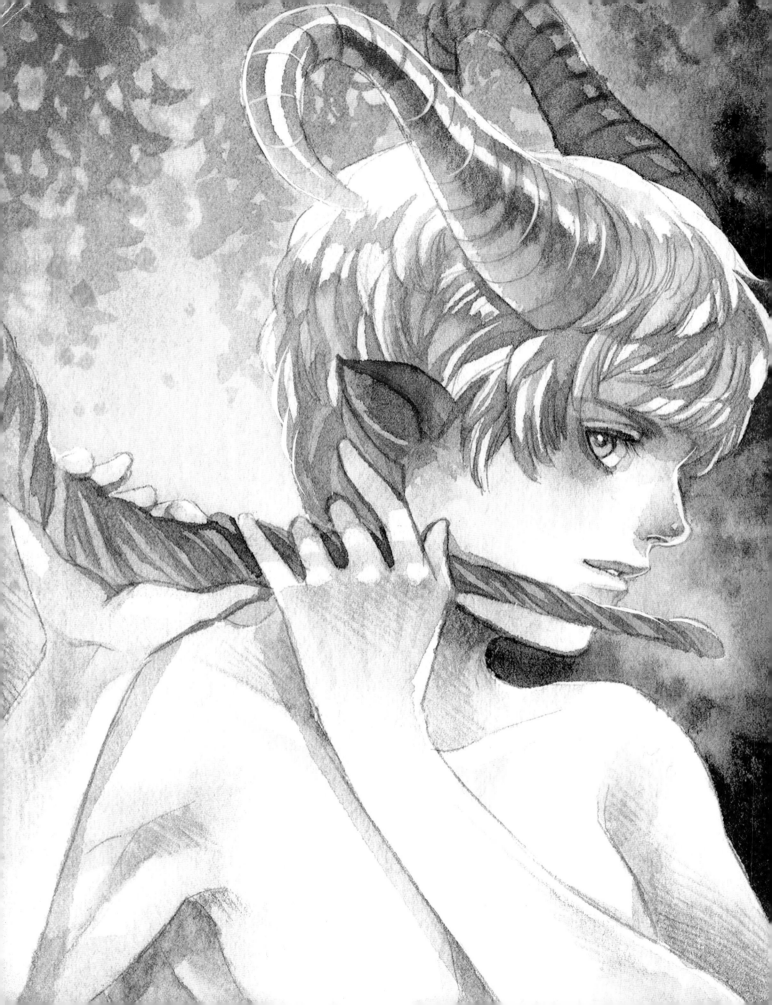

1

Tools and Materials

Choosing the right tools to work with is the first step toward turning your magical ideas into reality. Many art supplies available have subtle functions that can make a big difference in your artwork. Though some higher-quality art tools are also more expensive, you can find affordable tools that get the job done and fit your budget. The list of tools in this chapter is merely a guide. Try out different tools and practice using different mediums when creating your manga fantasy characters. Sometimes even mistakes can lead to inspiring and unexpected results!

Drawing Tools

To draw and paint successfully, it helps to have the right tools. Don't worry too much about brand or cost, just aim to use the best supplies you can afford. Rather than wade through thousands of unfamiliar tools at the art store, here is a list of the basics you need to achieve awesome paintings quickly and stress free.

Mechanical Pencils

Mechanical pencils are great for creating sharp and consistent pencil lines. They come in a variety of lead colors and thicknesses. The most basic is 0.5mm and can be found in most stores. Also try 0.3mm, 0.7mm and 0.9mm.

Leads can be classified from hard (H) to soft (B). The softer the lead, the darker the mark. Darker leads such as 4B, 6B or 8B are ideal for shading, but difficult to erase and smudge easily should you decide to paint over them. H, HB and 2B leads make better marks in this case.

Blue Pencils

Blue pencils are good for preliminary sketches. I like Prismacolor Col-Erase pencils because they don't leave a mess when you erase them.

Watercolor Pencils

Use watercolor pencils for refined details and touching up your paintings. Unlike traditional watercolors, the pencil marks can be diluted for unique effects. Watercolor pencils are not suitable for painting large areas such as backgrounds.

Vinyl Erasers

There are many shapes and brands of vinyl erasers. A Tombow Mono Zero eraser is my top choice. Though it's a little pricier than others, it erases pencil traces effectively. Pentel Hi-Polymer and Faber-Castell Dust-Free erasers are other alternative brands I like that are at a lower price.

Eraser Sticks

Eraser sticks are handy to erase delicate areas. They are pen-shaped and function similarly to mechanical pencils. Just click and use!

Brush Pens

The Pentel Color Brush is my favorite brush pen. It is water based, so the ink won't dissolve after you paint or use markers on top. And once it dries, it won't smudge or leave traces of ink on your marker nibs. However, since it is water based, the ink dissolves in water just like watercolors. It's a good idea not to use brush pens if you plan to paint watercolor on top.

Technical Pens

Although I normally prefer to use only pencil with my watercolor paintings, pens can be used as well. Use water-proof permanent pens for inking and outlining your drawings. Copic Multi-liner and Pigma Micron pens are popular brands that are available in many nibs and colors. Always make sure to let the ink dry completely before you color on top, whether you're using watercolors or markers.

White Acrylic Paint and Gel Pens

White gel pens are great for fast-drying highlights and very small details. The ink flow is generally smooth, but be sure to close the cap after use, otherwise the ink will dry and clog the tip. White acrylic paint is opaque and has great covering power as well.

Watercolor Tools

When dry, watercolors are transparent and liftable when more water is applied. As with other supplies, the quality of watercolors is often reflected in price. Tubes are more expensive than cakes but produce more intense, richer tones.

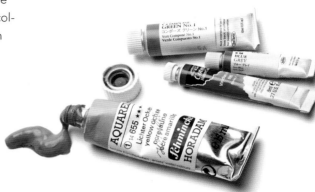

Watercolor Tubes

Tubes are available in many colors and shades that you can individually select yourself. If you choose to purchase tubes, start with the primary colors and practice making color mixtures from a limited set. Because tubes contain more binder, tubes are ideal for mixing large areas. For maximum intensity you can always use paint straight from the tube.

watercolor tubes

Watercolor Cakes

A set of cakes is ideal for the beginner, for painting outside and for the artist on a budget. Most sets come with the primary colors plus other pigments. Most cake paint sets come with other handy tools like a brush and a built-in palette, which can also be helpful. Although note that mixing pigments with cakes can take some practice to achieve the desired color.

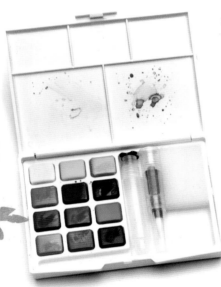

Liquid Watercolors

Liquid watercolors are strong and vibrant yet also transparent. They come in small bottles and are commonly used for air-brushing and calligraphy. You can use them straight from the bottle, but I recommend first diluting with water.

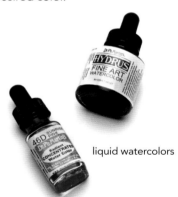

liquid watercolors

watercolor cakes

Brushes

Like paints, brushes vary in quality and price. Expensive brushes like natural sable are top-notch though today's synthetic brushes work well, too. Rounds and flats are the brushes I use most, but many other types can be useful.

Rounds—Rounds are great all-around brushes to use with watercolors from painting details to washes. The tip of the brush is pointed, and the harder you press down, the more liquid it will release. The smaller the number, the smaller the brush is. I recommend nos. 0, 1, 3, 5 and 7 as a starter set. You can build your collection from there as needed.

Flats—For larger areas, flats are ideal for their even application. Their straight edge is good for square or rectangular shapes, fine lines and crisp edges.

Mops—Mops can hold a great deal of liquid and are useful for spreading water on the surface or for applying a wash to a large area.

Riggers or scripts—Riggers have pointed tips but the brush hairs are longer than rounds. Since the tips are generally refined and small, riggers are great for outlining, touch-ups and subtle details.

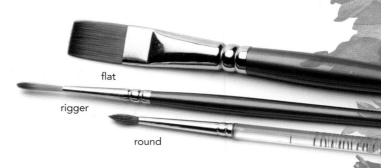

Cleaning Your Brushes

When you clean your brushes, don't let them sit in a water container for too long. The hair will bend and lose its shape making the brush difficult to use later.

flat

rigger

round

mop

Refillable Water Brushes

Like cakes, refillable brushes are handy for outdoor painting and good for diluting colored pencil marks on paper. Since the brushes contain water, there is no need to carry an extra water container. Simply squeeze the barrel to release water and then use it to paint on the surface. The downside is that the sizes are limited, and if you squeeze the barrel too hard, too much water can come out.

wooden nib

Palettes

Palettes come in different sizes and shapes, but the most common shapes are rectangular and oval. Though watercolor cakes come with a built-in palette, the spaces for you to mix colors are limited. My suggestion is to purchase an extra palette for mixing.

plastic palette

areas for mixing

Visit impact-books.com/manga-magic to download free bonus materials.

Water Container

There is no need to purchase a water container; an extra bowl or a cup of water from home works just fine. Make sure to change the water every now and then while you're working, especially when working with lots of colors.

Salt

Sprinkling table salt on a damp surface will pull the pigment and create a unique snowflake-like effect on your painting.

Rubbing Alcohol

Sprinkling rubbing alcohol on wet paint will create a bubble-like effect. Dip a cotton swab in rubbing alcohol for a more controlled response, or fill up a spray bottle and mist the paint for a more random look.

Masking Fluid

Masking fluid (or liquid frisket) is used to retain unpainted areas on the painting surface. When the masking fluid is dry, you can paint directly on top of it. To remove masking fluid, gently rub the masking with a rubber eraser. Don't rub too vigorously or you might tear the paper's surface. When using frisket, make sure to use a wooden nib or an old, inexpensive brush. Make sure not to leave the cap off for too long, or the masking fluid will harden and be difficult to use later on.

Wooden Nibs

Sometimes you will end up with clumps of dried frisket on your old brushes. For this reason, wooden nibs are great for applying just the right amount of frisket to the surface. Just make sure to rinse thoroughly with water after use.

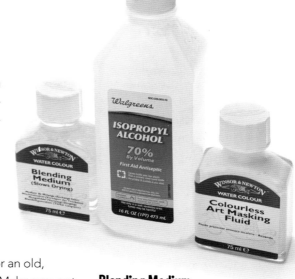

Blending Medium

Blending medium slows the drying time of your watercolors so you have more time to spread out your washes or blend with other colors. It's best to mix only medium with the paints because adding water will decrease drying time.

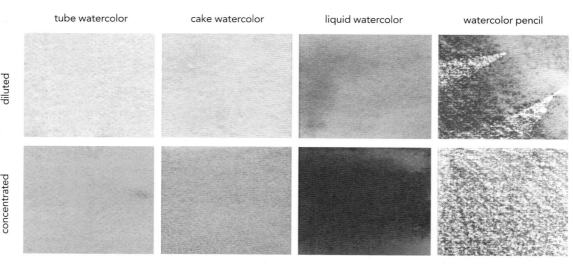

	tube watercolor	cake watercolor	liquid watercolor	watercolor pencil
diluted				
concentrated				

Tube vs. Cake Paints

Don't limit yourself to just tube or cake paint. There are great advantages to mixing and matching them in your artwork. Tube pigments are slightly more intense than cake pigments, but when diluted with water they lighten in a similar way. In this way they make fine substitutions for each other. Liquid watercolors are very saturated and will give you bold and rich colors straight from the bottle. On their own, watercolor pencils apply pigment a little spotty, but mixed with water they can create interesting, flowing textures.

Markers

Markers are a good medium for coloring by themselves and also mix well with watercolors. Experiment with different brands of markers to find what you like. The choices of brands I provide here are only suggestions. You don't have to buy the most expensive markers, but keep in mind that different markers may provide quite different results.

Copic Markers

Copic markers are imported from Japan. They are alcohol based, non-toxic, fast drying and great for trying out fun techniques like layering and blending. There are four types of Copic markers, each with a different style of nib: Classic, Sketch, Ciao and Wide.

Copic Sketch markers are my personal preference. They are double-ended with a flexible brush nib and come in hundreds of colors. Plus they're refillable, which is great for your pocketbook. You can buy these individually or spring to purchase a whole set.

For beginners on a budget, the Ciao markers are a nice alternative. They have the same nib as the Copic Sketch but in a smaller size, so they hold less ink. They are also available in fewer colors.

Since Copics are typically more expensive than other brands, my suggestion is to start with a few markers in each color range (also known as their classification) instead of buying all at once. Some colors are really similar and can be easily substituted for each other.

Neopiko and Prismacolor

Neopiko by Deleter and Prismacolor are also good marker brands and cheaper than Copic. Neopiko markers are also alcohol based and have flexible nibs; they function pretty much like Copic markers but are a little harder to find. Prismacolor markers come with broad nibs and are available in many colors, but they are not refillable.

Neopiko markers

Crayola

Crayola markers are probably the most common brand that you can find easily. If you're looking for bold, bright colors that won't cost you a fortune, Crayola or other water-based markers are a good choice. Just be careful not to spill water on your finished painting! Crayola is also good for layering but does not blend as easily as Copic or Neopiko.

Crayola Super Tip markers

Copic markers

Paper

The paper you choose can either help your painting process or make it harder. Papers are commonly categorized in three different types based on the roughness of the surface: rough, cold-pressed and hot-pressed. When you purchase from a store, paper can be found in spiral-bound books or pads, blocks or individual sheets. I usually purchase watercolor blocks or spiral-bound books since they are more convenient to store and come with multiple sheets. Experiment to see what suits your painting needs.

Paper Weight

Paper weight is important to pay attention to. The thickness helps paper maintain its shape and sturdiness, especially after many washes. I recommend the weight of 140-lb. (300gsm) since it is not too thick or too thin. The higher the number, such as 300-lb. (640gsm), the heavier the paper, and also the higher the price.

Rough Watercolor Paper

Rough watercolor paper has the most uneven surface. Its bumpiness allows you more time to spread pigments. If you like the textured look of the paper to show through your painting, this is a good choice. However, it is not recommended for a painting that requires small details because the roughness of the surface can be difficult to work on, especially with a small brush.

Cold-Pressed Watercolor Paper

Cold-pressed watercolor paper is less rough but still has moderate texture. It is able to absorb and spread pigments nicely, almost equal to rough watercolor paper. This is a nice choice of paper for the beginning watercolorist.

Hot-Pressed Watercolor Paper

Hot-pressed watercolor paper is the most smooth of the three, similar to bristol board. Hot-pressed watercolor paper is perfect for very detailed work or any work that emphasizes linework with pencils or pens. However, the surface is not great for blending colors together and sometimes can result in uneven washes. Choose this paper when you've had some practice with watercolor.

Cardstock

When coloring with markers, I like to use cardstock. It's inexpensive and easy to find. Choose at least 110-lb. (230gsm) for its thickness. Deleter makes a paper specifically for markers that varies in size and thickness, but with nice absorbency.

rough (most tooth)

cold-pressed (some tooth)

hot-pressed (smooth)

Color Basics

Understanding some color basics will give you an advantage when coloring your character and settings. To start, familiarize yourself with the color wheel and how to mix colors. It's also helpful to determine the color scheme of your painting before you begin.

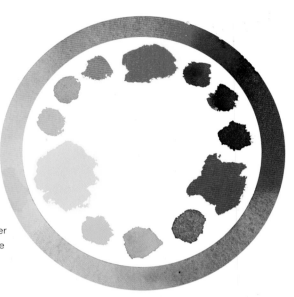

Color Wheel

The color wheel will help you select the right colors to use in your paintings. Primary colors (red, yellow, blue) mix to create secondary colors (orange, green, violet). Create tertiary colors by mixing together a primary and a secondary or by mixing two secondaries. Once you've mastered the basic mixtures, practice adjusting the shades/tints and levels of intensity (how bright or dull a color is) of your mixtures.

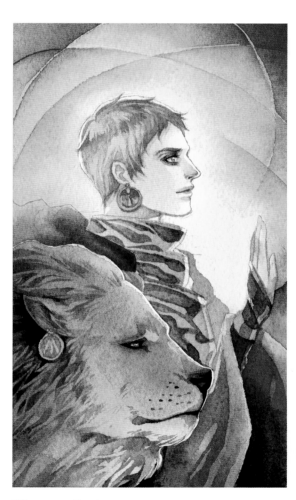
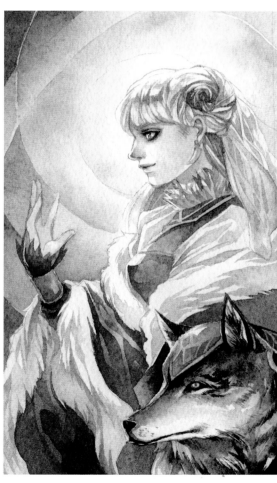

Warm vs. Cool

The temperature of colors is helpful when depicting mood in your paintings. In general, warm colors consist of yellows, oranges and reds, while cool colors are greens, blues and purples. If you are looking for fierce, fiery atmosphere, warm colors are ideal. Cool colors will establish a calm, peaceful and chilly atmosphere. Always seek out a nice balance for the most realistic landscapes and settings.

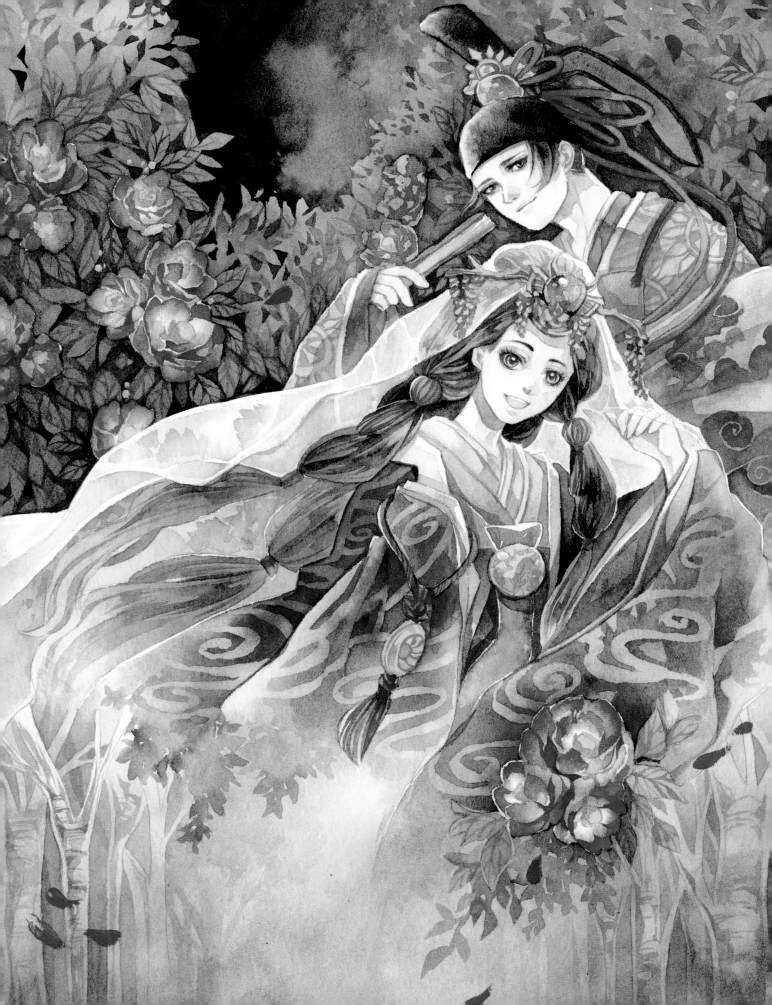

2

Coloring Techniques

If your tools are the weapons you use in battle, technique is the road to victory. Each watercolor technique has its own unique outcome. Understanding the basic watercolor techniques will allow you limitless potential in creating magical worlds and characters. However, the process of mastering watercolor takes practice and patience. If you allow your frustration to get the best of you, it can ruin a whole painting. Over time you will learn to use each technique and how to mix and match them to achieve your goal. Confidence in the medium will give you a colossal advantage. So don't be afraid—experiment, make mistakes, try again and have fun!

Preparing the Paper for Watercolor

To paint with watercolor, you must first prepare your surface to accept paint and moisture. Otherwise it will curl and warp and cause you lots of trouble. Stretching the watercolor paper is the ideal way to avoid this problem and provide you a much smoother painting experience.

1 Spread fresh water on the entire surface with a large flat brush. You can also use a spray bottle filled with water.

2 While the paper absorbs the moisture, lay it on a flat board. Use a dry paper towel or sponge to remove excess moisture.

3 After the paper is completely dry, tape down all the sides of the paper to your clean work surface. I like to use a low-adhesive artist tape. Do not use the paper until you make sure it is completely dry. Keep the paper secured with tape until the painting is finished.

Types of Washes

A wash is a thin, semitransparent application of paint over the painting surface, usually meant to cover large areas. It is one of the most basic techniques in watercolor painting.

Flat Wash

A flat wash is a smooth, even layer of watercolors that can be applied as a base color or background.

 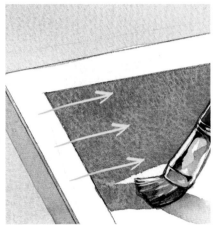

1 Wet the entire paper with water to help you spread the paint evenly. Apply color with a flat brush, dragging the brush horizontally across the paper.

2 Continue dragging the brush across the page. Try to maintain a consistent amount of paint on the brush. Keep going until you fill up the entire page.

3 Example of a completed flat wash.

Graded Wash

A graded wash is similar to a flat wash except the paint is gradually diluted as you work to achieve a nice, smooth gradient from dark to light.

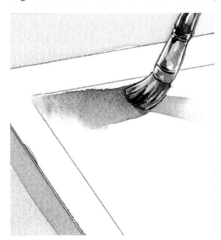 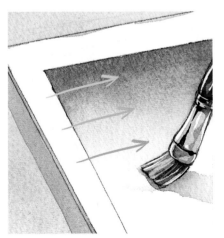

1 Wet the area you wish to cover with clean water and load a flat brush with the color of your choice. Start at the top and apply the first brushstroke.

2 Drag the brush horizontally, diluting each stroke with a small amount of water. Repeat by overlapping the bottom of each previous stroke until the brush contains no pigment.

3 Example of a completed graded wash.

Technique
WET-INTO-WET

Wet-into-wet is a painting technique in which paint is applied to an already wet surface to create a soft, almost fuzzy impression where the different colors blend together. The pigments spread out, creating undefined shapes that are ideal for foliage, hills and midground or background elements. With this technique you must be careful when applying paint to a semidry surface. This can cause the paint to be applied unevenly creating "cauliflower" marks. Take your time to make sure your layers blend smoothly.

The Soft Blending Effect of Wet-Into-Wet

Avoid Overworking

If you want to mix more colors but your surface has become semidry, allow it to dry completely before adding any new pigment. Then apply clean water to the surface before you brush on more color. This will keep the colors from muddying up too much.

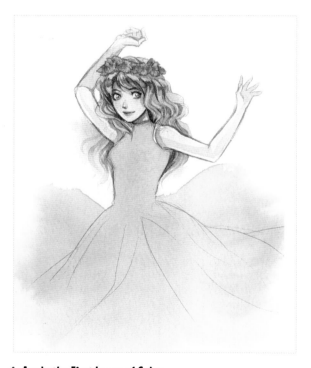

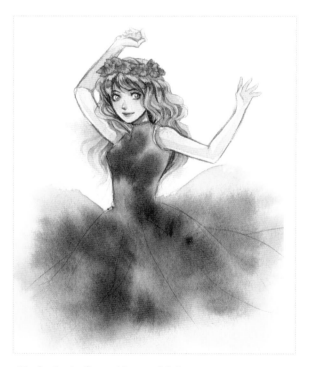

1 Apply the First Layer of Color
Use a no. 3 round to apply clean water to the dress. Spread the water on the surface far enough so the pigments can flow widely. Quickly cover the surface with Cadmium Orange.

2 Apply the Second Layer of Color
While the surface is still wet, switch to a no. 1 round and apply the second color of Mauve. The colors will blend smoothly with each other and create a nice, soft-edged effect.

Technique
GLAZING

Glazing is the layering of transparent paint over a dry wash. Each glaze subtly changes the tone of the underlying wash. When you layer a color similar to the dry wash, you increase the color's intensity. However, if you layer a complementary color on top, it will result in an earth tone. Color results are also dependent on the number of glazes you layer and how diluted the pigment is on the brush. The best way to determine if you have the desired amount is to test your brushstrokes on scratch paper.

The Layered Effect of Glazing

MATERIALS

PAINTS
Cerulean Blue, Cobalt Blue, Indian Yellow, Sap Green

OTHER TOOLS
cold-pressed watercolor paper, nos. 1 and 3 rounds

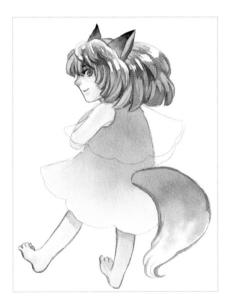

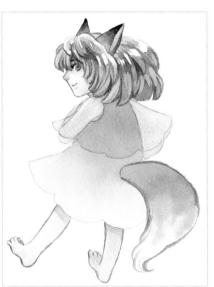

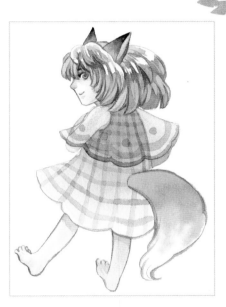

1 Paint a Graded Wash
In this example we are just glazing the dress and shawl. Apply fresh water to the dress area with a no. 3 round. While the surface is still wet, quickly apply a graded wash of Sap Green. Dilute the paint more toward the base of the dress to keep it lightest in color.

2 Apply the First Glaze
Once the surface is completely dry, use a no. 3 round to apply a layer of Cerulean Blue to the shawl area. The overlapping part is now darker from the effect of glazing.

3 Apply the Second Glaze
Use a no. 1 round to define the details. To create the checkered pattern on the dress, start off with horizontal stripes of Sap Green. Once dry, add vertical lines with Indian Yellow. Allow this to dry as well, then apply Cobalt Blue to create the pattern on the shawl. Note how each glaze layer subtly creates new colors from the overlapping.

Technique
DRYBRUSHING

Where a wash is created with a brush loaded with water, a dry-brush application uses less moisture on a dry surface. The broken brushstrokes allow the texture of the paper to show through, so for the most noticeable results, it works best on rough and cold-pressed watercolor paper. The dry-brush technique is great for rendering fur, stains and natural textures like tree trunks and individual leaves.

MATERIALS

PAINTS
Lilac, Manganese Violet, Raw Umber, Sepia

OTHER TOOLS
cold-pressed watercolor paper, nos. 1 and 3 rounds

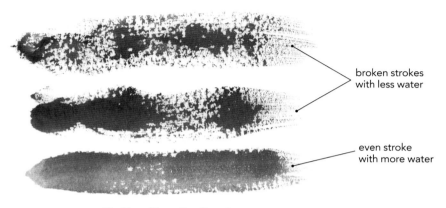

broken strokes with less water

even stroke with more water

The More Water You Use, the More Consistent the Brushwork

1 Apply a Wash
Wet the painting surface with clean water. Use a no. 3 round and Lilac to paint a wash from top to bottom. Tilt the paper, angling it toward you, to allow the color to flow to the bottom. Keep the paper tilted and allow the wash to completely dry.

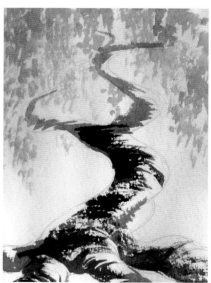

2 Drybrush the Trunk
Pour some concentrated Lilac on your palette. Use a dry no. 3 round to drybrush the wisteria flowers at the top of the paper. You can also dip a dry paper towel in paint. Drybrush the trunk and the branches with Sepia to emphasize the tree's natural textures.

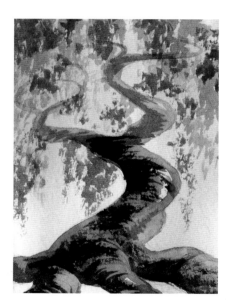

3 Finish the Details
Choose a darker shade of purple such as Manganese Violet and drybrush more flowers. Create a light wash of Raw Umber and fill up the remaining parts of the trunk and the branches with a no. 3 round. Use a no. 1 round for the smaller branches.

Technique
BRUSH PEN

A brush pen usually comes in a single color. I typically don't like to mix a brush pen with watercolor paints because it can create a smeared look, but it is worth it to experiment for unique results. Because the ink in the brush pen is concentrated, you don't have to use it too extensively. This exercise will help get you started with this cool tool.

MATERIALS

cold-pressed watercolor paper, black brush pen, refillable brush or nos. 2 and 4 rounds, pencil

marker over dry brush pen watercolor over dry brush pen

Let the Brush Pen Dry Completely

Using a brush pen with watercolor and marker leads to very different results. Since the ink in the brush pen is water based, it won't get diluted when you apply marker on top. When applying marker over brush pen, make sure that the brush marks are completely dry (I recommend at least a half hour of drying time, especially on watercolor paper). If you don't let the brush pen fully dry, markers will smear the ink and possibly leave residue on the marker nibs.

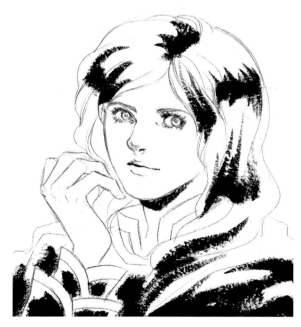

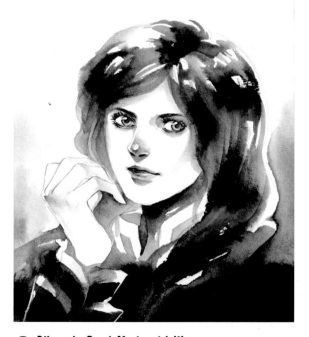

1 Sketch the Character and Apply Brush Marks
Sketch the character with a pencil. Start with a brush pen by applying brush marks on desired areas. Here I applied marks to the clothes and hair.

2 Dilute the Brush Marks with Water
With a refillable brush or no. 4 round, dilute the brush marks with water and spread the paint into the other areas. Use a smaller brush like a no. 2 round for the subtle details. You can also make marks on a separate sheet of paper and dilute with water to get a separate color wash.

Cool Watercolor Techniques

It's fun to create unique watercolor techniques with common household items. When combined with the other basic techniques in this chapter, there's no limit to the effects and textures you can create in your paintings.

Rubbing Alcohol

Rubbing alcohol will create a bubble-like texture when added to wet paint. Paint a wash and sprinkle, mist or drip rubbing alcohol over the damp surface. Just one drop of alcohol will push the pigment away. Repeat for more pronounced textures while the surface is still damp. If you apply rubbing alcohol to a less dry surface, the texture will also be less noticeable.

Salt

Salt is a common item most of us have in the kitchen. When you sprinkle salt over a wet wash of paint, the crystals will gradually absorb the pigment to create a snowflake-like effect. When the surface is completely dry, simply brush off the salt with your hand. The texture will be more noticeable on a wet, shiny surface than a barely damp one. Experiment with different types such as table salt and rock salt. The different sized crystals will produce various effects. This technique is great for sparkling underwater scenes and starry skies.

Lifting With a Paper Towel

First apply a wash. While the surface is still wet from the paint, crumple a paper towel and blot and dab the surface so the paper towel absorbs some of the pigment. This lifting technique typically leaves a soft-edged blot effect. But if you fold the paper towel and scrub the paint harder, you can create a sharper-edged effect. Lifting watercolor gets harder once the surface dries. If this happens, apply some drops of water to the paint to re-wet it, then gently scrub with a paper towel or a small brush for fine details. This technique is useful for clouds, fog, glowing spots and highlights.

Masking Fluid or Liquid Frisket

Masking fluid is extremely useful for retaining unpainted areas, especially small, delicate details. First, apply the masking fluid on your surface with an old brush. If it is too sticky, you can dilute it with a couple drops of water. Don't add too much water or the masking fluid will be too watery. Once dry, apply a wash of color on top of the masking fluid. After the wash is dry, gently rub the masking fluid with a rubber eraser. You are left with the clean white of the paper! You can add more washes over the preserved areas or leave as is. It's up to you!

Cool Watercolor Techniques

Plastic Wrap and Bubble Wrap

This technique is good for creating the effect of fabrics or a crystal-like background. First create a wash, then quickly place scrunched plastic wrap on top while the paint is wet. Play around with the plastic folds if you desire. Let the paint dry completely, then gently remove the plastic wrap. You can use a piece of bubble wrap instead for another unique look.

Dabbing With a Sponge

A sponge is a great tool for achieving the look of dust, dirt, foliage and stains. A sea sponge is ideal, but if you cannot get ahold of one, a regular sponge works, too. First, dip a sponge into wet paint, then gently dab the sponge on the surface to create the texture. Repeat the step several times and in different colors for more visible textures.

Dabbing With a Paper Towel

Similar to using a sponge, you can also dab with a paper towel. Crumple the paper towel and dip it into the paint. The paint should be diluted but not too watery because the paper towel will soak up the moisture really quick. Quickly dab the crumpled paper towel on the surface for a cool effect and repeat as often as you like!

Common Problems With Watercolor

Like most mediums, mistakes and accidents can frustrate even the most talented artists. Though occassionally we can turn those mistakes into cool effects, most of the time the mistakes are beyond fixing. The key to avoiding problems is to allow enough time for the paint to dry and to plan ahead accordingly. Planning and patience are crucial. Keep practicing and your confidence will build and your mistakes will decrease over time.

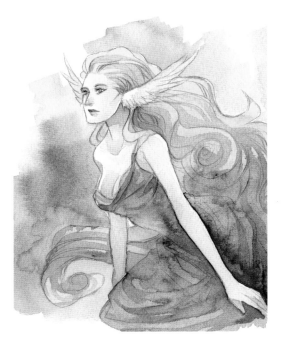

Color Bleeding

With watercolor, trying to paint everything at once will not help you accomplish the painting faster. When you paint two areas next to each other without allowing enough dry time, one color will bleed into the other. Here the color of her hair has spilled over into her dress and the background. Similarly, the blue has bled into the hair. This mistake can possibly be overlooked as an effect, but the truth is it's a mess. Avoid this problem by making sure the surface is completely dry before applying a new color next to another.

Overmixing Colors = Mud

Working with multiple colors at once can create beautiful results. But overmixing too many colors while the surface is damp can lead to a muddy gray tone that looks nothing like a beautiful glaze or graded wash. Sometimes it's best to pull back. Start with just one or maybe two colors at first. Then later you can add more colors or glazes when everything is dry. Don't push everything at once or you might lose it all.

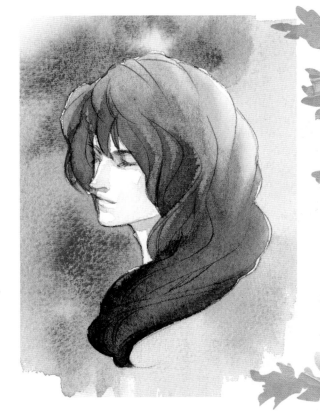

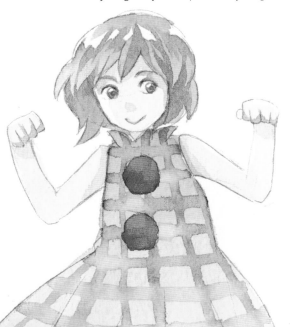

Not Enough Time to Dry

We want our paintings to be finished as fast as possible, but sometimes allowing the paint to dry for just a few extra minutes can be worth the wait. When glazing, if the first wash is not dry enough and you apply the second layer too soon, colors will blend together and not overlap. It is really important to let that first wash dry.

Uneven Wash

Uneven washes can be caused by so many things. Did you wet your watercolor paper evenly? Did you use too small of a brush to cover a large area? Did you spread the paint inconsistently? These actions can each cause a painting to go downhill. The solution is to use the right brush. A flat brush (¾-inch [19mm] or larger) can help you avoid these headaches. And always make sure you wet your painting surface first before applying an even wash.

Removing Masking Fluid Too Soon

If you have any doubt that your paint is not completely dry, wait to rub off the masking fluid. The wet paint will bleed into the area where the masking fluid had been and ruin the crisp edges.

Cauliflower Marks

When you apply wet paint onto a damp or semidry area, there is a high chance that your paint will not blend well and will cause uneven marks. These are sometimes called "cauliflower marks." The drier the paint, the more visible these marks will be. When this happens, you might try letting the paper dry completely, then apply the paint again. Don't try to fix the cauliflower marks while the paper is still damp because it will keep getting worse. On the bright side, you can use the cauliflower marks to your advantage to create unique textures in clouds, tree bark, foliage and coral.

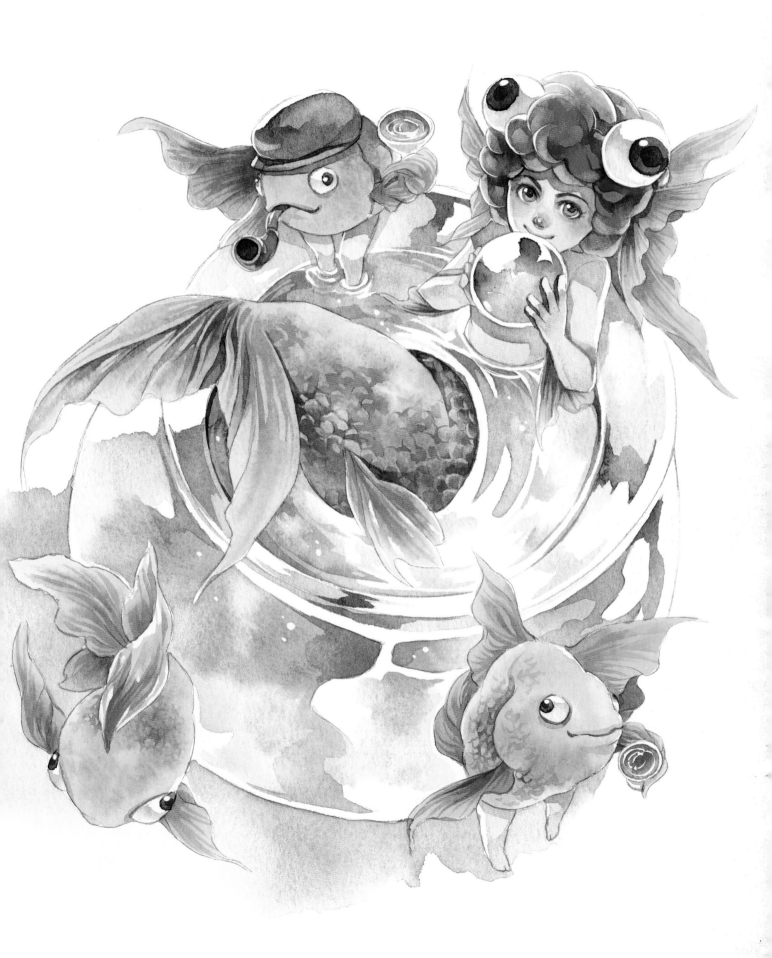

Technique
LAYERING WITH MARKERS

MATERIALS

MARKERS
B21-Baby Blue, B93-Light Crockery Blue, B97-Night Blue, E44-Clay, E71-Champagne, E84-Khaki, E87-Fig, W7-Warm Gray No. 7

PAPER
110-lb. (230gsm) cardstock

Although the primary focus of the demonstrations in this book is watercolor, marker can create equally cool results. Layering is a basic marker technique used to create volume in your paintings. Each time you layer a color on top of another, the color becomes gradually darker. Layering in families of colors is common, but you can also get creative with complementary colors for dynamic effects.

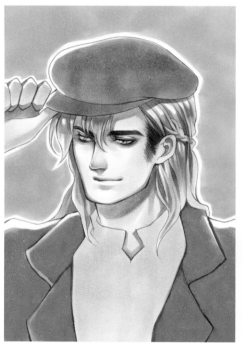

1 Apply the First Layer

Apply the first layer of markers using Champagne for the hat, Baby Blue for the shirt and Khaki for the jacket. Aim to color each area evenly with this first layer. I recommend using a broad nib for a more even application.

2 Apply the Second Layer

Build depth with darker shades for the second layer. Use Fig to paint shadows on the jacket, Light Crockery Blue for the folds of his shirt and Clay for the shadows of the hat. You want to begin the details but not overdo it so the first layer still shows through.

3 Add the Final Details

To add more shadows, make sure to select even darker shades than step 2. Choose Warm Gray No. 7 to deepen the shadows on the jacket and the hat. For the shirt, use Night Blue to emphasize the folds. During the final stages be careful not to overwhelm the picture with too many shadows.

Technique
BLENDING WITH MARKERS

Blending is a technique that allows you to intermix different colors together. Unlike layering, blending creates a nice, smooth gradient. It can be used in almost every aspect from your character's outfits and accessories to terrain and backgrounds. Blending can also be used to suggest distance. Simply use this technique on any area that recedes from the viewer.

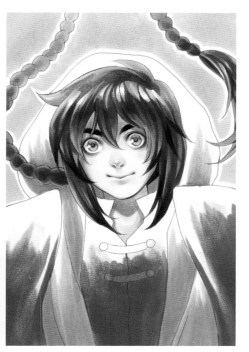

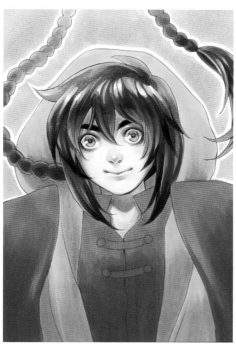

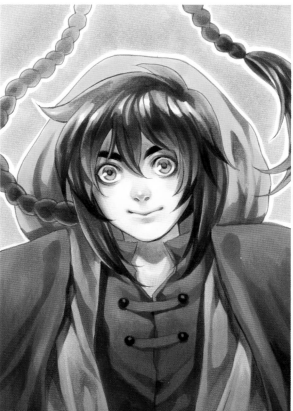

MATERIALS

MARKERS
E59-Walnut, E99-Baked Clay, R46-Strong Red, RV69-Peony, YR09-Chinese Orange, YR14-Caramel, Y35-Maize, 0-Colorless Blender

PAPER
110-lb. (230gsm) cardstock

1 Apply the Darkest Tones
In this exercise we will just paint the red shirt and yellow scarf. Start with the darkest shades first, then blend into the lighter shades to leave less noticeable brushstrokes from the markers. Paint the bottom half of the shirt with Strong Red, then use Caramel for the bottom half of the scarf. Use Colorless Blender to fade the colors in some areas, if desired.

2 Blend the Second Layer
Overlap Chinese Orange on top of the Strong Red that you painted in step 1, then use the marker nib to help blend the two colors together. Gradually the colors will blend together. For the scarf, paint Maize at the top and blend into the Caramel from step 1.

3 Add the Darkest Colors
Once the base colors and blended areas are complete, apply the final details to complete the picture. Use a darker shade such as Peony to suggest the folds and creases. Soften them with Strong Red, if desired. Apply Baked Clay on the scarf's folds and suggest the darkest shadow areas with Walnut.

33

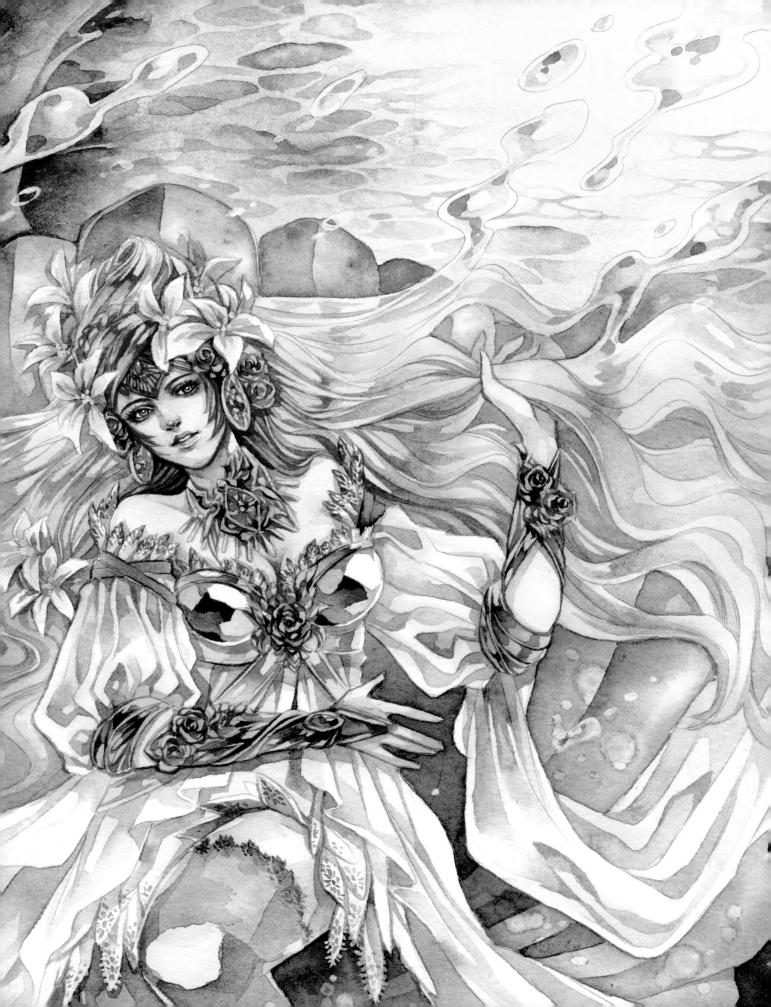

3

Bodies and Anatomy

In fantasy realms, each race or species is marked by distinctive physical attributes. For example, in the mythical genre of manga, human-like figures are commonly depicted as gods. Dwarves are stocky and hardworking, and fairies are tiny and playful, to name a few. You can base your manga characters on traditional stories (Greek mythology or Japanese folklore, for example) or use your imagination to create your own. There is no limit to how you choose to design your characters. This chapter explores the fundamentals of body structure as well as common body types and features found in fantasy worlds. Once you have the basics nailed down, have fun dreaming up and drawing your own unique characters!

Figure Basics

To prevent mistakes and create accurate figures, it helps to start with a simple skeleton. Begin with circles for the joints, lines for the limbs and basic shapes for the body parts. When your poses start to look realistic, sketch around them to form your character.

Sketching the Muscles
After you've established the pose, refine the figure's muscles and curves to make them believable.

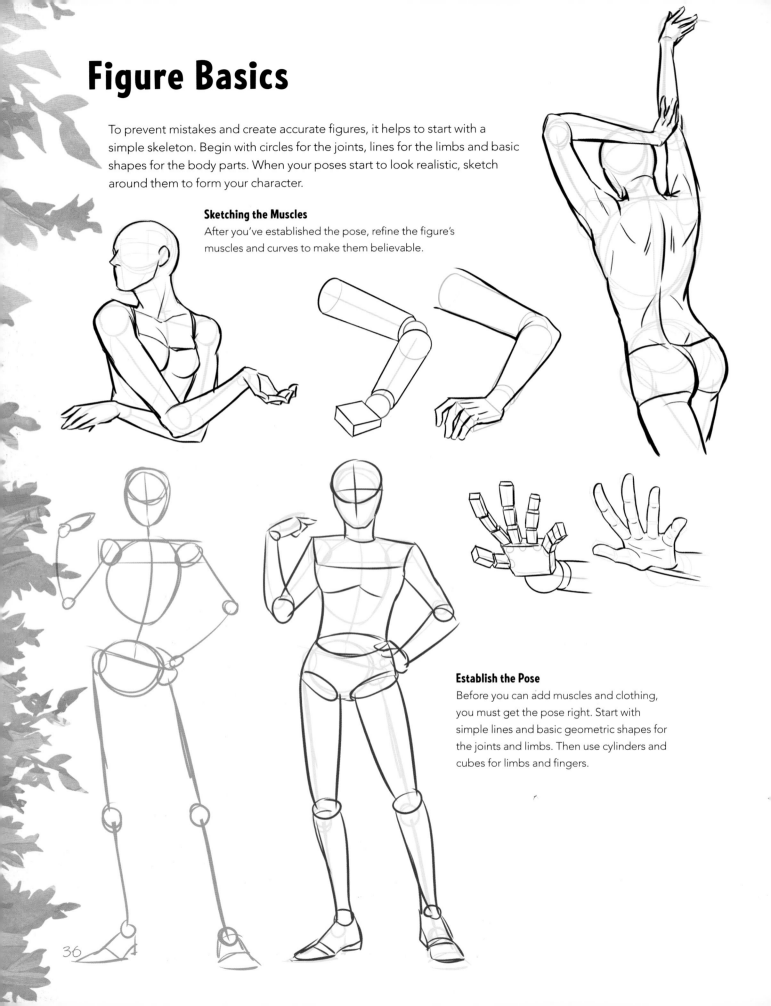

Establish the Pose
Before you can add muscles and clothing, you must get the pose right. Start with simple lines and basic geometric shapes for the joints and limbs. Then use cylinders and cubes for limbs and fingers.

Male Body Types

Body types for both females and males can be categorized into three major types: thin, average and muscular. Consider the type that best suits your character and exaggerate as needed.

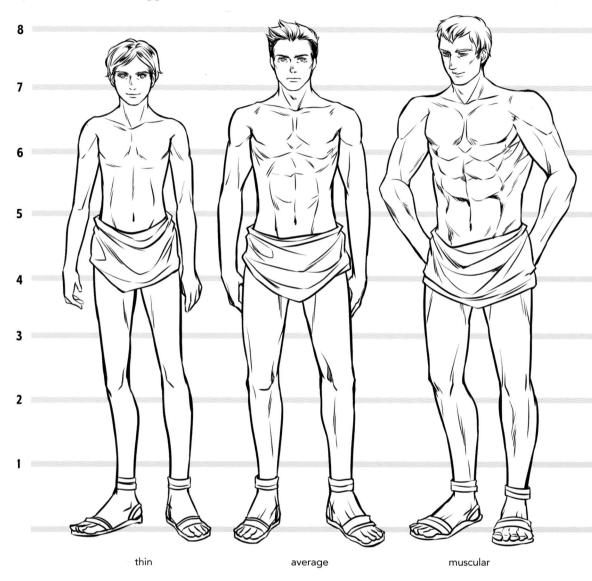

thin average muscular

Basic Body Types

Although there are three basic body types for manga figures, feel free to exaggerate them to create unique bodies. Keep in mind that the standard proportion of a typical human figure is about 8 heads tall.

Thin: A skinny frame consists of narrow shoulders and limbs. Muscles are less pronounced. Use this body type for delicate or androgynous characters.

Average: An average body has more muscle definition and broader shoulders than a thin frame. The chest and abs are more defined than on a thin body structure.

Muscular: This body type has very wide shoulders and a great deal of muscle definition. While the torso is wider, the waist and hips tend to be narrow compared to the shoulders.

Female Body Types

The female body frame doesn't differ too much from male though some features will have a more feminine definition such as the curves of the breasts and hips.

Female Hips

The size of your female character's breasts and hips is up to you. Even though she is muscular in build, the hips should be depicted wider than the tapered waist.

Seek Out Good Female Reference

Artist Alphonse Mucha is well known for his delicate female illustrations with natural curves and bodies. Although his female bodies aren't typical of anime or manga style, the references are still worth a look.

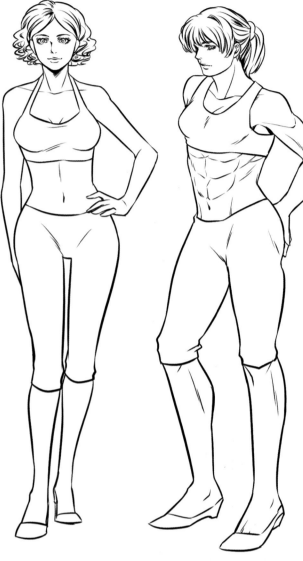

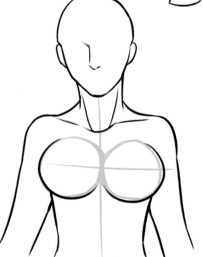

Female Breasts

Regardless of breast size, actual breasts aren't perfectly round like balloons. In fact, it's more useful to imagine a balloon filled with water and hanging over the shoulder. The natural way the balloon falls and curves will more accurately resemble the female breast. Breasts should be drawn in proportion to the character so they don't look unnatural.

Other Body Types

Just like humans, fantasy creatures and beings come in all shapes, sizes and ages. You can exaggerate a character's build to be thin or plump or even add wrinkles to show age. Observe people on the street to spark your imagination. Whether it's a Buddha belly or elongated limbs, use your imagination and have fun designing!

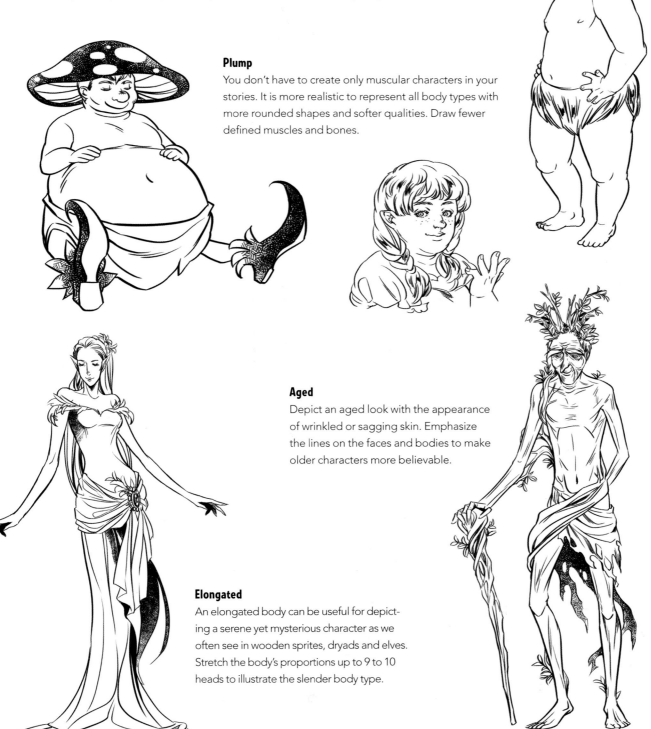

Plump
You don't have to create only muscular characters in your stories. It is more realistic to represent all body types with more rounded shapes and softer qualities. Draw fewer defined muscles and bones.

Aged
Depict an aged look with the appearance of wrinkled or sagging skin. Emphasize the lines on the faces and bodies to make older characters more believable.

Elongated
An elongated body can be useful for depicting a serene yet mysterious character as we often see in wooden sprites, dryads and elves. Stretch the body's proportions up to 9 to 10 heads to illustrate the slender body type.

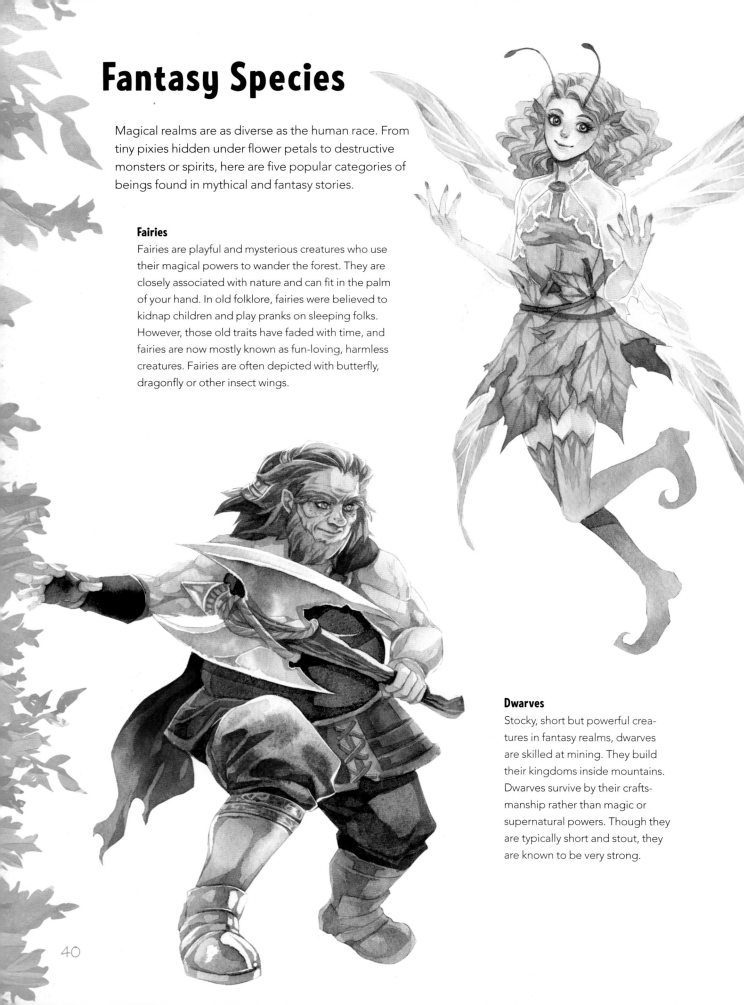

Fantasy Species

Magical realms are as diverse as the human race. From tiny pixies hidden under flower petals to destructive monsters or spirits, here are five popular categories of beings found in mythical and fantasy stories.

Fairies

Fairies are playful and mysterious creatures who use their magical powers to wander the forest. They are closely associated with nature and can fit in the palm of your hand. In old folklore, fairies were believed to kidnap children and play pranks on sleeping folks. However, those old traits have faded with time, and fairies are now mostly known as fun-loving, harmless creatures. Fairies are often depicted with butterfly, dragonfly or other insect wings.

Dwarves

Stocky, short but powerful creatures in fantasy realms, dwarves are skilled at mining. They build their kingdoms inside mountains. Dwarves survive by their craftsmanship rather than magic or supernatural powers. Though they are typically short and stout, they are known to be very strong.

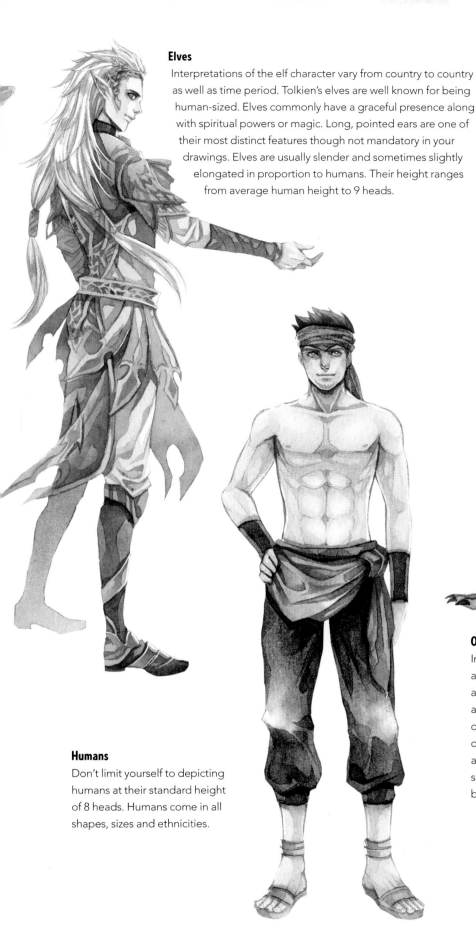

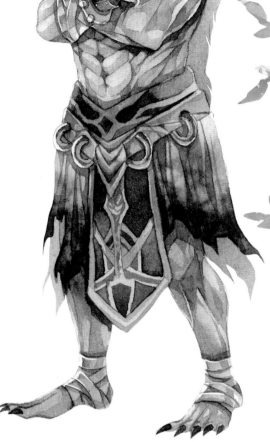

Elves

Interpretations of the elf character vary from country to country as well as time period. Tolkien's elves are well known for being human-sized. Elves commonly have a graceful presence along with spiritual powers or magic. Long, pointed ears are one of their most distinct features though not mandatory in your drawings. Elves are usually slender and sometimes slightly elongated in proportion to humans. Their height ranges from average human height to 9 heads.

Humans

Don't limit yourself to depicting humans at their standard height of 8 heads. Humans come in all shapes, sizes and ethnicities.

Orcs

In most legends, orcs are described as barbaric and savage, though this is a misconception. While orcs generally are stronger and more powerful than other races in fantasy realms, they don't have to be barbaric. Depict orcs as muscular and stoic, and vary their skin tones from greenish gray to dark black like the night sky.

Scale and Size

When combining different sized characters in a scene, it's important to keep their height and structure consistent. Here I have arranged the five character species so you can compare their proportions to an average human man. When designing your fantasy characters, remember that body size and scale are just as important as the unique facial features and costumes that you choose to make your characters believable in their realms.

Simple Body Sketches in Proportion

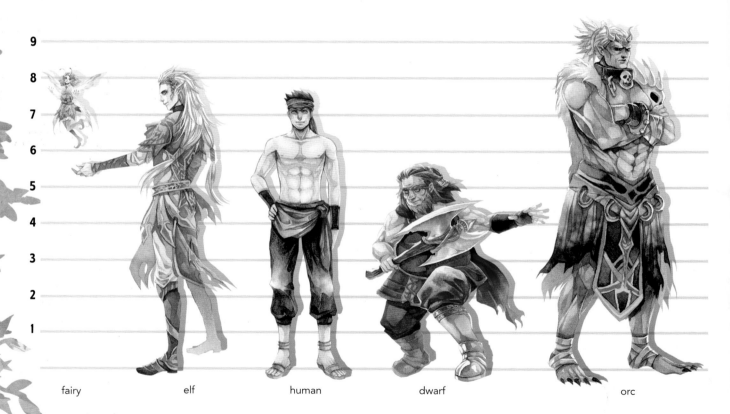

fairy elf human dwarf orc

Common Fantasy Proportions

Use this chart to determine the size and proportion of your mythological creatures. Start with an average human's proportion and scale up or down until your character's size feels logically correct.

Fairy: Average heights of fairies may vary from finger-sized to one hand high or slightly above. Here the fairy is 2 heads tall.

Elf: Lean and slender, around a human's height or taller. Here shown about 9 heads.

Human: Standard human height is about 8 heads for both men and women.

Dwarf: Shorter than a human, but stockier and wider in proportion. Here shown as 6 heads tall.

Orc: Larger and stronger than other races. Here shown about 10 heads tall.

Unisex Body Types

An androgynous character is one who shares both feminine and masculine qualities. In Greek mythology, Hermaphroditus and Dionysus are reputable for having their androgynous appearances illustrated. One way of depicting unisex body types is to show less muscle definition and softer, more effeminate facial features like the eyes and lips.

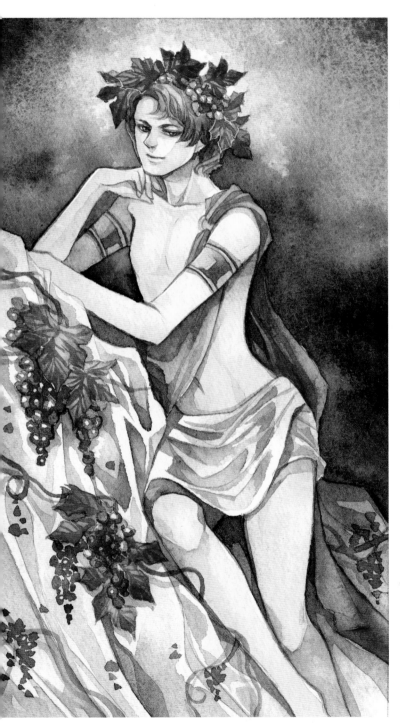

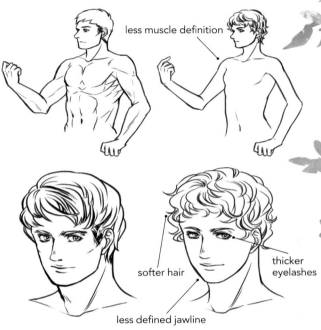

less muscle definition

softer hair

thicker eyelashes

less defined jawline

Soften the Features
When you are depicting a unisex character, the body should be soft with the muscles less defined, especially the limbs. Make the jawline less pronounced and the facial features more feminine. It should be impossible to identify the sex of the character based on the overall image.

Dionysus
Androgynous fantasy characters are usually illustrated as male figures. Dionysus, the god of wine and fertility, is often depicted with an androgynous body. While many ancient Greek gods have beards or pronounced muscles, he is typically illustrated as more effeminate and youthful, emphasizing the beauty of both genders. Dionysus is a good example to research to help you visualize how you might portray a unisex character.

Technique
Painting Skin

Skin tones normally range from pale to fair to dark. There are many methods to depict skin color. Some may prefer a realistic style; others like a more anime look. In this exercise, we paint a fair skin tone in watercolor. But you can follow the steps with the other mixtures provided to fit your character's needs.

MATERIALS

PAINTS
Brown Madder, Burnt Sienna, Cadmium Red, Cadmium Yellow, Mauve, Sepia

OTHER TOOLS
cold-pressed watercolor paper, nos. 0, 2 and 3 rounds

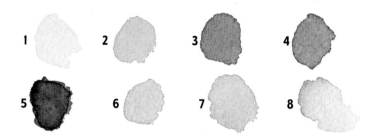

My Favorite Skin Tone Mixtures
Experiment with these basic mixtures to create a variety of beautiful skin tones for your characters. I recommend you premix your skin tones before you begin coloring.

1 Cadmium Yellow and Cadmium Red
2 Cadmium Yellow, Cadmium Red and Burnt Sienna
3 Raw Umber and Brown Madder
4 Sepia and Brown Madder
5 Sepia and Permanent Magenta
6 Cadmium Yellow, Cadmium Red and Lilac
7 Cadmium Yellow, Cadmium Red and Verditer Blue
8 Cadmium Yellow, Cadmium Red and Olive Green

1 Paint the Base Layer
With a no. 2 round, use Brown Madder or Burnt Sienna to create the base shadows. (I sometimes use Lilac, Mauve or Turquoise for this initial layer as well.) Soften some of the edges with clean water on your brush. Use diluted Cadmium Red to portray a rosy complexion on the cheeks.

2 Paint the Second Layer
Mix Cadmium Yellow with a bit of Cadmium Red (or Permanent Carmine if you want a pinker shade) and dilute the mixture with water. Use a no. 3 round and clean water to blend the skin areas. Work wet-into-wet to achieve a nice soft skin tone. Place less color on the cheekbones, chin and forehead to create highlights in these areas. Let dry completely.

3 Add Shadows and Details
Add Burnt Sienna to darken the skin tone mixture from step 2. Darken the shadows around the eyes, on the eyelids, under the lower lip and under the chin to create definition. Apply a bit of Sepia or Mauve to the skin mixture to paint the deepest shadows. Switch to a small brush like a no. 0 for the tiny details and use Sepia to refine the eyelashes and lips.

Technique
Painting Hair

Hair has highlights and shadows the same as other subjects. Don't make the rookie mistake of painting each individual strand of hair; instead use shadows to subtly build the details.

PAINTS
Payne's Gray, Sepia, Translucent Brown, Yellow Ochre

OTHER TOOLS
cold-pressed watercolor paper, nos. 0, 2 and 3 rounds

MATERIALS

1 Paint the First Layer
Using a no. 3 round, apply a light graded wash of Yellow Ochre to indicate the hair's highlights. Keep the upper part light and the bottom part dark.

2 Paint the Second Layer
When the first layer is completely dry, apply the shadowy strands using the mixture from step 1, a no. 2 round and a wet-on-dry technique.

3 Define the Highlights
Emphasize the highlights with a mix of Yellow Ochre and a bit of Sepia or Payne's Gray. Use water to dilute the shadowy strands, softening them toward the bottom of the hair.

4 Refine the Details
Create an even darker shadow mixture of Translucent Brown and Sepia to paint some more strands. Add Payne's Gray into the mixture to darken it and paint the smallest details around her face and neck with a no. 0 round.

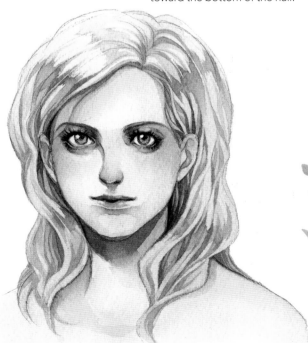

Features Inspired by Nature

Nature provides a huge source of inspiration for your mythical characters. From mushroom pixies to redwood dryads to poppy sprites, the way you choose to incorporate nature into your characters—from the specific type of tree or plant to how the elements blend with the body structure—helps make them recognizable and tell their stories. For inspiration, use books, magazines and the Internet for reference or take a walk in your garden or local park.

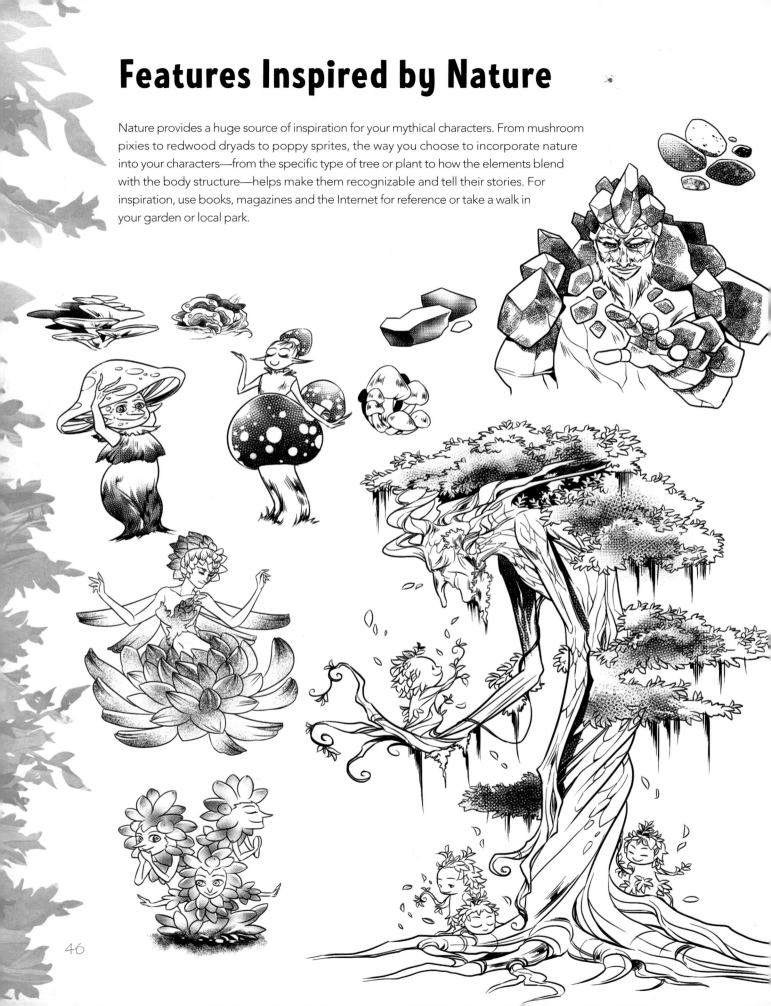

Demonstration
Wood Nymph

In classical mythology, the wood nymph resides in the forest singing beautiful songs about her surroundings. In this exercise, we create a human-like character with natural features.

1 Sketch the Figure
Roughly sketch the pose of a female figure. To capture the nymph's grace, place her in a kneeling position rather than a dynamic pose. This adds to the believability that she is a part of nature.

2 Add the Details
Attach tree branches and roots to her body so that they follow the curve of the body. Apply some leaves on the branches to detail the garment.

3 Complete the Painting
Use an earthy color scheme and a variety of rounds to paint the nymph's body, leaves and branches.

PAINTS
Cadmium Red, Cadmium Yellow, Green Gold, Olive Green, Raw Umber, Sap Green, Sepia

OTHER TOOLS
cold-pressed watercolor paper, nos. 0, 2, and 3 rounds

MATERIALS

Demonstration
GOLEM

In Jewish folklore, Golem is a mighty and magical creature formed from rocks and stones. He may look monstrous and frightening, but his heart is gentle and he is fond of protecting the sacredness of nature with all his might.

MATERIALS

PAINTS
Burnt Sienna, Indigo, Olive Green, Perylene Green, Raw Umber, Sap Green, Sepia

OTHER TOOLS
cold-pressed watercolor paper, nos. 0, 2, and 3 rounds, pencil

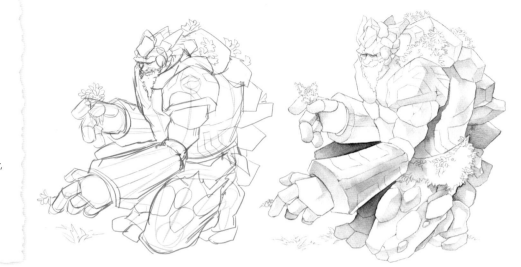

1 Sketch the Pose
Use a pencil to sketch Golem's pose and proportions. Exaggerate some of his body parts like his torso and hands to depict his mighty appearance. The size of the head should be small compared to the rest of his body.

2 Paint the Base Layer
Apply an Indigo wash for the base layer with a no. 3 round. The light source is coming from the top so keep the shadows lighter on the left. Smooth some of the edges with water. On Golem's right leg, apply a concentrated graded wash of Indigo to help it recede into the background.

3 Add Shadows and Details
When the base layer is dry, lay clean water over the entire body and apply a wet-into-wet wash of Raw Umber. While the paint is wet, create a mixture of Raw Umber and Sepia and apply shadows on the right side of Golem as well as on his knuckles.

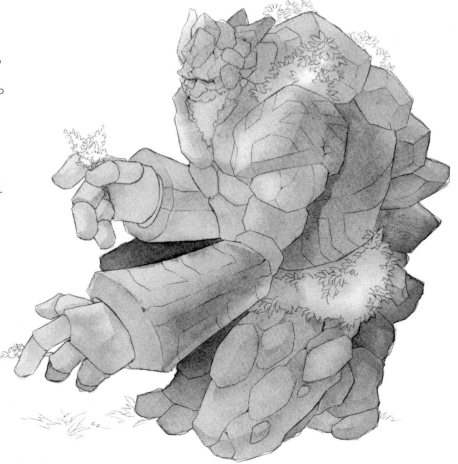

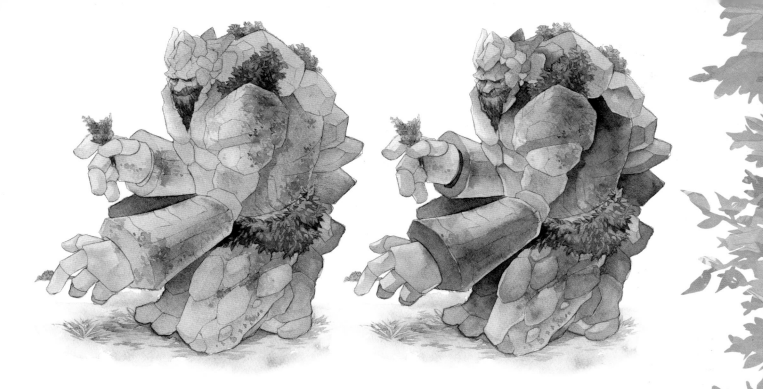

4 Paint the Shrubs and Moss

Paint the shrubs with a mix of Sap Green and Olive Green and a no. 2 round. Depict the grassy ground with a thin layer of Sap Green diluted with water. Apply random spots of Sap Green wet-on-dry to his thigh, arm and shoulder to indicate moss, and dilute with water to vary the moss's darkness. When the shrub color is dry, mix Olive Green and Perylene Green to deepen the shadows and call out some individual leaves.

5 Darken the Stones

Paint some individual stones with a diluted mixture of Burnt Sienna and Sepia and a no. 3 round. Apply more layers of the mixture to select stones to help them stand out. Use Sepia for the deepest shadows on the back of his torso and under his chin.

6 Paint the Final Details

Switch to a no. 0 round for refining details. Apply Sepia on the shadows in between the stones on the Golem's body. Refine the cracks on the rocks with Burnt Sienna. Mix Sepia with a bit of Perylene Green for the darkest cracks. Finally, add some random textures to the stones with Burnt Sienna and Sepia.

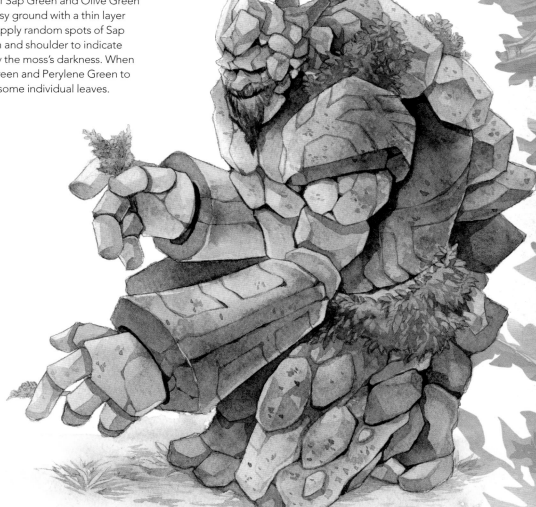

Features Inspired by Animals

In many mythological tales there are beings depicted with both human and animal traits. From mermaids to Minotaurs, these creations are not so strange as they are a reflection of our imagination and creativity as storytellers and artists.

Insect Wings
Insect wings make great reference source for fairies, pixies and natural spirits. Butterfly or dragonfly wings come in lots of patterns and colors.

Mermaid Tails
Mermaid bodies are flexible and designed to swim through strong water currents. The upper half is human, but the lower half should match the anatomy and movement of a fish. Some mermaids may have webbed hands or arms, or different fins and tails.

Bird Wings
Bird wings are frequently used as reference for angel's wings. The size of the wings should be balanced with the body size of the character. Wings are typically located on the back in the approximate space between the scapulas and spine.

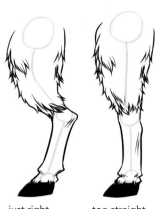

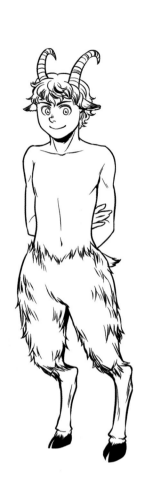

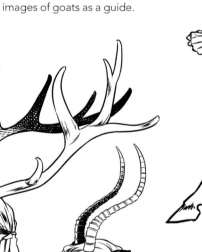

just right too straight

Pan: Half Human/Half Goat

The Pan of Greek mythology is depicted as a man with the legs, horns and ears of a goat. The most important part to get right is the legs. When standing upright, Pan's goat legs should be bent slightly backward. Use reference images of goats as a guide.

Centaur: Half Human/Half Horse

The centaurs of Greek mythology have the head, arms and torso of a human and the legs and body of a horse. Make sure to keep the two distinct forms in proportion. The upper body shouldn't be too big or too small in comparison with the horse body.

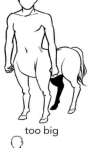

too big

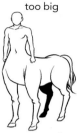

too small

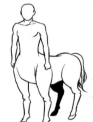

just right

deer antlers elk antlers

goat horns

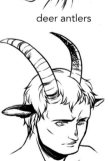

goat horns

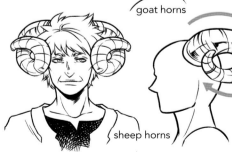

sheep horns

Antlers and Horns

Deer and elk antlers are similar in shape but different in size. Elk antlers are much larger. Use size to indicate the power ranking between the two.

Goat and sheep horns are commonly confused. Just remember that sheep horns are curly whereas goat horns are straight or slightly curved. Sheep horns tend to curl backward and swirl into a spiral. Sometimes you can use goat horns to depict a character with a wicked nature such as the satyr of Roman mythology. Experiment with the other types of horns and antlers such as impala, buffalo and moose.

Demonstration
HARPY

In Roman mythology, a Harpy has the body and head of a woman and the wings and legs of a bird of prey. She will lure you in with her irresistible beauty and colorful feathers, then trap you in her dangerous gaze. In this exercise, pay close attention to where her arms and legs transition into bird wings and claws.



MATERIALS

PAINTS
Antwerp Blue, Brown Madder, Cadmium Red, Cadmium Yellow, Cobalt Blue, Cobalt Turquoise, Indigo, Mauve, Payne's Gray, Permanent Carmine, Permanent Magenta, Translucent Brown, Sepia, Yellow Ochre

OTHER TOOLS
cold-pressed watercolor paper, nos. 0, 1, 2, 3 and 5 rounds, pencil, salt

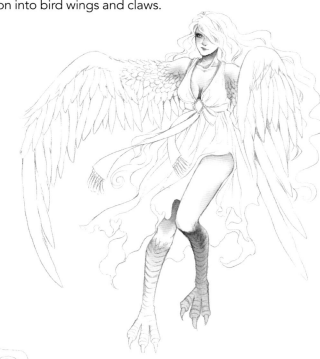

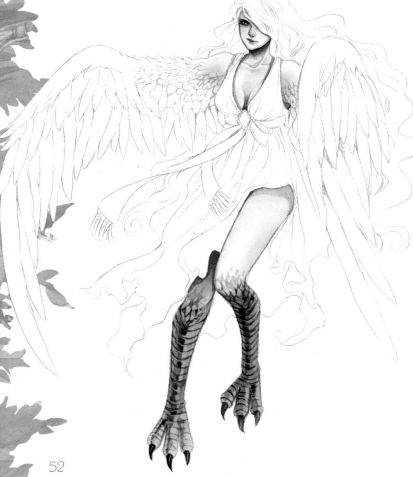

1 Sketch the Pose and Paint the Skin Tone
Sketch the pose with a pencil, then using a no. 2 round, mix Translucent Brown and a bit of Brown Madder together. Apply the mixture under the chin and legs to establish initial shadows. After that, apply Cadmium Red on the cheek and dilute the edges with clean water.

2 Deepen the Skin Tone and Paint the Claws
Create a mixture of Cadmium Yellow and a bit of Permanent Carmine for the skin's color. Load the mixture with water and then paint on the skin with a no. 3 round. Leave some time for the wash you paint to dry. Mix Translucent Brown and Mauve together, using that mixture to emphasize the deepest shadows.

Spread a Yellow Ochre wash from the knees down to the entire claws. Wait until the wash is dry, then mix Yellow Ochre and Sepia together and use a no. 1 round to create the claw details. To create a transition from the claws to the skin, apply diluted Yellow Ochre above the knee, creating small scales. Add some deeper shadows with Sepia, if desired.

ph2

ph3

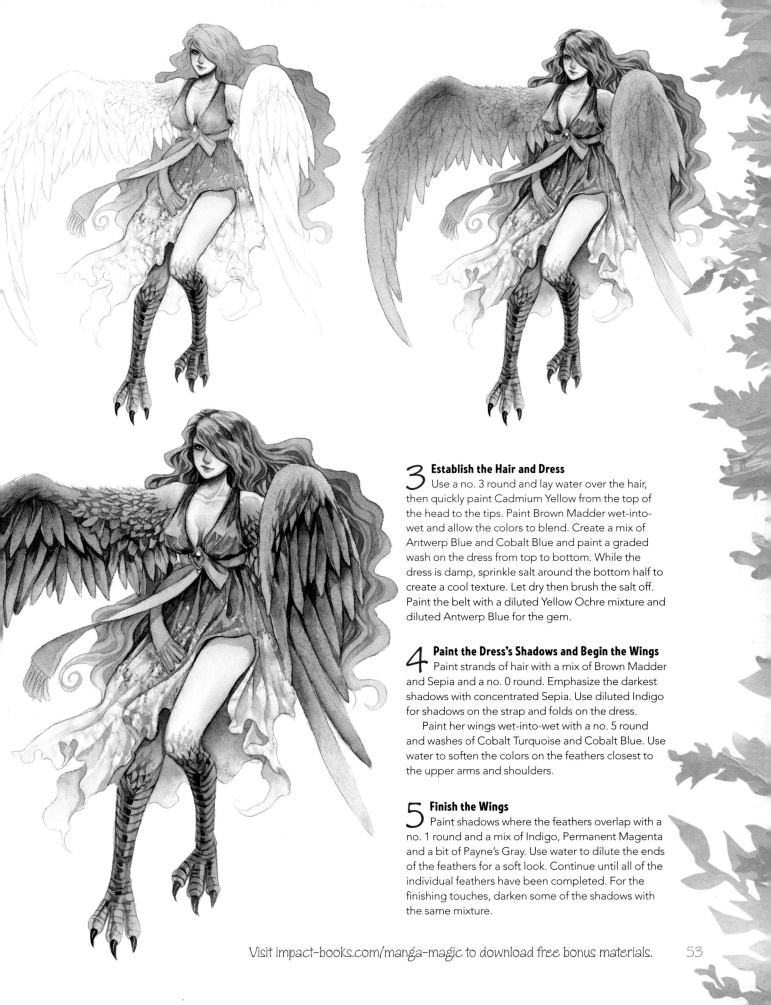

3 Establish the Hair and Dress

Use a no. 3 round and lay water over the hair, then quickly paint Cadmium Yellow from the top of the head to the tips. Paint Brown Madder wet-into-wet and allow the colors to blend. Create a mix of Antwerp Blue and Cobalt Blue and paint a graded wash on the dress from top to bottom. While the dress is damp, sprinkle salt around the bottom half to create a cool texture. Let dry then brush the salt off. Paint the belt with a diluted Yellow Ochre mixture and diluted Antwerp Blue for the gem.

4 Paint the Dress's Shadows and Begin the Wings

Paint strands of hair with a mix of Brown Madder and Sepia and a no. 0 round. Emphasize the darkest shadows with concentrated Sepia. Use diluted Indigo for shadows on the strap and folds on the dress.

Paint her wings wet-into-wet with a no. 5 round and washes of Cobalt Turquoise and Cobalt Blue. Use water to soften the colors on the feathers closest to the upper arms and shoulders.

5 Finish the Wings

Paint shadows where the feathers overlap with a no. 1 round and a mix of Indigo, Permanent Magenta and a bit of Payne's Gray. Use water to dilute the ends of the feathers for a soft look. Continue until all of the individual feathers have been completed. For the finishing touches, darken some of the shadows with the same mixture.

Visit impact-books.com/manga-magic to download free bonus materials.

Demonstration
PAN

Pan is widely known for his entertaining songs and dancing whenever spring arrives. He lives deep inside a mountain and is a friend to the wood nymphs who dwell near his living quarters.

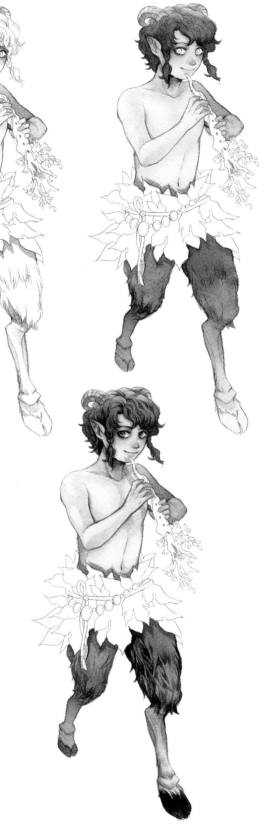

MATERIALS

PAINTS
Burnt Sienna, Cadmium Red, Cadmium Yellow, Lilac, Mauve, Permanent Carmine, Perylene Green, Raw Umber, Sap Green, Sepia, Translucent Brown

OTHER TOOLS
cold-pressed watercolor paper, nos. 0, 2 and 3 rounds, pencil

1 Sketch the Pose and Paint the Face
Sketch the pose with a pencil. Paint a light wash of Cadmium Red on his cheeks, ear and the tip of his nose with a no. 2 round and soften with water. The rosy cheeks give Pan a playful, child-like quality. Paint a wash of Lilac for the shadows on his left arm and right leg. Paint the deepest shadows under his chin and beneath the leaves using Mauve.

2 Paint the Skin Tone and Fur
Create a mix of Cadmium Yellow, a touch of Permanent Carmine and water and paint a light wash on the skin with a no. 3 round. Use Translucent Brown on his goat legs, then lighten the shins with a thin wash of Raw Umber. Paint a flat wash of Cadmium Yellow on the hair. Paint Burnt Sienna wet-into-wet toward the tip of the hair. Paint a diluted wash of Raw Umber for the horns.

3 Paint the Skin's Shadows, Eyes and Hooves
Darken the skin's shadows using the skin tone mixture from step 2 plus a little Sepia and a no. 2 round. Paint a light wash of Sap Green on the eyes. Add Mauve into the Sepia and use a no. 0 round to define strands of hair and details on the leg fur. Mix a light wash of Sepia and Mauve for the horns and use concentrated Sepia on his hooves.

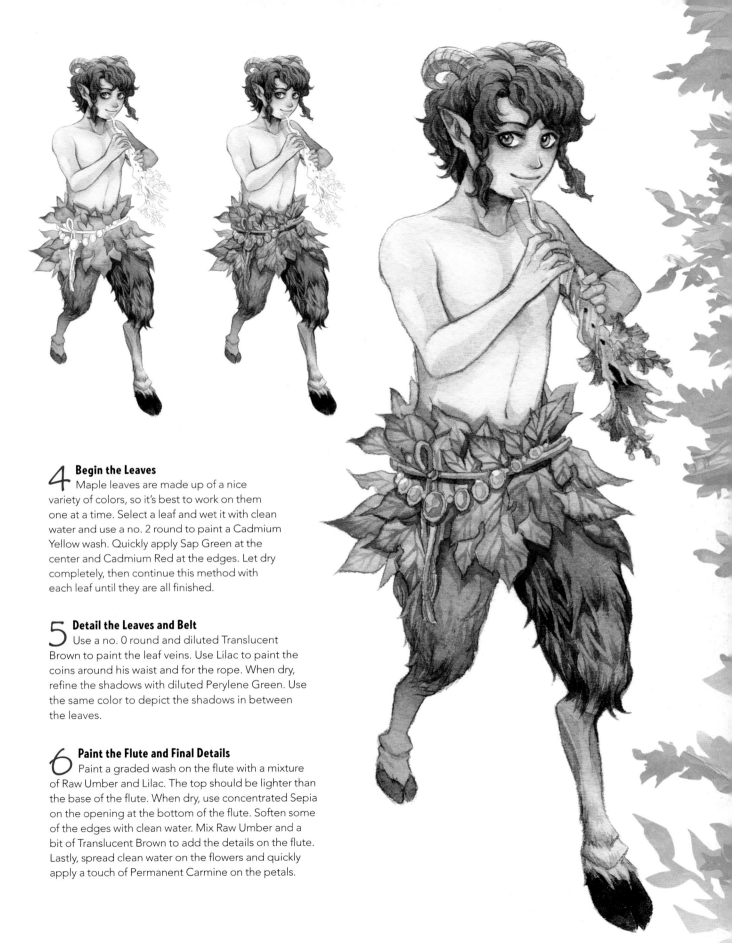

4 Begin the Leaves

Maple leaves are made up of a nice variety of colors, so it's best to work on them one at a time. Select a leaf and wet it with clean water and use a no. 2 round to paint a Cadmium Yellow wash. Quickly apply Sap Green at the center and Cadmium Red at the edges. Let dry completely, then continue this method with each leaf until they are all finished.

5 Detail the Leaves and Belt

Use a no. 0 round and diluted Translucent Brown to paint the leaf veins. Use Lilac to paint the coins around his waist and for the rope. When dry, refine the shadows with diluted Perylene Green. Use the same color to depict the shadows in between the leaves.

6 Paint the Flute and Final Details

Paint a graded wash on the flute with a mixture of Raw Umber and Lilac. The top should be lighter than the base of the flute. When dry, use concentrated Sepia on the opening at the bottom of the flute. Soften some of the edges with clean water. Mix Raw Umber and a bit of Translucent Brown to add the details on the flute. Lastly, spread clean water on the flowers and quickly apply a touch of Permanent Carmine on the petals.

4

Clothing and Costumes

If you've ever played with a paper doll, you may have admired how perfectly the doll's paper clothes fit and conform to the two-dimensional shape. Although costume design is one element to consider when creating our manga characters, we must also take into account the dynamics of putting our characters into action. The creases, folds and weight of fabric as well as how the clothing moves and shifts with the body are equally as important as the design and color. In this chapter, we will study the basics of movement and clothing to help give your characters unique and eye-catching looks that will make a lasting impression.

Fabric and Texture

Costumes and clothing play a major role in reflecting a character's personality and background. Think about the type of style and materials that would work best for your characters to give the viewer the most information about who they are.

Soft Fabric

Sheer fabric like chiffon or silk is loose and delicate. Such lightweight fabric will cling to the body, often creating lots of drapes and folds. Shiny silk is great for depicting a character with power or wealth, whereas cotton and wool are typical of common folk.

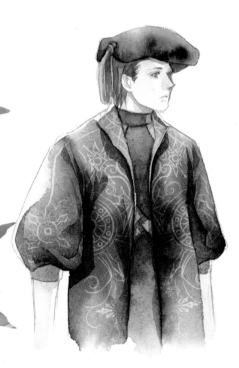

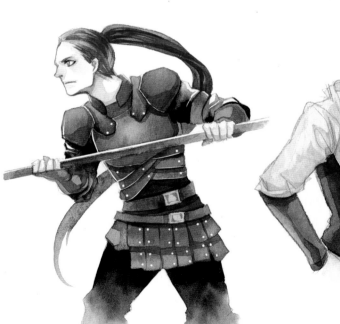

Stiff Fabric

Stiff, tough fabric has fewer drapes and folds. Its shape is more likely to stay intact while a character is in action. Stiff fabric can be used to represent formal or dignified characters.

Leather

The color of leather is usually earthy or neutral unless it is dyed. Because of its durability, leather can be used in all types of clothing, armor and accessories.

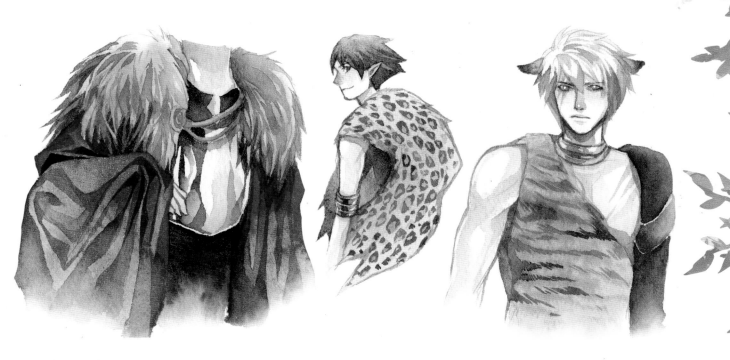

Fur and Skins

Fur can be both a decorative addition to a costume as well as its own garment. For instance, Viking warriors used fur for their cloaks and leg warmers, while an exotic tribal society might use animal skins in their traditions and rituals. Whether stripes, dots or spots, take some time to study the patterns of different animals and the ecosystems in which they live.

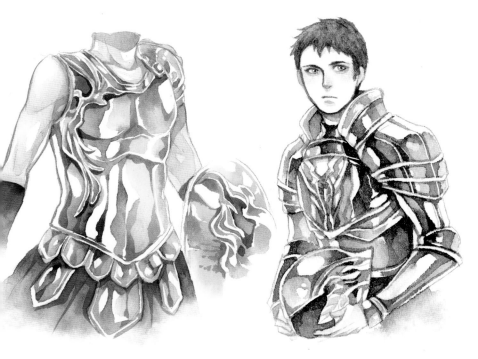

Metal

Armor and weaponry are often made of metals such as iron, silver, gold or copper. The main quality of metal is its reflectiveness. The key to depicting metal is to emphasize the high contrast between its highlights and shadows. The more precious or rare a metal is, the more powerful or important the character who wears it will be. Gold is a deep bright yellow and highly reflective. Iron and silver are normally a silvery gray though the silver aspect is shinier and more reflective. Copper usually has a reddish tint. Pay attention to these subtle color shifts when painting different types of metal.

The Movement of Clothing

When a body moves, it is logical for garments to follow the movement of the body, too. However, it is important to consider the type of material (is it soft? stiff? durable?) to make the outfit believable. In addition to the action of the body (are they flying in the sky or diving in the ocean?), outside sources such as the environment and weather also affect how the clothing moves.

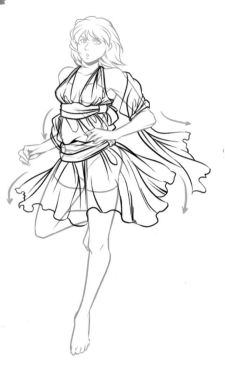

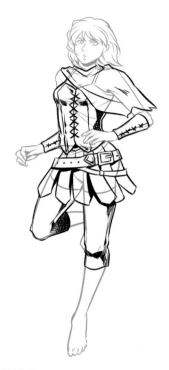

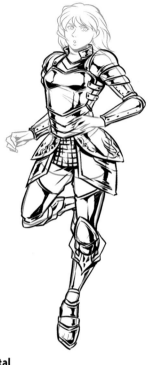

Soft Fabric
Soft, sheer fabrics such as silk, cotton and wool are loose and flowy in appearance.

Stiff Fabric
Leather can maintain its shape or flow with the body, depending on how thin you choose to depict it.

Metal
Metal retains its shape because of its hard quality.

satin

cotton

silk

wool

Fabrics in Motion
Although satin, silk, cotton and wool are all soft fabrics, their subtle characteristics and details set them apart. For example, satin is more translucent in texture while silk is shiny and subtly reflects the colors of nearby objects. Wool is usually the least frilly of the soft fabrics and is fluffy in texture.

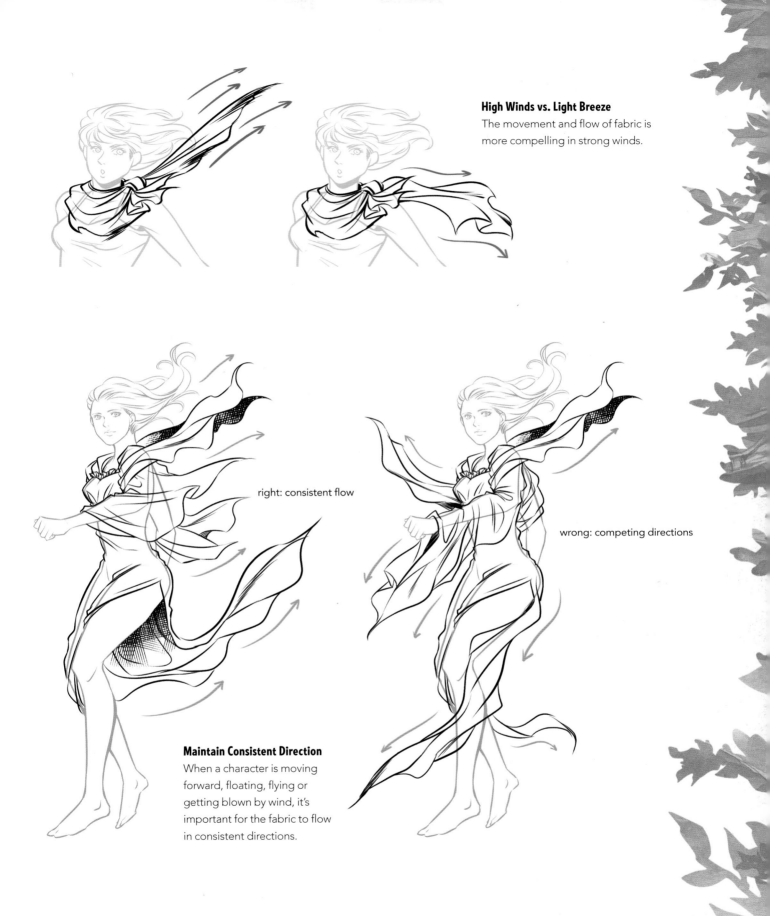

High Winds vs. Light Breeze

The movement and flow of fabric is more compelling in strong winds.

right: consistent flow

wrong: competing directions

Maintain Consistent Direction

When a character is moving forward, floating, flying or getting blown by wind, it's important for the fabric to flow in consistent directions.

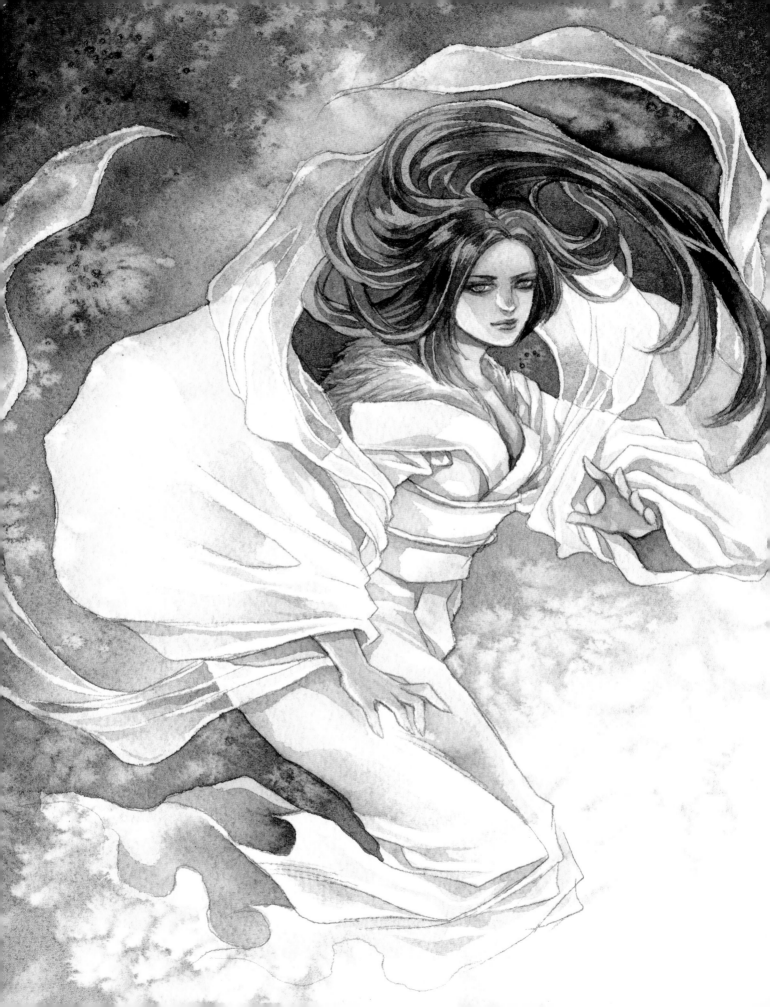

Demonstration
YUKI ONNA

Yuki Onna is the snow woman of Japanese folklore. Her hair is dark as night, and her skin pale as the snowy landscape. She is known for her ghostlike beauty and for her ruthless, evil demeanor. Her icy flowing kimono is perfect for learning how to depict translucent fabric.

MATERIALS

PAINTS
Blue Apatite, Cobalt Blue, Indigo, Lilac, Mauve, Naples Yellow, Payne's Gray, Phthalo Blue, Raw Umber

OTHER TOOLS
cold-pressed watercolor paper, nos. 1, 2, 3 and 5 rounds, pencil, salt

1 Sketch the Pose
Lightly sketch the pose with a pencil on cold-pressed watercolor paper. Pay close attention to the direction of the fabric in relation to her movement.

2 Establish the Background
Paint the background wet-into-wet. Wet the whole paper and apply a wash on the sky and background with a mix of Phthalo Blue and Payne's Gray using a no. 5 round. Leave the figure unpainted and the bottom right corner very light in tone. Don't worry if the paint slightly bleeds into the figure area. Quickly sprinkle salt on top while the surface is still damp to create a soft, snowy effect. After the surface is dry, brush off the salt.

3 Darken the Sky

Darken the edges around the character and kimono to make Yuki stand out. Apply glazes of Phthalo Blue, Indigo and Mauve with a no. 2 or 3 round to the outer areas except the bottom right. While the paint is still wet, sprinkle a bit more salt to enhance the texture. Use a no. 2 round to paint the smaller areas between her hair and kimono.

4 Begin the Kimono's Base Layer

Create a mixture of Cobalt Blue, Blue Apatite and lots of water and begin laying the shadows of the kimono with a no. 2 round. Be careful to leave plenty of white to give the garment a translucent quality. To lighten an area, soften the color with fresh water. Use the same mixture to paint her face and hands. Create a concentrated version of the mixture and lay a flat wash on the hair.

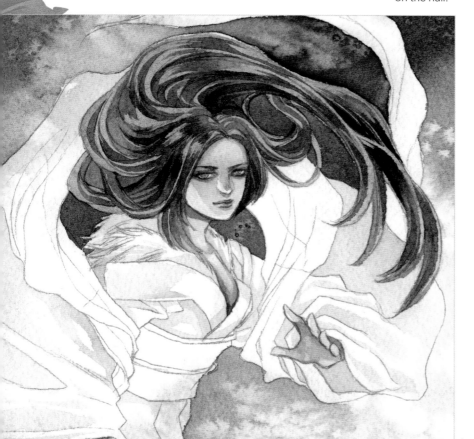

5 Paint the Skin and Hair

Mix a delicate skin tone with a touch of Naples Yellow, Lilac and water. Paint a flat wash of the mixture on the skin areas and let dry completely. Add a touch of Cobalt Blue to the skin tone and paint the deepest shadows and details of the hands and face. Define the shadowy strands of hair with a glaze of Blue Apatite and Payne's Gray using a no. 1 round.

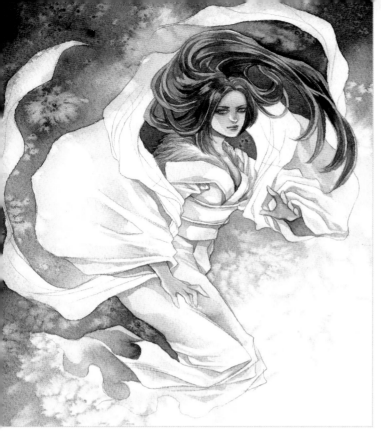

6 Darken the Kimono's Shadows and Paint the Collar
With a no. 1 round, refine some of the kimono's shadows with diluted Blue Apatite and Payne's Gray. Make a few of the shadows quite dark, but be careful not to overdo it. Use Raw Umber and Blue Apatite to paint the fur on her collar with a dry-brushing technique.

7 Block Out the Highlights
Use a pencil to lightly indicate the sections of the kimono that overlap—on the sleeves and at her hip. Keep these overlapping parts unpainted.

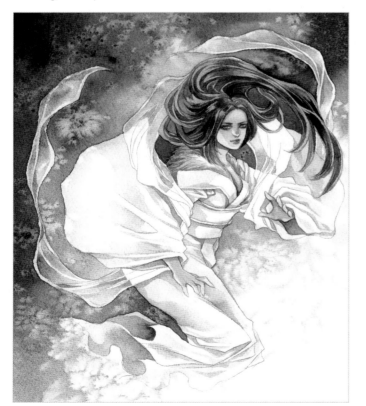

8 Enhance the Translucent Look of the Kimono
With a no. 1 round, apply Blue Apatite on the flowing areas of the kimono and soften the edges with fresh water. Keep the color lighter than the background. Make sure to leave the fold lines visible to indicate the movement of the fabric.

9 Complete the Overlapping Areas
Paint a very diluted mix of Phthalo Blue and water on the overlapping areas from step 7. Soften some of the edges with water as done in step 8. The result is a translucent effect of Yuki's kimono against the background.

Armor

Armor is the protective covering worn by soldiers and warriors, who commonly represent determination and power. Interchange the components to suit the traits and style of your character. Whether illustrating a full getup or using just a few coverings, customize the armor's details to celebrate what makes your character unique.

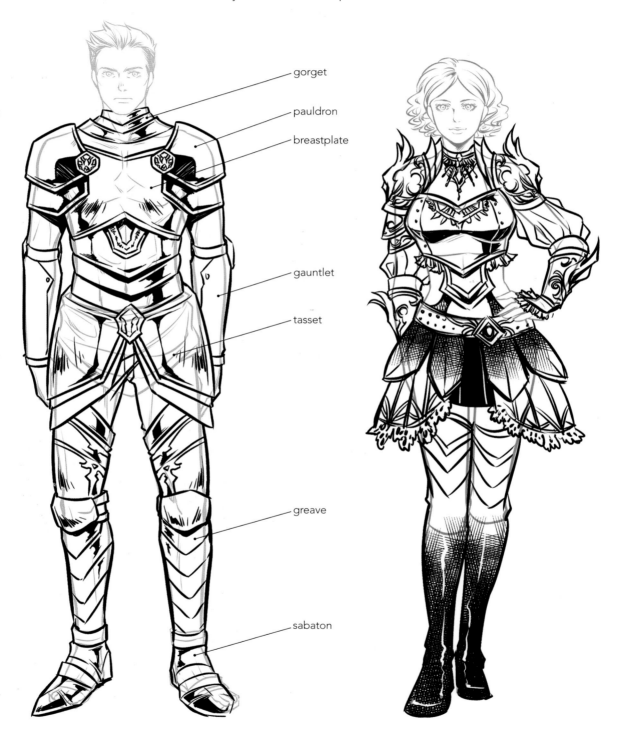

gorget

pauldron

breastplate

gauntlet

tasset

greave

sabaton

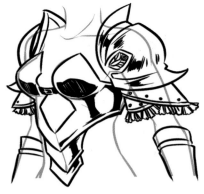

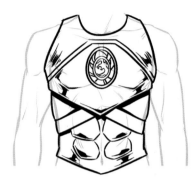

Female Breastplates

To depict female armor, simply adjust the proportions to fit the curves of the female body. You can downplay or exaggerate the breastplate and use lace or lightweight fabric as decorative elements to give the armor an elegant quality.

Pauldrons

Pauldrons cover the shoulders and are made of durable materials such as leather or metal. The main dome-shaped piece can be embellished with various designs to help the character's shoulders stand out.

Male Breastplates

The breastplate typically covers the chest or the entire torso. It's up to you to decide how much it mimics the shape of the figure and abs. Once the plate covers the desired area, add decorative elements and textured material such as metal scales or leather.

Female Armor Bottoms

Here are some examples of armor bottoms for female characters. Short skirts, long skirts, pants and leggings—have fun designing costumes that fit your characters!

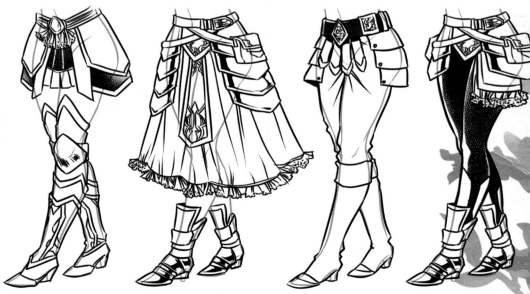

Hand and Footwear

Though not a requirement, gloves, gauntlets, bracers and boots are common components of a fantasy character's wardrobe. You can easily adjust the details for more feminine or masculine styles. It's fine to create armor that matches from top to bottom, but you can also get creative with the patterns and details. Bare feet and hands are also acceptable if you feel they're right for your characters. Have fun experimenting with different styles whether classical, traditional, adapted or a combination of many.

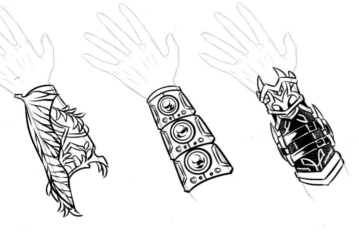

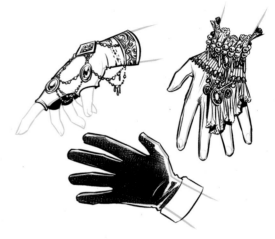

Bracers
Bracers cover the arm from the wrist to the elbow. They can be leather or metal or even made of leaves. Try decorating the straps with elegant carvings.

Gloves
Whether simple or fingerless, embroidered or covered in gems, there are countless ways to design gloves.

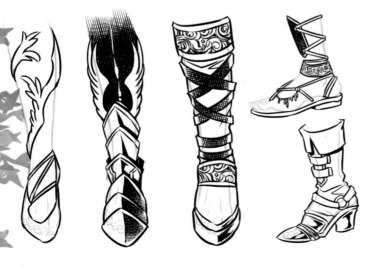

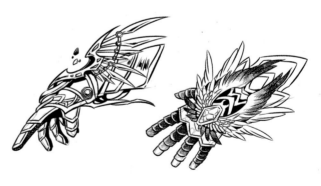

Gauntlets
Gauntlets are armored gloves that usually match the style of the overall armor. To make them more realistic, paint at least as many finger plates to match the minimum number of finger joints in the hand.

Shoes
Get creative when designing shoes and boots. Sometimes it's good to consider a more practical style so the shoe doesn't distract from the rest of the costume.

Demonstration
KNIGHT

A knight is someone who always raises his weapon to protect people and towns. His might and wisdom are reflected in both his actions and his outfit. Patterns, symbols and trim are great ways to make your character unique and reveal details about his background and personality.

MATERIALS

PAINTS
Cadmium Red, Cadmium Yellow, Payne's Gray, Sap Green, Sepia

OTHER TOOLS
cold-pressed watercolor paper, nos. 0, 1, 2, 3 and 5 rounds, pencil

1 Sketch the basic outline of the character and armor. For the breastplate design, the wings symbolize freedom while the arrows portray wisdom and virtue.

2 Sketch the design of the gold trim. Adjust the proportion and angles of the symbols on the breastplate, pauldrons, bracers and tassets so they work with the curves of the body.

3 Paint the armor. I chose a bold rust and gold palette to depict the knight as strong and brave.

Dresses

The dress styles of different historical periods make excellent inspiration for your mythological and fantasy characters. Study various cultures to get ideas for dress designs and accessories.

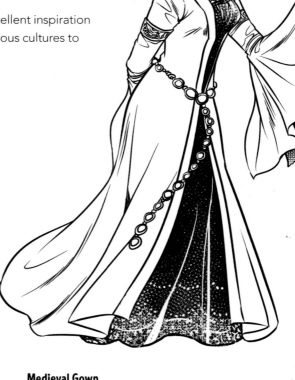

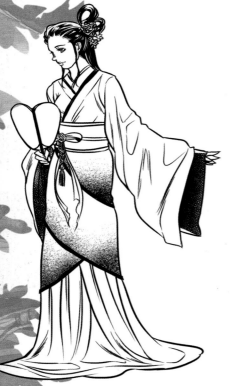

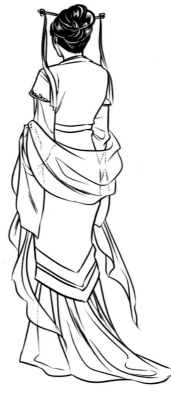

Medieval Gown

Medieval gowns typically have long sleeves and can be made of a variety of fabrics such as silk, wool or velvet. Use bright colors and extravagant embroidery for noble women, and more plain, simple features for peasants.

Chinese Gown

Chinese gowns range widely depending on the historical era. Hanfu is one of the well-known styles. It consists of long, wide sleeves, a cross-collar and a sash. The gown can consist of two or more layers. To depict the soft quality of the fabric, Chinese gowns require many folds and creases when the body moves.

Grecian Gown

A Grecian gown (or chiton) is a long tunic made of light-weight fabric and sewn into the form of a dress. It is often sleeveless and secured with a belt or girdle. Chitons are usually admired for their beautiful simplicity rather than their ornate details.

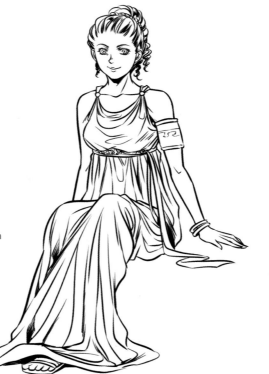

Jewelry

Accessories are a great element to use for decorating your character's costumes. They draw attention while addressing the charm and personality of the individual. Materials for jewelry ranges from priceless gems to soft worn leather. You can even design it out of wooden branches, leaves, coral pieces or seashells.

Earrings
From hoops to dangling, earrings can be any shape as long as they aren't too big for the head.

Bracelets
Bracelets can be worn singularly or in multiples like bangles. They can be as simple as a loop of gold or silver or elaborately decorated with gemstones or trinkets. They can be round, twisted, knotted or even braided. Use the beauty of bracelets to enhance your character's outfits, especially if she has a sleeveless costume.

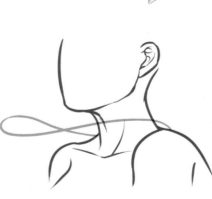

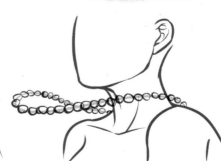

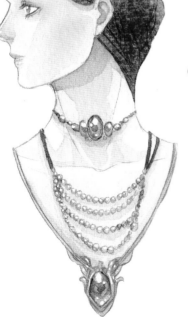

Necklaces
The weight of a necklace depends on what and how much you attach to the chain or string. Always start with a loose line wrapping or swinging around the neck, then add the adornments. Both the size and number of strings and adornments can vary. Some necklaces even consist of distinctive shapes bound together without a base string.

Visit impact-books.com/manga-magic to download free bonus materials.

Demonstration
GEMSTONES

Painting gemstones is similar to painting glass or crystal in that it's crucial to get the reflections right. For a round gem the gleam appears smooth, while cut gemstones are made up of many facets that each reflect light differently. Gemstones come in many colors and can be used to convey mood and meaning. Use the handy color chart to practice others.

Gemstone Colors and Paints

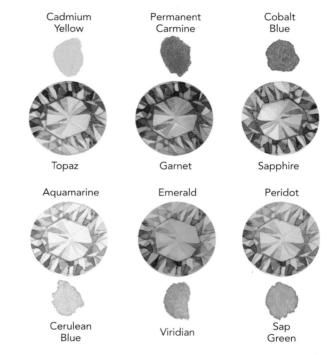

Cadmium Yellow — Topaz

Permanent Carmine — Garnet

Cobalt Blue — Sapphire

Aquamarine — Cerulean Blue

Emerald — Viridian

Peridot — Sap Green

Round Gemstone

1 Draw an oval shape, leaving a space for the highlight. Paint a graded wash of Cadmium Yellow from top to bottom, leaving the highlight white.

2 Apply a glaze of Permanent Carmine. Leave some unpainted areas to indicate the highlights. You can use a paper towel to lift up the red paint as well.

3 Paint the shadows with a mix of Permanent Carmine and Payne's Gray. Refine the shadows under the highlight and edges of the gem. Soften the paint with clean water.

Cut Gemstone

1 Draw an oval shape and sketch the facets within. Lay a flat wash of very diluted Manganese Violet on the entire gem.

2 When dry, use a smaller round to apply a glaze of Manganese Violet on a few of the facets.

3 Mix Manganese Violet with a bit of Payne's Gray to darken some of the facets. It's okay to overlap some of the facets painted in step 2.

Demonstration
GOLD BRACELET

Luminous golden jewelry with ornate patterns is the ideal adornment for mythological and fantasy characters. The key to painting shiny subjects such as gold or metal is to depict strong contrasts between shadows and highlights. The colors shouldn't blend together as with some other materials. In this exercise we use a yellow/brown palette to depict gold, but you could also use cool grays for silver or brownish red for copper.

PAINTS
Cadmium Yellow, Payne's Gray, Raw Umber, Translucent Brown

OTHER TOOLS
cold-pressed watercolor paper, nos. 0, 1, 2, 3 and 5 rounds, pencil

MATERIALS

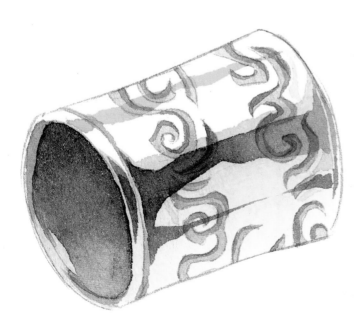

1 Use a pencil to sketch a bracelet shape of a basic cylinder, and lightly draw patterns. Paint a graded wash of Cadmium Yellow on two-thirds of the bracelet, keeping the bottom lighter in color. Leave a large white highlight at the top.

2 Add a reflective streak in the top highlight with concentrated Cadmium Yellow. Mix Cadmium Yellow with Payne's Gray to paint shadows in the lower part of the bracelet. Keep both highlights and shadows strong and solid.

3 Paint Raw Umber on the patterns. Darken the inside of the bracelet with Payne's Gray and Translucent Brown.

4 Emphasize the details of the carvings. Switch to a smaller brush such as a no. 0 round and use a mixture of Raw Umber and a bit of Payne's Gray to fill in the tiny shadows of the pattern.

Patterns and Symbols

Create your own unique patterns from scratch! Start with a basic shape or line and elaborate from there. Patterns are fun to add to your costume designs regardless of the texture or type of material.

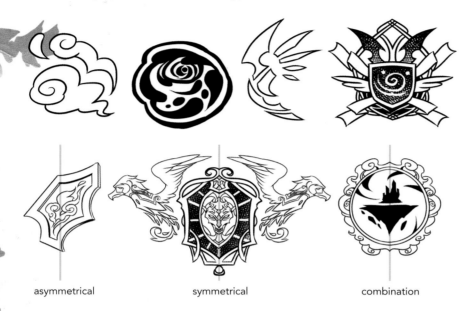

asymmetrical symmetrical combination

Crest

Each clan has a unique crest and the symbols within tell a story. A crest's meaning can reflect heritage, family lineage or personality or even contain the meaning of a name. You can choose to place a crest anywhere on your character including accessories, garments, armor and weapons. Symbols can be simple or detailed, symmetrical or asymmetrical, or a combination of multiple structures. It's up to you to decide what you prefer.

Design Your Own Patterns

Use simple shapes such as triangles, circles or straight or curvy lines to create your basic patterns. Consider the gaps in between the repeating design. If the gaps are too narrow, expand them; if they are too wide, move them closer.

Keep It Simple

A complex pattern can give a garment an elegant and luxurious look and feel. But try not to overdecorate! Too many patterns and symbols will make the material look busy and distract the viewer.

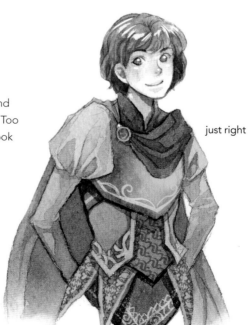

just right

too busy

Motifs

Designing patterns around a specific motif can reveal a great deal about your character's origin or personality. The outdoors are a great source of inspiration to tell the stories of your characters through designs and patterns.

Animal Motif
Use the symbolic characteristics of animals to imply the traits of your characters. For instance, lions may represent strength and leadership. Wolves might imply solitude. Bird wings are often associated with freedom.

Nature Motif
Patterns of vines, leaves, branches or flowers can be used to associate a character with the natural world.

Celestial Motif
Is your character a god or goddess of the sun or moon? Or a creator of a certain planet? Use the sun, moon and stars as a motif to suggest divine qualities.

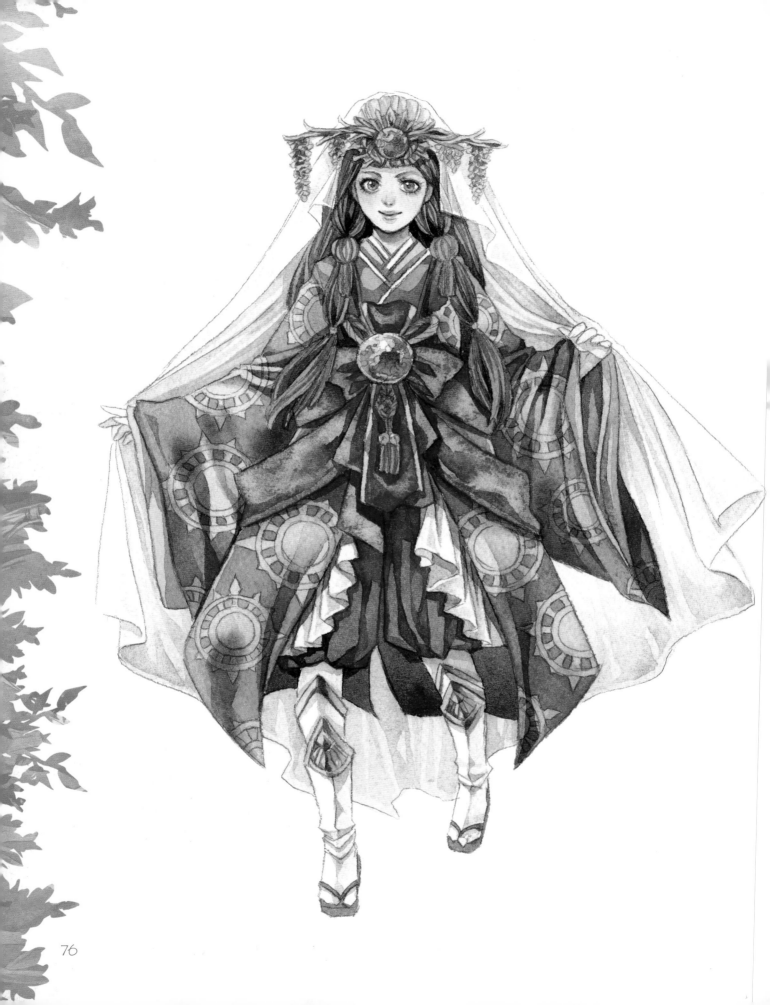

Demonstration
AMATERASU

Amaterasu is the goddess of the sun. Her smile shines as bright as the daylight that she embraces. Her attire typically reflects her celestial nobility with solar patterns and bright colors. All the elements should radiate her grace and warmth.

MATERIALS

PAINTS
Cadmium Orange, Cadmium Red, Cadmium Yellow, Manganese Violet, Naples Yellow, Permanent Carmine, Potter's Pink, Quinacridone Rust, Sepia, Terra Rosa, Translucent Brown

OTHER TOOLS
cold-pressed watercolor paper, nos. 0, 1, 2, 3 and 5 rounds, pencil

1 Sketch the Pose and Paint the Skin Tone

Sketch the sun goddess on cold-pressed paper with a pencil. Paint her rosy cheeks with a no. 1 brush and Permanent Carmine softened with water. Mix Cadmium Yellow with a bit of Permanent Carmine and lots of water for the skin tone color. When the cheeks are dry, use a no. 2 round to paint the face, knees and hands. Deepen the shadows with Potter's Pink and a bit of Translucent Brown. Paint her eyes with Naples Yellow.

2 Paint the Hair

Mix Quinacridone Rust and a bit of Sepia and paint a flat wash over the hair that is not overlapped by the translucent veil. Dilute the mixture with water until it's fairly light, and paint a light wash on the hair that is under the veil. When the washes are dry, switch to a no. 0 brush to paint shadowy strands with Sepia. Apply a glaze of the same mixture on the hair around the neck to deepen and refine the shadows.

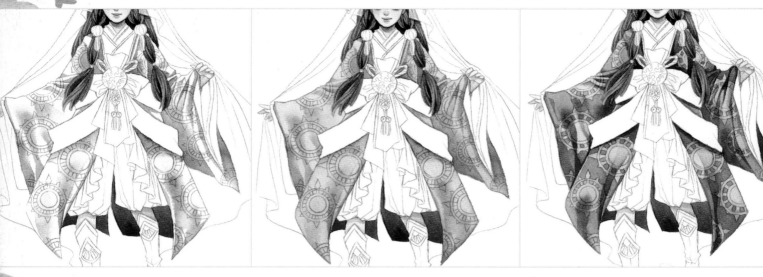

3 Begin the Kimono's Base Layer

Create a mix of Manganese Violet and a bit of Quinacridone Rust for the base layer of the kimono. Aim for a purple color with a red tint. With a no. 3 round define some of the folds. Soften some of the more shadowy folds with water. Use the same mixture but a bit more concentrated for the inside of the kimono behind her knees.

4 Paint the Kimono's Second Layer

After the colors for the base layer are fully dry, paint a flat wash of Naples Yellow all over the kimono with a no. 5 round.

5 Paint the Sun Patterns

Define the sun patterns with a diluted wash of Terra Rosa and a no. 3 round. Use a no. 1 round to fill up the smaller details around each sun. Wait until all the paints are completely dry. Use a mix of Quinacridone Rust, Manganese Violet and a bit of Sepia to deepen some of the shadowy folds.

6 Paint the Sash and Collars

Paint a dark wash of Cadmium Red on the sash with a no. 2 round. Wait for the sash to become semidry and create a wash of Cadmium Yellow, then set aside. When the sash is semidry, drop random marks of Cadmium Yellow on the red area. The yellow will spread into the red but not blend completely, creating cauliflower mark effects. Here, this is our goal, rather than a mistake. Paint the center trim of the sash with Naples Yellow. Use Naples Yellow and Cadmium Orange for the kimono's inner sleeves and collar.

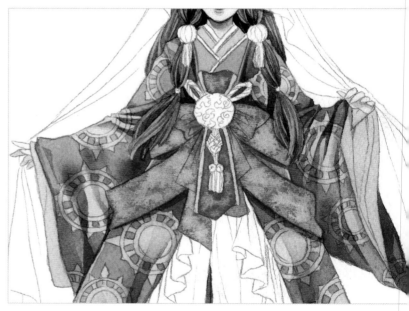

7 Paint the Shadows of the Sash

Create a mix of Manganese Violet and a bit of Translucent Brown. The mixture should be more violet than brown. With a no. 2 round paint shadows on the sash, inner sleeves and collar. Add more layers to deepen the shadows, if desired.

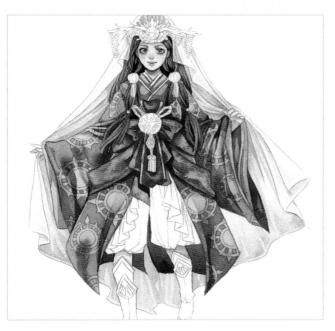

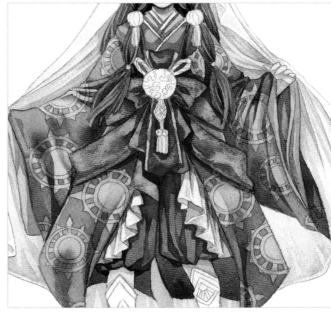

8 Paint the Veil

Dilute Potter's Pink and paint the inside shadows of the veil with a no. 2 round. Keep the first layer of shadows fairly light. When the first layer is dry, use the same color to deepen the shadows where the folds are close to the figure. Switch to a no. 0 round to detail the tiny, delicate fold lines of the veil.

9 Finish the Kimono and Pants

With a no. 2 round, paint the shadows on the inside frills of the dress with Potter's Pink. Darken the Potter's Pink with a bit of Sepia. Apply this mixture to deepen the shadows where the sash and the kimono overlap. Paint a flat wash of Cadmium Red on the pants. Wait until the layer is dry, then use a mixture of Sepia and Permanent Carmine to define the shadowy folds.

10 Paint the Sandals

Her sandals and knee-high socks are a combined element. Paint the socks first with a mixture of Manganese Violet and Quinacridone Rust. With a no. 2 round, apply paint at the center of the socks while leaving the sides unpainted. While the paint is still damp, quickly soften the color with diluted Potter's Pink. When dry, deepen the shadowy wrinkles around the ankles with Potter's Pink. Paint the gold trim with Cadmium Yellow, Translucent Brown and Sepia for the shadows. Finish off the sandals with Translucent Brown.

11 Finish the Decorative Accessories

The headdress is made of golden branches and wisteria blooms. Mix a gold color with Cadmium Yellow and Cadmium Orange and paint the headdress with a no. 2 round. Use a no. 0 round and a mix of Quinacridone Rust and Sepia for the tiny shadows between the branches and wisteria petals. Be sure to leave some areas for highlights.

With a no. 1 round, paint a light wash of Cadmium Red on the balls that tie the hair. Use the mixture for shadows as well. For the golden sphere on the sash, paint it as you did the headdress, leaving an unpainted spot at the center for the highlight. The shadows should be the darkest, so use Sepia under the highlight. Soften the edges with a diluted wash of Quinacridone Rust. Finish the rope with Cadmium Orange and the bells with Cadmium Yellow.

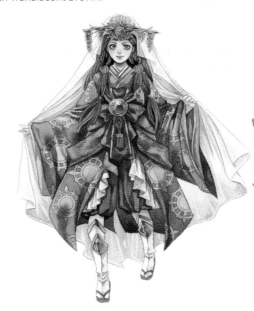

Visit impact-books.com/manga-magic to download free bonus materials.

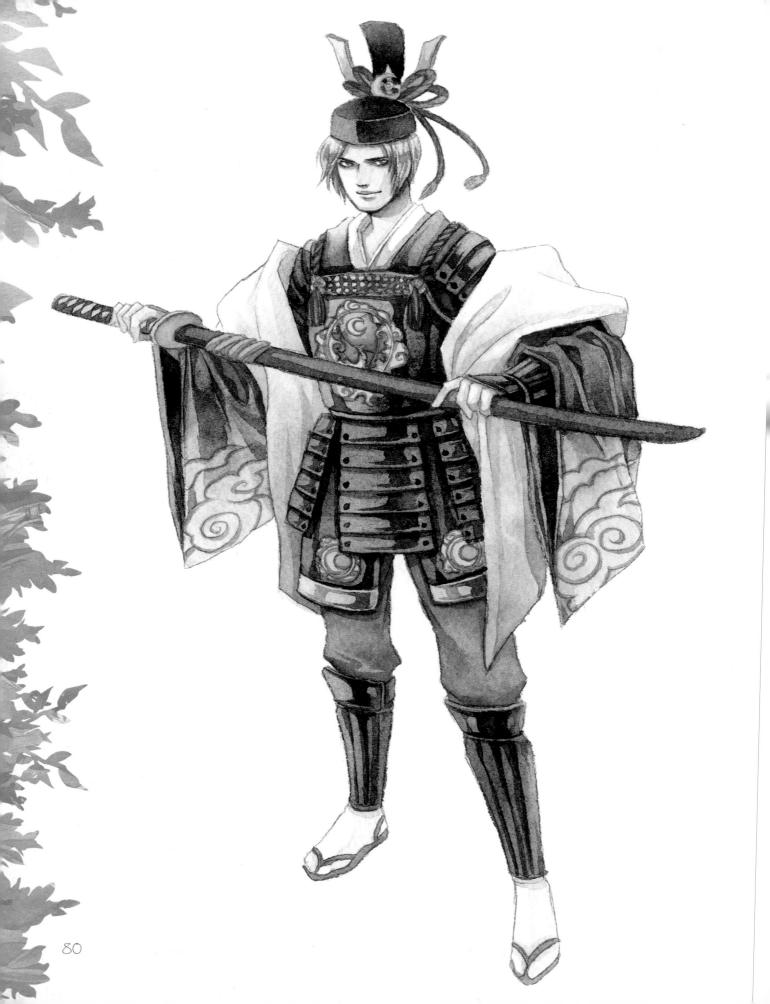

Demonstration
TSUKUYOMI

While Amaterasu rules the day, her brother Tsukuyomi rules the night. He is the god of the dusk, dark sky and moon. Tsukuyomi's outfit is a combination between traditional garb (his kimono) and samurai armor. The features of each are distinct yet noble enough to depict him as a celestial character.

MATERIALS

PAINTS
Blue Apatite Genuine, Cadmium Red, Cadmium Yellow, Cobalt Blue, Cobalt Turquoise, Indigo, Manganese Violet, Naples Yellow, Payne's Gray, Permanent Carmine, Raw Umber, Sepia, Translucent Brown, Verditer Blue, Viridian

OTHER TOOLS
cold-pressed watercolor paper, nos. 0, 1, 2 and 3 rounds, pencil

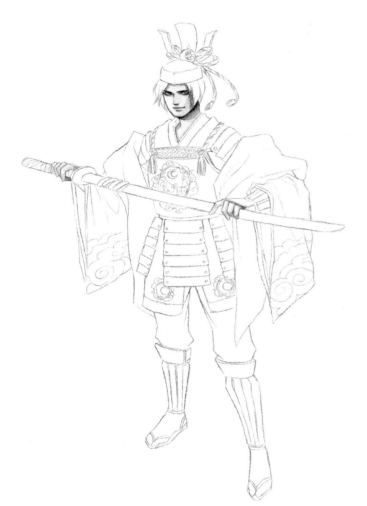

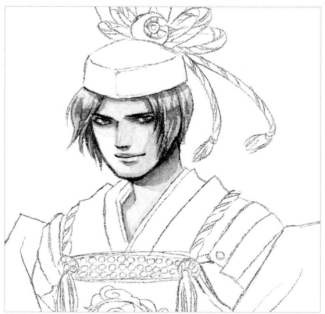

1 Sketch the Pose and Paint the Skin Tone
Sketch the moon god on cold-pressed paper with a pencil. Create a mix of Cadmium Yellow and a bit of Permanent Carmine and paint the face and hands with a no. 2 round. The light source is from the left so keep the left side of the face lighter. Mix a small bit of Translucent Brown into the skin mixture and paint the small details with a no. 0 round. Emphasize the shadows especially under his chin and under the cap. Continue glazing to deepen the shadows, if desired.

2 Paint the Hair
Establish the hair's yellow highlights with a flat wash of very diluted Naples Yellow using a no. 1 round. Switch to a no. 0 round and apply the blue streaks on the bangs with Verditer Blue, leaving highlights toward the top. Use clean water to soften the streaks all the way to the tips of the hair. Once all the layers are dry, define the shadows between the strands with concentrated Verditer Blue.

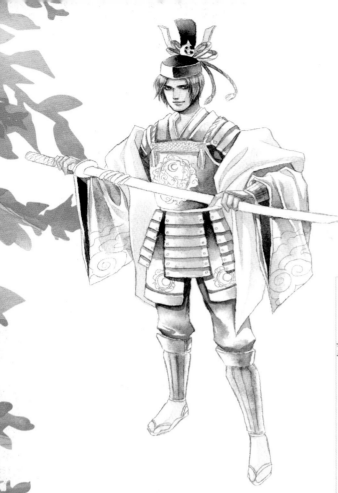

3 Begin the Armor's Base Layer

On his armor and kimono, apply a wash of Blue Apatite Genuine for the shadows with a no. 2 round. Keep the shadows lighter on and around the highlight areas. Soften some of the edges of the shadows with water, especially around the folds and wrinkles of the sleeves. Both shoulder armor and tassets consist of small plates layered on top of each other. Paint shadows in between each plate. Mix Payne's Gray with Blue Apatite Genuine to paint darker shadows on the inner sleeves, under the tassets and beneath the thigh guards. Paint concentrated Payne's Gray on the cap, and diluted Verditer Blue for the sash and the socks.

4 Paint the Kimono

Paint the kimono with a graded wash of Cobalt Blue with a no. 3 round. Keep the upper area dark but faded toward the bottom. Leave the cloud patterns white at this point. After the wash is dry, use a no. 1 round to darken the folds. Create a mix of Indigo and Payne's Gray for the dark areas inside the sleeves and beneath the chest plate.

Use a no. 2 round to wet the cloud pattern with water. Fill the pattern with Naples Yellow and Cobalt Turquoise. When dry, use a no. 0 round to define the outer lines of the cloud with concentrated Verditer Blue.

5 Paint the Sash

The sash will remain light in color. Use a no. 2 round and wet the sash with water, then paint it with diluted Indigo and Viridian. While waiting for the surface to dry, create a mix of Verditer Blue and Blue Apatite Genuine for refining the shadows. Apply the mix to deepen the sash's shadowy folds.

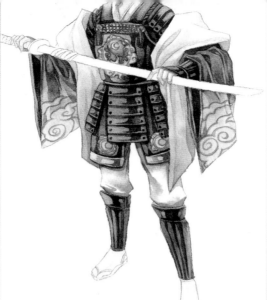
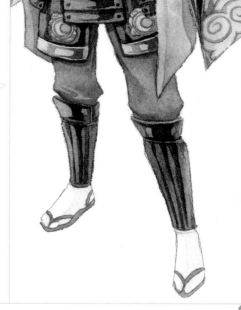

6 Create the Armor's Base Layer

Paint the symbols on the cuirass and thigh guards with a flat wash of Naples Yellow. Create a blue-gray mix with Payne's Gray, Cobalt Blue and a bit of Manganese Violet for the armor. The mixture will complement the kimono nicely. Paint a flat wash of this mixture on the armor and use Cadmium Red for the ropes.

7 Finish the Armor Details

Paint the shadows on the armor with a glaze of Payne's Gray and a no. 0 round to illustrate a hard metal quality. Emphasize the shadows on the cuirass along the small plates on the shoulder armor and tassets. Dilute Payne's Gray with water and apply shadows on the rope, the top of the cuirass and tips of the thigh guards. Use a mix of Raw Umber and a bit of Payne's Gray to outline the symbols, focusing on the crescent. Use a diluted wash of Indigo to fill the tiny space within the symbols.

8 Paint the Pants and Sandals

Create a mix of Raw Umber and Sepia and paint a flat wash on the pants with a no. 2 round. Paint the sandals with Translucent Brown.

9 Complete the Headdress

Use a no. 1 round to paint a light flat wash of Naples Yellow on the moon crest of the headdress. Refine the shadows of the crest with Raw Umber. Mix Cobalt Blue and Indigo to paint the cap, and finish the ropes with Cadmium Red.

10 Paint the Sword

Apply a flat wash of Naples Yellow on the handle, guard and handing cord using a no. 2 round. For the blue of the cord wrap, use a no. 0 round and Cobalt Blue. Mix Raw Umber with a bit of Indigo to apply the shadows of the guard and the hanging cord. Finish the sword by painting a flat wash of Indigo on the scabbard. Once the wash is dry, refine its shadow with the same color.

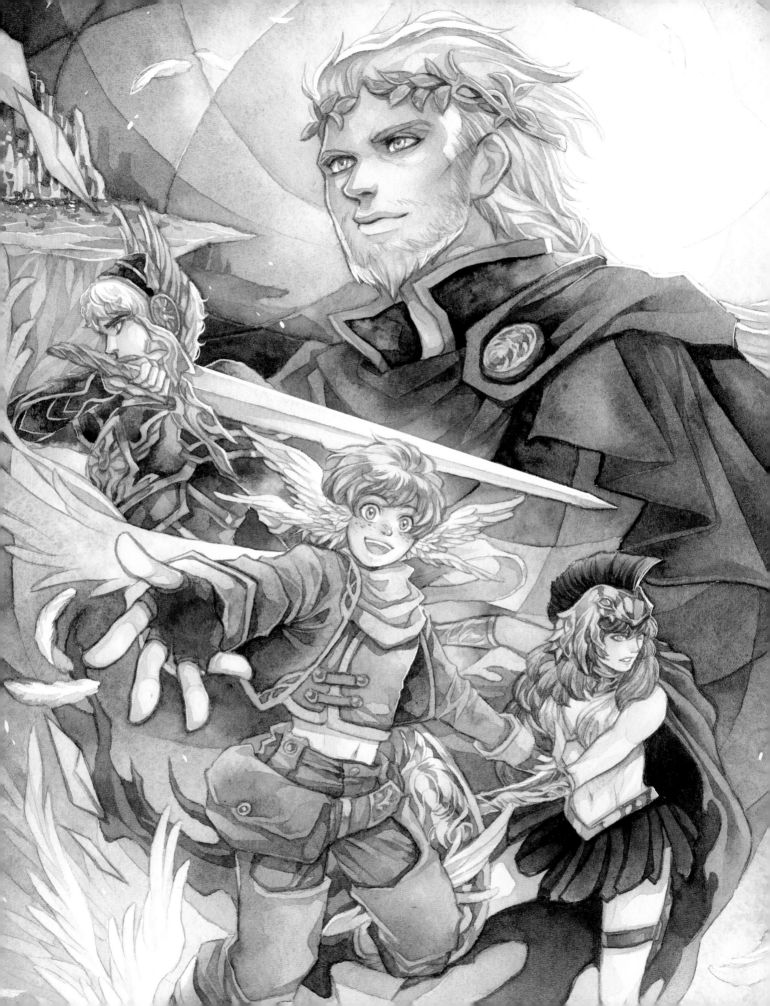

5

Mythological Characters

Though mythical and fantasy stories have been told for generations, a few secrets have been kept from the history books, and it's up to us to bring them to life. In this chapter, I present some alternative character renditions inspired by traditional Greek and Japanese mythology. By combining the basics of the previous chapters, we can create, draw and paint our own interpretations of the classics.

Before you embark on a character redesign, there is some information to consider. Study and make notes of each character's common features and characteristics depicted throughout history—things like facial expressions, clothing styles, poses and overall demeanor. Keep these attributes at the front of your mind as you set out to put your own unique spin on well-known mythological and fantasy characters. Let's create new stories together!

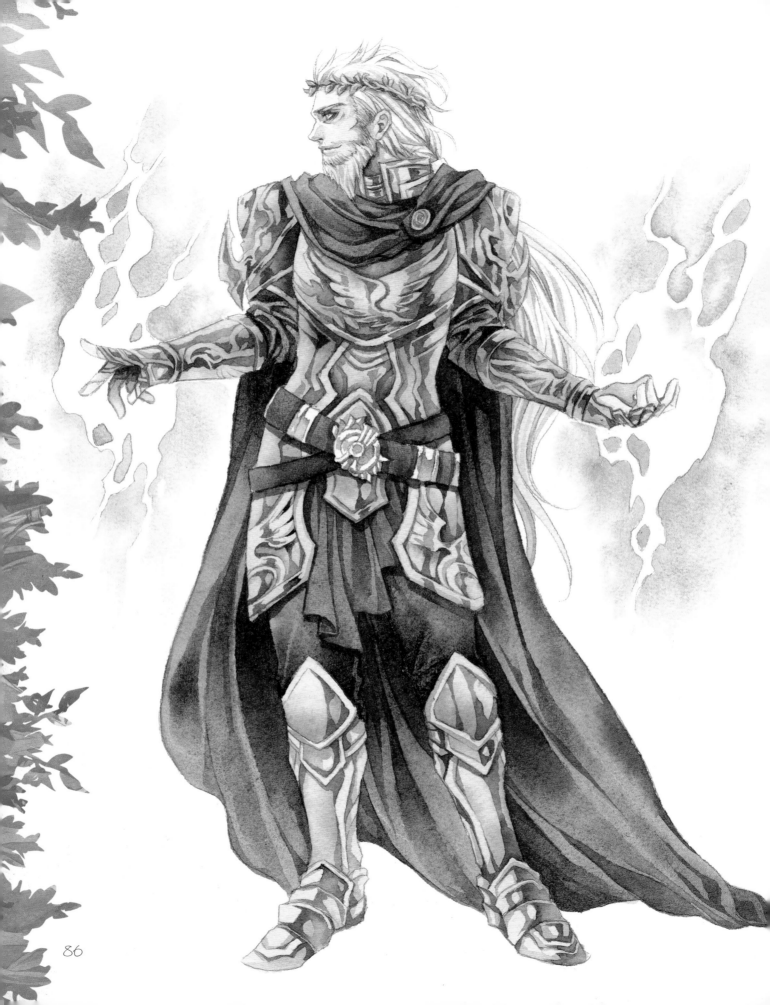

Demonstration
ZEUS

At the peak of Mount Olympus sits Zeus, the most powerful of all the Greek deities. Though he is a wise and powerful ruler whom the other Olympians can depend on, being king of the gods isn't always easy. While Zeus is capable of keeping almost everyone satisfied and at peace, sometimes life on Olympus can be a bit of a hassle and Zeus can get a little grumpy. But a slight headache will never stop him from having a good time when he's hanging around chatting with the most gorgeous goddesses of the land.

Color Scheme

MATERIALS

PAINTS
Blue Apatite Genuine, Cadmium Red, Cobalt Turquoise, Crimson Lake, Manganese Violet, Mauve, Naples Yellow, Payne's Gray, Quinacridone Rust, Van Dyke Brown

OTHER TOOLS
cold-pressed watercolor paper, nos. 0, 1, 2 and 3 rounds, pencil

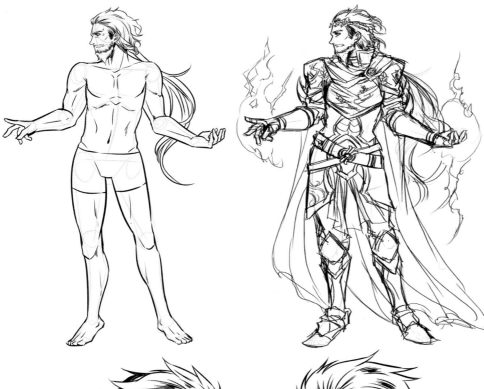

1 Plan Out the Design
Zeus's body structure is muscular, though it won't be visible under armor. When Zeus sits on his throne listening to his fellow Olympians speak, he is relaxed. But once he takes action, his stance is confident enough to hold everyone's attention. Zeus's golden armor is engraved with elaborate patterns and details that reflect his high status as ruler.

2 Sketch the Pose and Establish the Skin Tone and Hair

Sketch the character with a pencil on watercolor paper. With a no. 2 round, apply a diluted mixture of Naples Yellow and a little Mauve to the exposed skin of his hands and face. Darken the facial details and shadows with a concentrated version of this mixture. Refine the deepest shadows with Mauve and Van Dyke Brown. Paint the hair and beard with a gray mixture of diluted Blue Apatite Genuine. Leave some areas unpainted for the hair's highlights. Use a no. 0 round and diluted Payne's Gray to define some individual strands of hair.

3 Paint the Underpainting of the Armor and Cape

With a no. 3 round, paint a wash of Quinacridone Rust on the armor and wreathed crown. For a lighter color, dilute the paint with water. Paint the cape with a mix of Mauve and Van Dyke Brown, glazing shadows as you go. Work wet-on-dry for sharper details or wet-into-wet for a more blended, soft look.

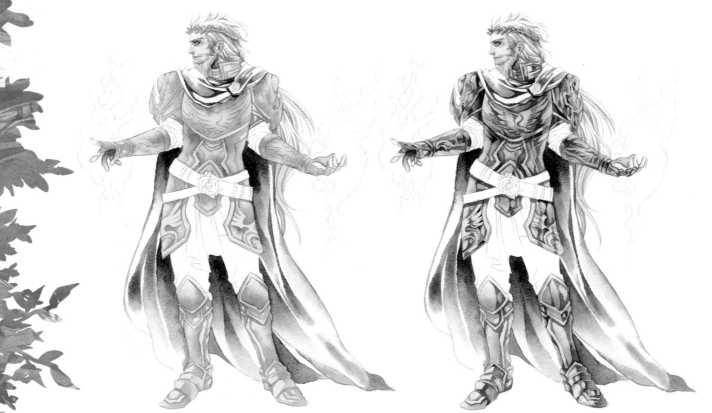

4 Paint the Armor

Once the underpainting is dry, paint a flat wash of Naples Yellow on the armor and wreathed crown. Let dry completely before moving to the next step.

5 Add Shadows to the Armor

Using a no. 1 round and a concentrated mix of Payne's Gray and Van Dyke Brown, add shadows to the armor and wreathed crown. If desired, dilute some of the shadows with water. The darkest shadows should enhance the shine of the golden armor.

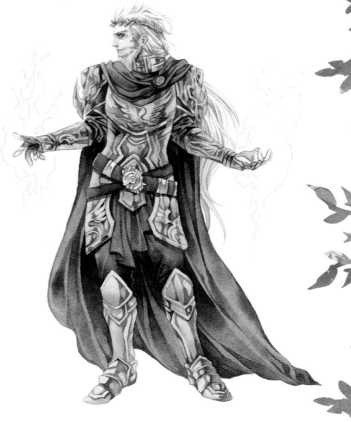

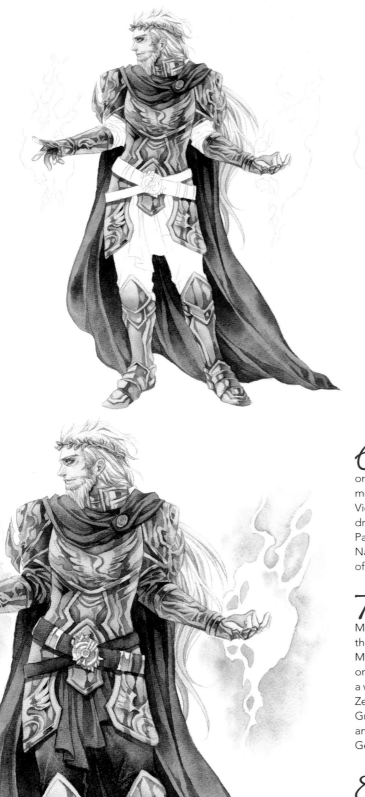

6 Paint the Cape

Paint a wash of Crimson Lake and Manganese Violet on the cape with a no. 3 round. Paint the Crimson Lake more prominent at the top of the cape and Manganese Violet more prominent at the base. After the surface is dry, darken the cape's folds with a mixture of Mauve and Payne's Gray. For the brooch, simply paint a flat wash of Naples Yellow with a no. 0 round. Add shadows with a bit of diluted Van Dyke Brown.

7 Paint the Legs, Arms and Belt

Use a no. 1 round and a dark mix of Payne's Gray and Mauve to create a base layer on the clothing areas. Paint the sleeves with a mix of Blue Apatite Genuine and a bit of Manganese Violet. Paint a wash of diluted Van Dyke Brown on the pants and deepen the folds with Payne's Gray. Paint a wash of Cadmium Red and Mauve for the cloth around Zeus's waist, and deepen the shadows with diluted Payne's Gray. For the belts, paint a flat wash of Quinacridone Rust and Van Dyke Brown, and a diluted mixture of Blue Apatite Genuine and Payne's Gray for the buckle.

8 Paint the Flash

Work wet-into-wet to create the intimidating flash coming from his hands. Wet the outer edges of the flash with a no. 3 round. Apply Cobalt Turquoise around the edges, blending outward. Use a no. 1 round for the smaller gaps.

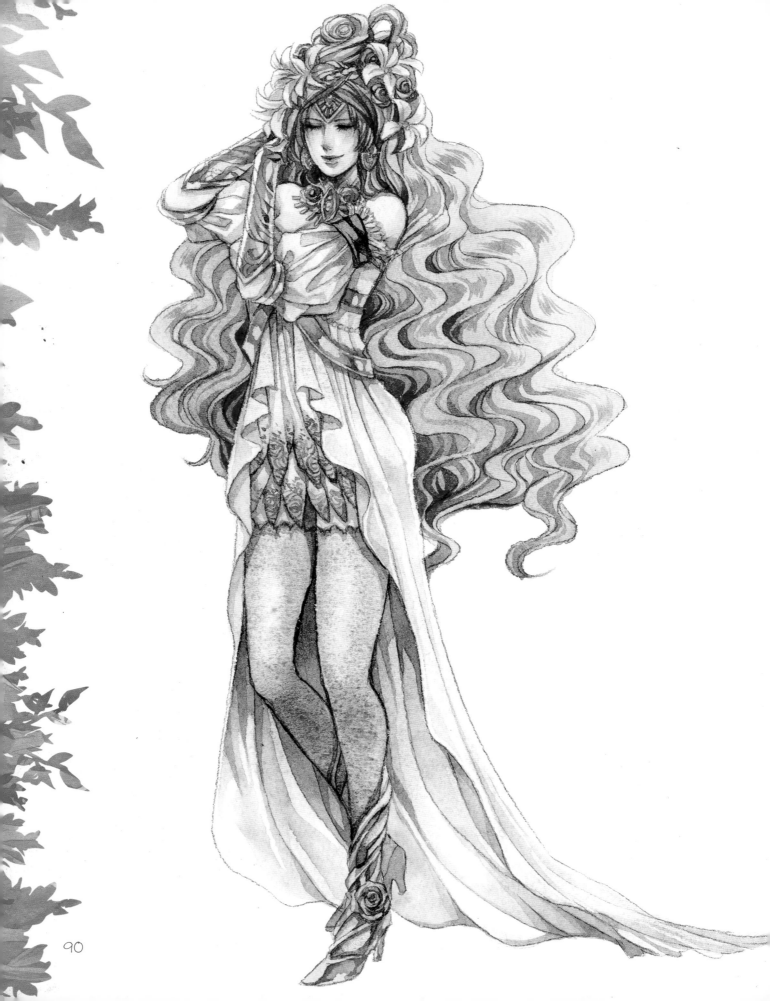

Demonstration
APHRODITE

If a picture is worth a thousand words, Aphrodite's beauty should fit the bill. Her reputation as the most beautiful goddess has inspired thousands of outsiders to travel across the sea just to catch a glimpse of the goddess of love for themselves. Aphrodite isn't bothered by the visitors, and she greets them with her gorgeous smile. Her charm and sense of style are unrivaled, and she looks flawless in any outfit. All the constant attention has built up Aphrodite's confidence in almost every aspect, including her personality. Sometimes she can be as headstrong as she is beautiful.

MATERIALS

PAINTS
Cadmium Yellow, Indigo, Lavender, Lilac, Mauve, Payne's Gray, Permanent Carmine, Potter's Pink, Raw Umber, Sepia, Verditer Blue, Violet Gray

OTHER TOOLS
cold-pressed watercolor paper, nos. 0, 1, 2 and 3 rounds, pencil

Color Scheme

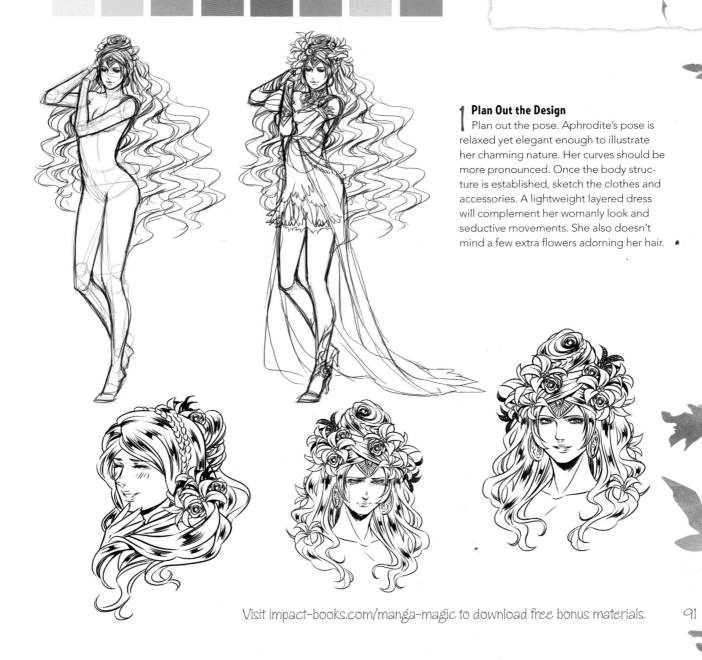

1 Plan Out the Design
Plan out the pose. Aphrodite's pose is relaxed yet elegant enough to illustrate her charming nature. Her curves should be more pronounced. Once the body structure is established, sketch the clothes and accessories. A lightweight layered dress will complement her womanly look and seductive movements. She also doesn't mind a few extra flowers adorning her hair.

Visit impact-books.com/manga-magic to download free bonus materials.

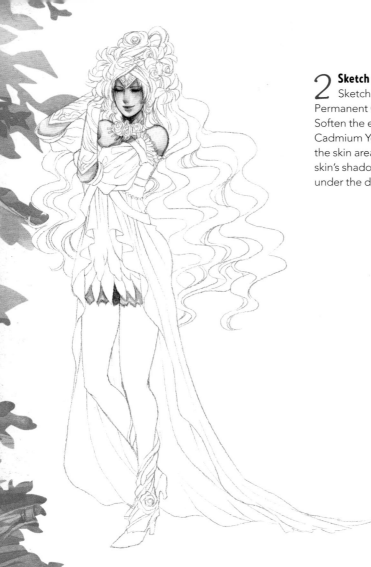

2 Sketch the Pose and Establish the Skin Tone

Sketch the character on cold-pressed paper with a pencil. Apply diluted Permanent Carmine on the lips and both sides of the cheeks with a no. 1 round. Soften the edges with water. Create Aphrodite's fair skin tone with a mix of Cadmium Yellow and a bit of Permanent Carmine. Mix with water and apply to the skin areas until you've established a fairly light underpainting. Deepen the skin's shadows with a more concentrated version of the mixture. Apply Sepia under the darkest areas such as the chin and eyes.

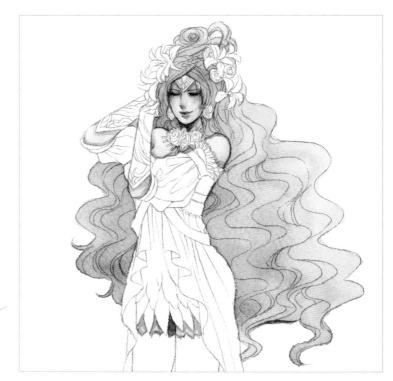

3 Create the Underpainting of the Hair

Use a no. 3 round to spread clean water on the entire hair area. Switch to a no. 1 round and working wet-into-wet, quickly add more colors such as Cadmium Yellow, Violet Gray and Permanent Carmine. Wait until the surface is completely dry before moving to the next step.

4 Apply Shadows for the Hair

To build up the hair's volume, mix Violet Gray and a bit of Permanent Carmine, and refine the shadowy strands with a no. 0 round. Add a touch of Payne's Gray into the mixture and deepen the shadows closest to the figure, especially behind the neck. Use the mixture from step 3 to refine the yellow shadows of the hair.

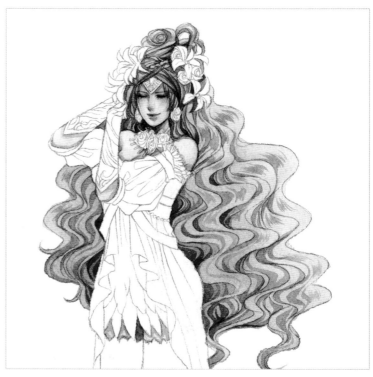

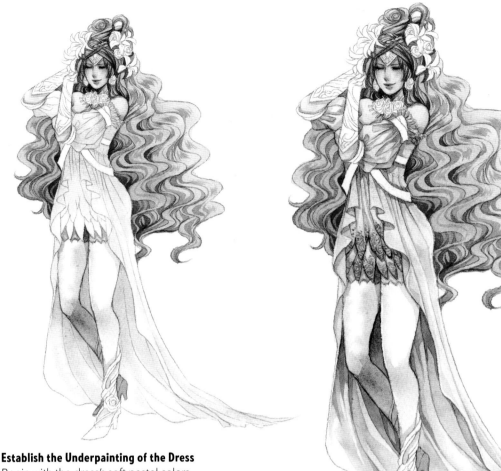

5 Establish the Underpainting of the Dress

Begin with the dress's soft pastel colors. Spread clean water over the dress except the inside areas, then quickly apply diluted Potter's Pink with a no. 2 round. To paint the darker color inside the dress, spread clean water and paint with diluted Mauve. Use the same diluted Mauve to establish the underpainting of the legs. To suggest the depth of the back leg, paint it darker by layering another glaze of diluted Mauve.

6 Paint the Dress's Details

With a no. 2 round, apply a graded wash of Verditer Blue at the bottom layer of the skirt, keeping the lowest section the darkest. Paint a graded wash of Lilac on the overlapping layer. When the washes are fully dry, paint shadowy folds with Lavender and Violet Gray. Create a mix of Indigo, a bit of Payne's Gray and water to paint the inside folds of the dress. Switch to a no. 0 round and paint the delicate patterns on the skirt with concentrated Mauve and Verditer Blue.

7 Paint the Stockings

Lay a flat wash of Potter's Pink on the stockings with a no. 2 round. Define some of the shadows with a mix of Potter's Pink and Indigo.

8 Refine the Shoes and Accessories

Refer to the completed illustration on page 90. Use a no. 1 round to paint the straps on the top of the sleeve with Verditer Blue. Add Indigo for the shadows. Paint Lilac at the center of the flowers and soften the edges with water. For the gold accessories, paint a light wash of Cadmium Yellow on the shoes, necklace, bracelets, earrings, straps and the roses in the hair. The shadows should be nice and dark to capture the shiny quality of gold, so use a no. 0 round to refine shadows with Raw Umber and Payne's Gray.

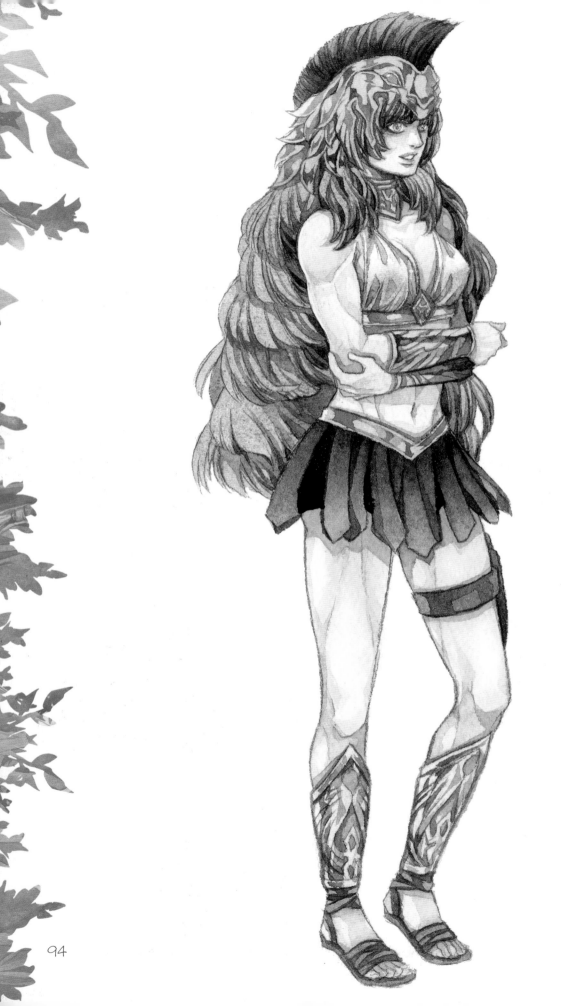

Demonstration
ATHENA

Athena was born a natural leader. She takes great joy and honor in protecting her city, which in turn encourages her to be stronger and wiser. When she is home from battle, Athena enjoys practicing her favorite combat routines with her peers. She is more likely to be found swinging her sword than brushing her hair. She has many strong personality traits—she's loyal, honest and candid. Though she's as tough as they come, she is quite sentimental toward the people she cares about, but never sentimental on the battlefield.

Color Scheme

MATERIALS

PAINTS
Burnt Sienna, Cadmium Red, Cadmium Yellow, Payne's Gray, Permanent Carmine, Perylene Violet, Potter's Pink, Raw Umber, Sepia, Translucent Brown

OTHER TOOLS
cold-pressed watercolor paper, nos. 0, 1, 2 and 3 rounds, pencil

1 Plan Out the Design
Athena's pose is confident but not overwhelming to those she converses with. Unlike Aphrodite, Athena's body structure is more muscular due to her strength and duty as a commander. She prefers clothes that benefit her speed and strength, so definitely no frilly dresses or gowns. Here I've designed her costume like a Greek warrior. Athena stands proud in her armor. Her helmet is inspired by both a lion and an owl, animals that reflect her strength and wisdom.

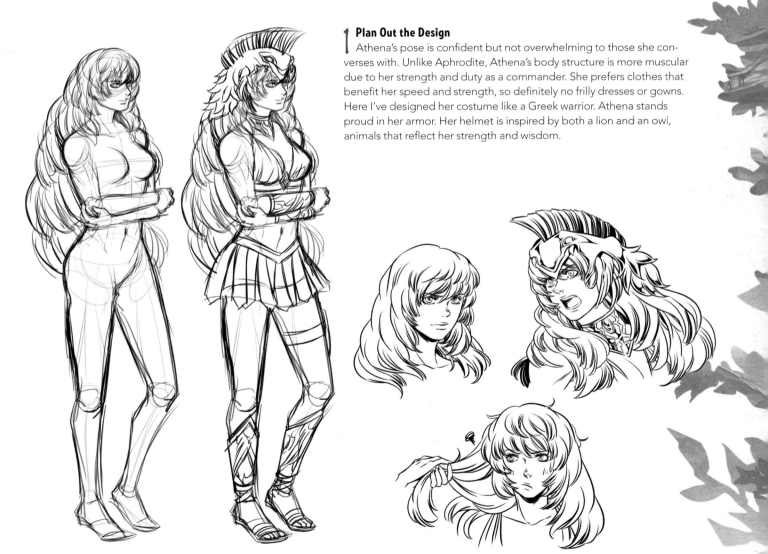

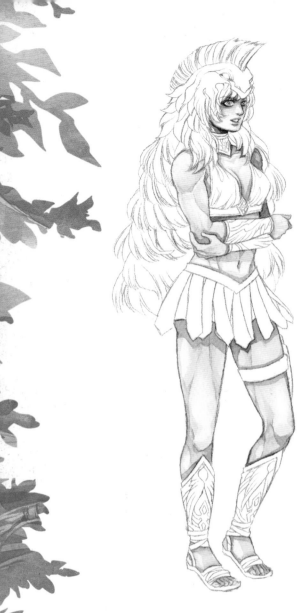

2 Sketch the Pose and Establish the Skin Tone

Sketch Athena with a pencil on watercolor paper. Create a mixture of Cadmium Yellow, a bit of Permanent Carmine and water, then lay the base skin tones with a no. 3 round. Let dry then use the same mixture to define shadows to indicate Athena's muscles. Use Burnt Sienna for even darker shadows and Sepia for the darkest tones.

3 Paint the Hair

Lay a flat wash over the hair using a mix of Potter's Pink and a bit of Burnt Sienna using a no. 3 round. Once dry, use a no. 1 round and diluted Perylene Violet to depict the shadows of her hair. Because the light source is from the left side, keep most of the shadows on the right. When picking up small details such as the shadows around the strands, paint a bit of Payne's Gray with a no. 0 round.

4 Add the Color Base for the Helmet

Apply a coat of water to the helmet with a no. 2 round, then quickly apply a wash of Cadmium Yellow. Paint concentrated Perylene Violet at the root of the crest. Soften the edges with water.

5 Refine the Details of the Helmet

With a no. 1 round, paint the shadows of the helmet with Raw Umber and Payne's Gray working wet-on-dry. Allow some of the Cadmium Yellow from step 2 to show through. Switch to a no. 2 round and apply a flat wash of Cadmium Red to the gem and helmet crest. Use a no. 0 round to apply small shadowy strands of hair with Payne's Gray.

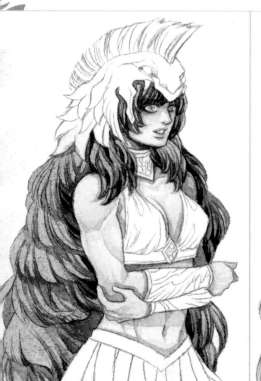
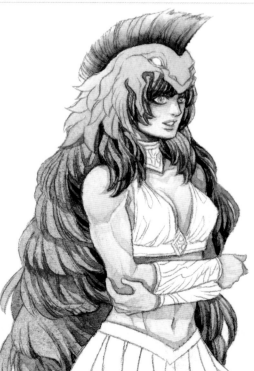
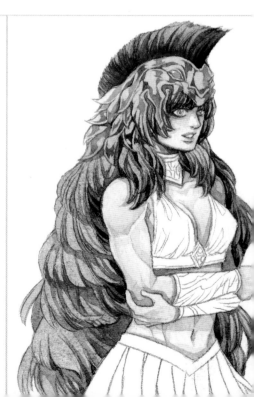

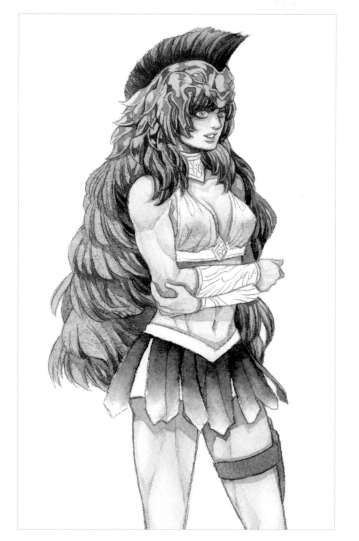

6 Establish the Outfit's Underpainting

Begin Athena's top first. Use a no. 2 round and a light mix of Potter's Pink and water, and paint about half of the brassiere, quickly softening the edges with water. Paint a graded wash of Sepia on each stripe of the skirt, leaving the base of the skirt lighter than the top. For the dagger strap at her thigh, apply a flat wash of Translucent Brown.

8 Finish the Accessories, Armor and Sandals

Refer to the completed illustration on page 94. Paint all of the gold accessories, including the necklace, base of the brassiere, bracers and greaves, with a light wash of Cadmium Yellow and a no. 2 round. Switch to nos. 0 and 1 rounds for the shadows. With Raw Umber and Payne's Gray, refine the solid shadows by emphasizing the patterns on the armor and accessories. Paint a flat wash of Translucent Brown on the sandals, and complete their shadows with diluted Sepia.

7 Complete the Outfit

Mix a slight amount of Payne's Gray into Potter's Pink, and use the mixture to refine shadows at the top of the brassiere with a no. 1 round. Deepen the shadows by adding a few layers on top, if desired. Use a no. 2 round to lay a flat wash of Burnt Sienna on the skirt's stripes. Allow the surface to dry, then apply Sepia for the shadows. Create a concentrated wash of Payne's Gray and paint the dark shorts underneath the skirt. Complete the shadows for the leg strap with a mixture of Translucent Brown and a bit of Payne's Gray.

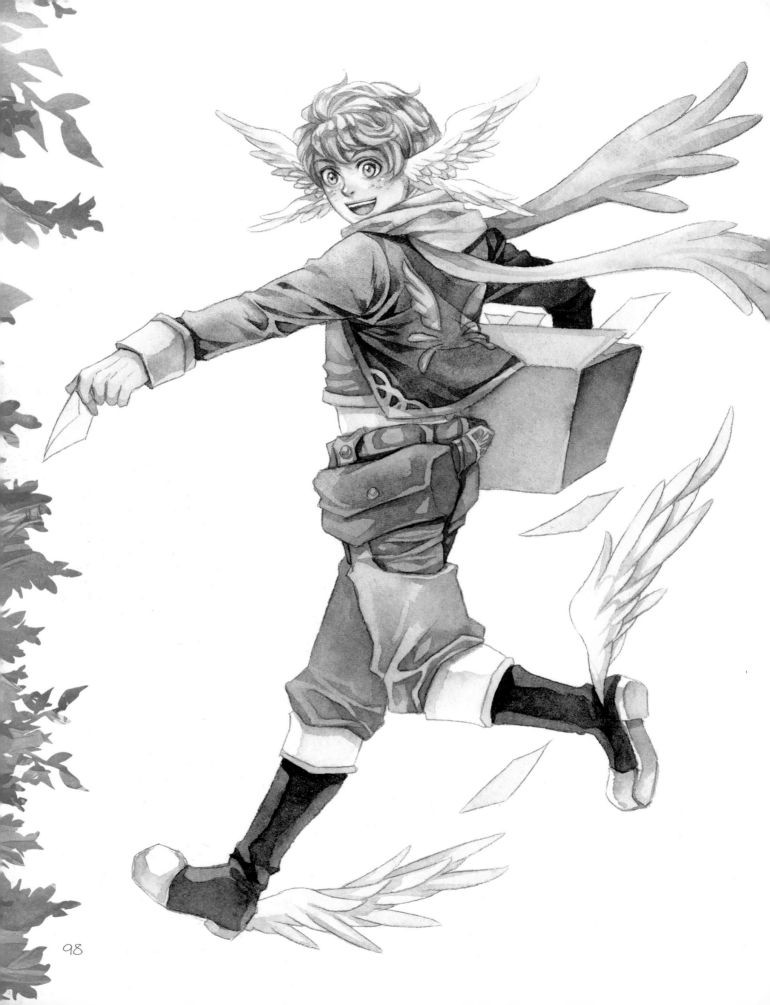

Demonstration
HERMES

Everybody in Olympus knows how busy Hermes the messenger is. Being responsible for all of the gods' correspondence is certainly not an easy task. Though Hermes leads a busy life, he is often seen with a bright, cheerful smile. His sincere attitude has earned him a positive reputation though many wonder how he finds the time to help others while managing his crazy schedule. And, of course, Hermes never expects anything in return. No matter what happens, one can always count on the friendly, optimistic messenger of Olympus to be there when they need a hand.

MATERIALS

PAINTS
Burnt Sienna, Cadmium Yellow, Cerulean Blue, Cobalt Blue, Cobalt Turquoise, Indigo, Naples Yellow, Payne's Gray, Permanent Carmine, Potter's Pink, Quinacridone Rust, Raw Umber, Sepia, Verditer Blue

OTHER TOOLS
cold-pressed watercolor paper, nos. 0, 1, 2 and 3 rounds, pencil

Color Scheme

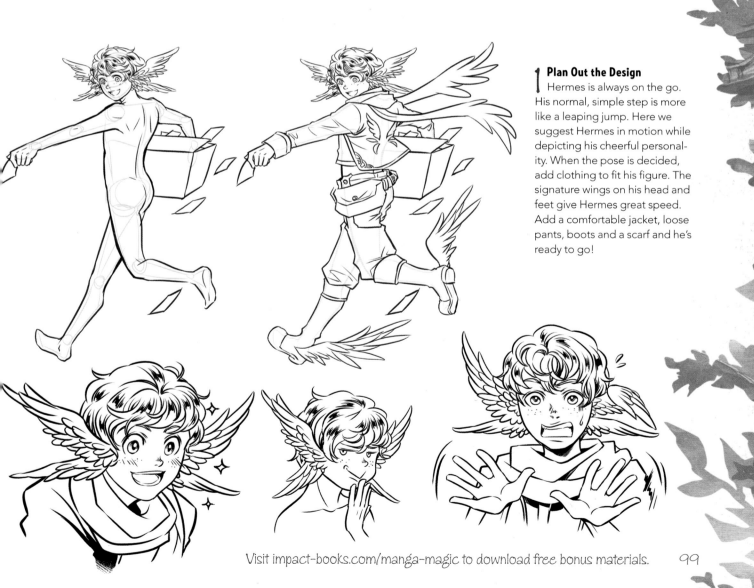

1 Plan Out the Design
Hermes is always on the go. His normal, simple step is more like a leaping jump. Here we suggest Hermes in motion while depicting his cheerful personality. When the pose is decided, add clothing to fit his figure. The signature wings on his head and feet give Hermes great speed. Add a comfortable jacket, loose pants, boots and a scarf and he's ready to go!

Visit impact-books.com/manga-magic to download free bonus materials.

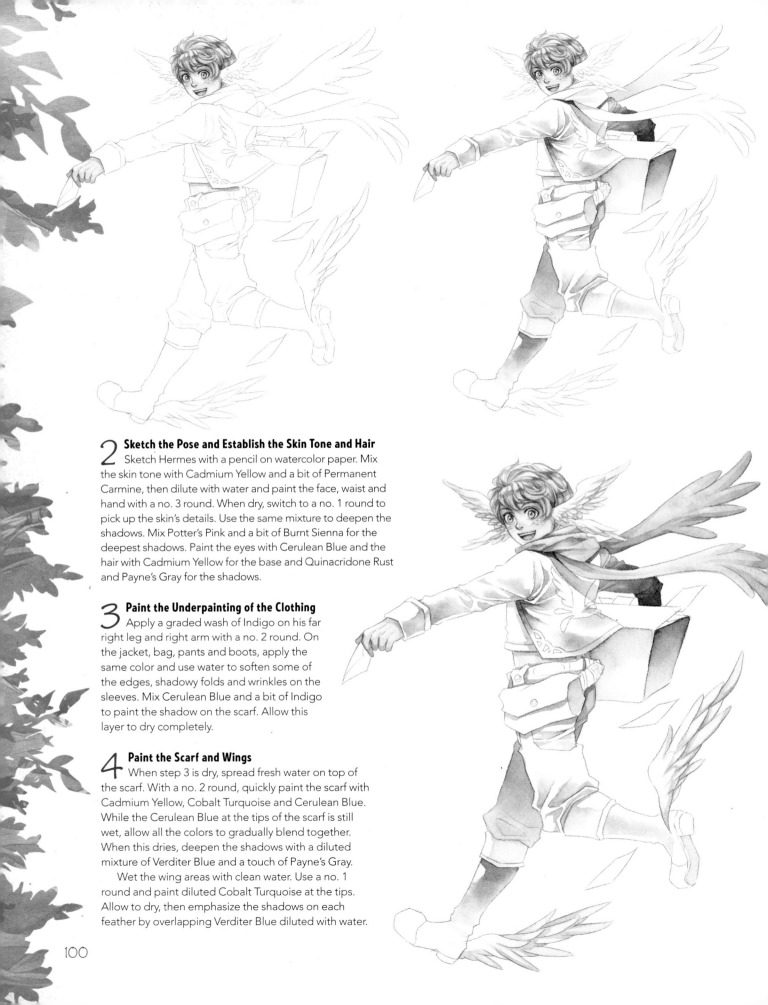

2 Sketch the Pose and Establish the Skin Tone and Hair

Sketch Hermes with a pencil on watercolor paper. Mix the skin tone with Cadmium Yellow and a bit of Permanent Carmine, then dilute with water and paint the face, waist and hand with a no. 3 round. When dry, switch to a no. 1 round to pick up the skin's details. Use the same mixture to deepen the shadows. Mix Potter's Pink and a bit of Burnt Sienna for the deepest shadows. Paint the eyes with Cerulean Blue and the hair with Cadmium Yellow for the base and Quinacridone Rust and Payne's Gray for the shadows.

3 Paint the Underpainting of the Clothing

Apply a graded wash of Indigo on his far right leg and right arm with a no. 2 round. On the jacket, bag, pants and boots, apply the same color and use water to soften some of the edges, shadowy folds and wrinkles on the sleeves. Mix Cerulean Blue and a bit of Indigo to paint the shadow on the scarf. Allow this layer to dry completely.

4 Paint the Scarf and Wings

When step 3 is dry, spread fresh water on top of the scarf. With a no. 2 round, quickly paint the scarf with Cadmium Yellow, Cobalt Turquoise and Cerulean Blue. While the Cerulean Blue at the tips of the scarf is still wet, allow all the colors to gradually blend together. When this dries, deepen the shadows with a diluted mixture of Verditer Blue and a touch of Payne's Gray.

Wet the wing areas with clean water. Use a no. 1 round and paint diluted Cobalt Turquoise at the tips. Allow to dry, then emphasize the shadows on each feather by overlapping Verditer Blue diluted with water.

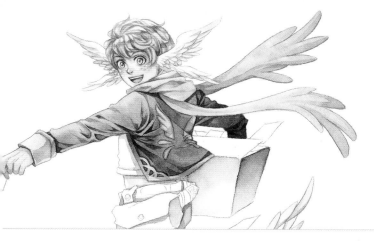

5 Shade the Jacket

Working wet-into-wet with a no. 3 round, paint washes of Cobalt Turquoise and Cobalt Blue on the jacket, avoiding the trim and the wings logo. Apply diluted Cobalt Turquoise on the cuff. Use a mix of Cobalt Blue and Payne's Gray to emphasize the shadows of the folds and wrinkles. For the trim and logo, paint a simple flat wash of Naples Yellow. Mix a touch of Burnt Sienna into the Naples Yellow, and use it to darken the outer line of the logo and shadows of the trim.

6 Paint the Vest and Bag

Dilute Raw Umber and paint the vest with a no. 2 round and use Cobalt Turquoise on the vest's trim. Define the creases with diluted Burnt Sienna. Paint a flat wash of Quinacridone Rust on his waist bag, and deepen some of the shadows with a mixture of Quinacridone Rust and bit of Indigo. Use a no. 0 round and Cadmium Yellow to paint the tiny details on the bag such as the button and the buckle.

7 Paint the Pants

Use a no. 3 round and spread a flat wash of Raw Umber on the outer pants. Once dry, darken the creases that bunch up around his knees with Burnt Sienna and a no. 1 round. Soften the creases with water, if desired. When dry, use the same method for the inner pants. Use a no. 2 round to paint a wash of Cobalt Turquoise and a little Indigo on the upper part of the pants, and darken the creases with diluted Payne's Gray.

8 Paint the Boots

Use a no. 2 round to add a flat wash of Sepia on the boots, leaving the toe caps and soles unpainted. Emphasize the shadows with a layer of Payne's Gray. Paint the trim at the top with Cadmium Yellow. Since the toe caps and the soles are metal, add diluted Payne's Gray around the bottom half of these areas. Allow the white of the paper to show through for the reflection. Soften some of the edges with water as well.

9 Paint the Box and Finishing Details

Refer to the completed illustration on page 98. Finish the box he's holding with a mix of Raw Umber and Cobalt Turquoise using a no. 3 round. Add another layer of Raw Umber to deepen the shadows of the box. Paint the rest of the letter with a diluted wash of Verditer Blue using a no. 1 round.

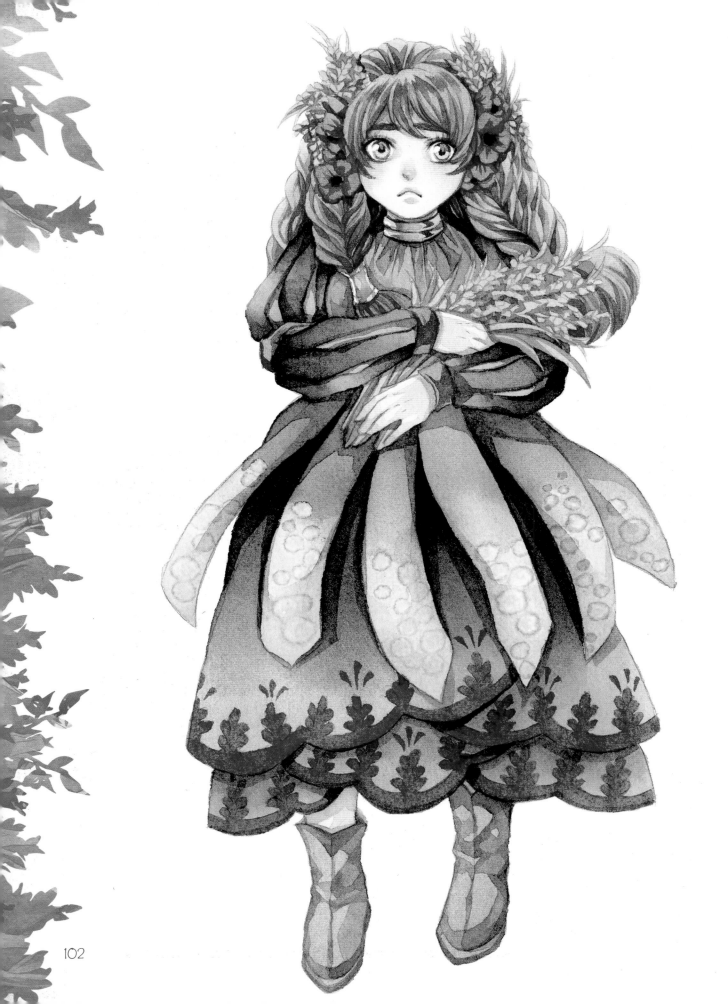

Demonstration
DEMETER

The kitchen chamber never runs out of food or supplies thanks to Demeter, the goddess of harvest. Demeter's big responsibility is managing the agricultural resources so that no one ever starves in her realm. She has a down-to-earth personality and, though occasionally shy and timid, she is also practical and humble about her role on Olympus. It is not that Demeter lacks confidence, she just doesn't see the point of displaying a big ego toward anyone or anything.

Color Scheme

PAINTS
Burnt Sienna, Cadmium Red, Cadmium Yellow, Cobalt Turquoise, Green Gold, Indigo, Lilac, Manganese Violet, Olive Green, Payne's Gray, Permanent Carmine, Perylene Green, Quinacridone Rust, Raw Umber, Yellow Ochre

OTHER TOOLS
cold-pressed watercolor paper, nos. 0, 1, 2 and 3 rounds, pencil, rubbing alcohol

MATERIALS

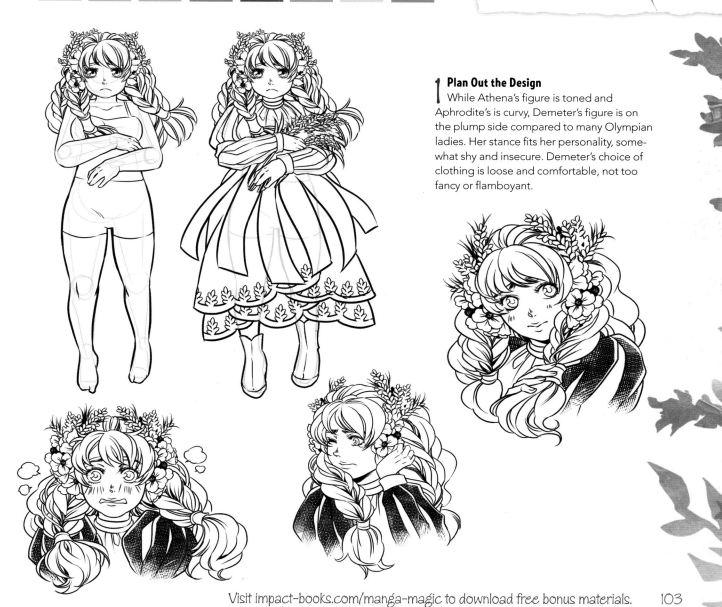

1 Plan Out the Design
While Athena's figure is toned and Aphrodite's is curvy, Demeter's figure is on the plump side compared to many Olympian ladies. Her stance fits her personality, somewhat shy and insecure. Demeter's choice of clothing is loose and comfortable, not too fancy or flamboyant.

2 Sketch the Pose and Establish the Skin Tone

Sketch the character with a pencil on watercolor paper. Paint her rosy cheeks with a diluted mixture of Permanent Carmine and soften the edges with water and a no. 2 round. Use a diluted mixture of Cadmium Yellow and a bit of Permanent Carmine on the face and hands. When dry, darken the shadows at the edge of the face and hands with diluted Burnt Sienna and a no. 1 round. For the eyes, add a flat wash of Lilac.

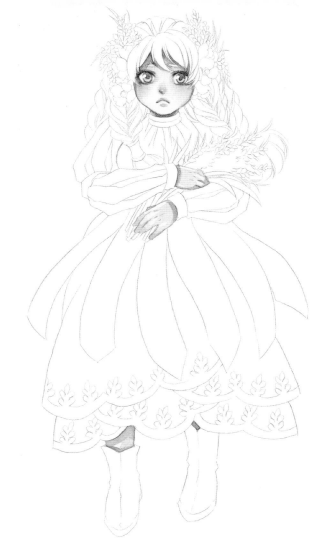

3 Begin the Hair and Hair Ornament

Create a base for the highlight first. Use a no. 2 round to wet the entire hair area. Painting wet-into-wet, quickly apply a wash of Cadmium Yellow and Burnt Sienna. Mix Burnt Sienna and Manganese Violet for the hair's shadows and use a no. 0 round to shade and define some individual strands of hair. Add volume to the hair by deepening extra shadows behind the neck and strands in between the braids.

For the headdress and flowers, use a no. 1 round to paint a flat wash of Cadmium Red on flowers and Cadmium Yellow on the wheat bundles. When dry, paint shadows with diluted Manganese Violet. Dilute Cadmium Yellow with a bit of water and paint the braid's ring. Apply the shadows to the ring with Raw Umber and Payne's Gray.

4 Paint the Sleeves

The sleeves consist of layers of fabric. Working wet-into-wet with a no. 2 round, apply clean water on each stripe, then a concentrated Indigo and Olive Green. Repeat on the other stripes. Paint the gaps in between each stripe with Yellow Ochre, then paint Cadmium Red on the cuffs. For the cuffs' shadows, apply a mix of Manganese Violet and a bit of Indigo. Use the mixture to refine the shadows between the stripes as well.

5 Paint the Top Layer of the Dress

Create a mix of Olive Green and Green Gold and use a no. 3 round to lay a graded wash starting at the top of the dress and getting lighter toward the bottom. While the surface is still wet, sprinkle drops of rubbing alcohol at the tips of the dress to create a bubble effect.

6 Add Shadows and an Underpainting to the Dress

Create the shadow mix with Indigo and Cobalt Turquoise and apply it to the top layer with a no. 1 round. Soften some of the shadowy folds with water, if desired. Next, paint the neck rings with a flat wash of Cadmium Yellow, and complete the shadows with a mix of Raw Umber and Payne's Gray. Establish the underpainting of the dress with a graded wash of Perylene Green and a no. 2 round. Keep the bottom of the dress the lightest.

7 Complete the Dress

Spread clean water on the dress and paint Burnt Sienna and Gold Green with a no. 3 round using the wet-into-wet technique. Keep the Gold Green at the bottom of the dress for more green tint, if possible. When this dries, use a no. 1 round to depict the red patterns with concentrated Quinacridone Rust. Deepen the overlapping shadows with a bit of diluted Indigo.

8 Finish the Boots and Details

Refer to the completed illustration on page 102. Paint a flat wash of Cadmium Yellow on the wheat bundles in her arms with a no. 1 round. When dry, refine the shadows and details with Yellow Ochre and a bit of Burnt Sienna. For the boots, paint a wash with a mix of Raw Umber and a bit of Burnt Sienna. After the layer is dry, complete the shadow details with diluted Perylene Green.

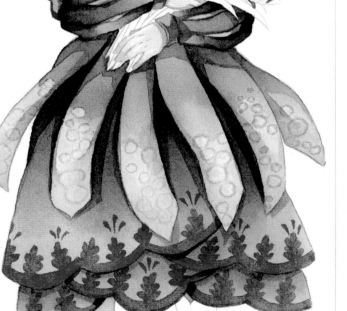

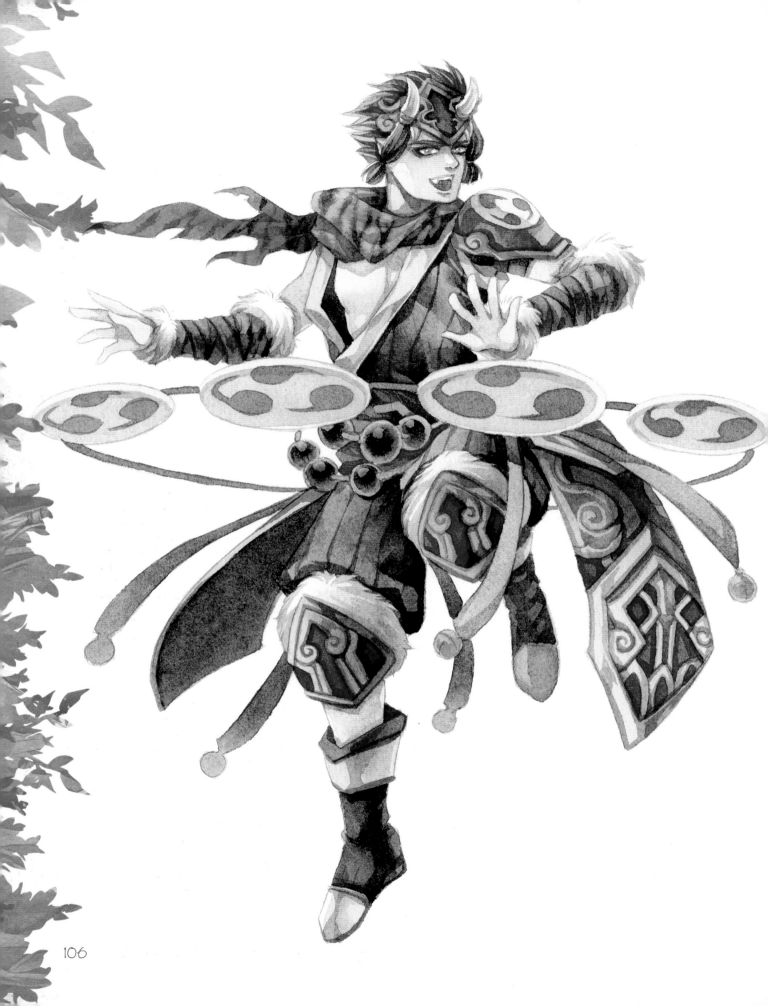

Demonstration
RAIJIN

What if thunder and lightning were mysteriously created by a god beating the drums? That is the power of Raijin, the thunder god, who can summon storms and drive away malicious spirits with his magical instrument. Raijin sometimes scares the townsfolk with his wild appearance and unbridled power, and they believe him to be as rebellious as his look. Raijin doesn't waste his time worrying about what people think of him even though their beliefs are incorrect. As long as he knows he has performed good deeds, Raijin is content.

Color Scheme

<div style="writing-mode: vertical">**MATERIALS**</div>

PAINTS
Burnt Sienna, Cad,mium Orange, Cadmium Red, Cadmium Yellow, Cerulean Blue, Indigo, Manganese Violet, Naples Yellow, Payne's Gray, Potter's Pink, Quinacridone Rust, Raw Umber, Terra Rosa

OTHER TOOLS
cold-pressed watercolor paper, nos. 0, 1, 2 and 3 rounds, pencil

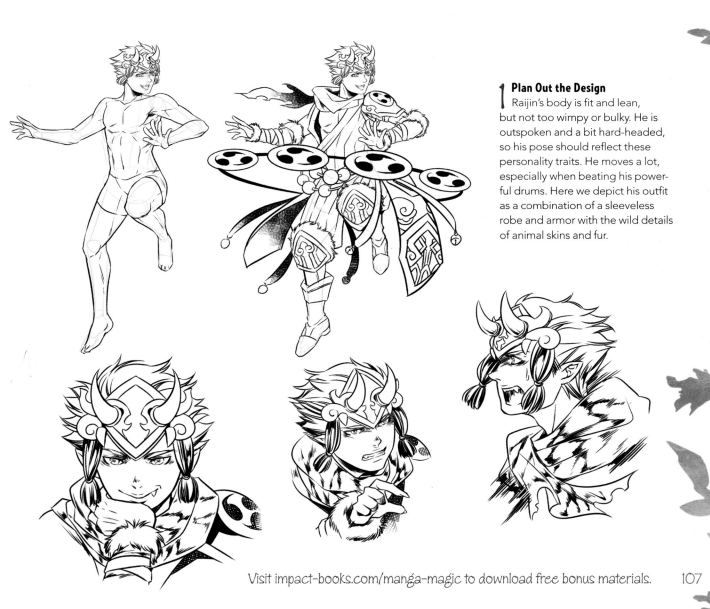

1 Plan Out the Design
Raijin's body is fit and lean, but not too wimpy or bulky. He is outspoken and a bit hard-headed, so his pose should reflect these personality traits. He moves a lot, especially when beating his powerful drums. Here we depict his outfit as a combination of a sleeveless robe and armor with the wild details of animal skins and fur.

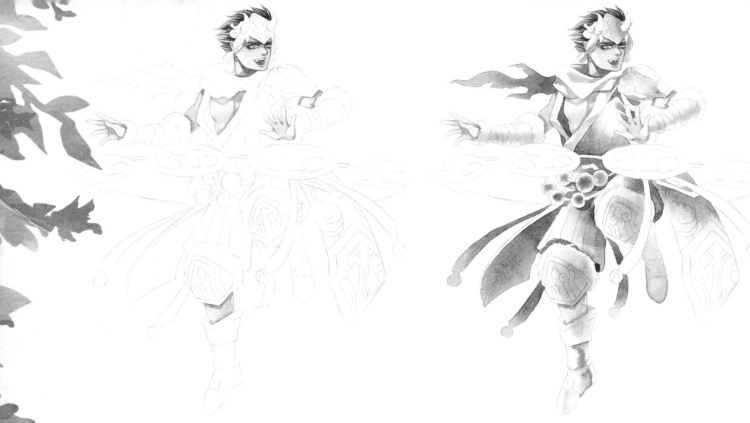

2 Sketch the Pose and Establish the Skin Tone and Hair

Sketch the pose with a pencil on watercolor paper. Create a mix of Potter's Pink and bit of Burnt Sienna and paint the under-painting of the skin's shadows using a no. 1 round. Lay a wash over the areas with a diluted mixture of Cadmium Yellow and Cadmium Red. Once dry, complete the skin by deepening some of the shadows with Burnt Sienna.

Paint a flat wash of Cadmium Orange on the hair to establish the highlight base. With a no. 0 round, use Terra Rosa and Cadmium Red to depict some strands of hair.

3 Paint the Underpainting of the Clothing

Mix Manganese Violet and Payne's Gray and establish the underpainting of the clothing. Use a no. 3 round for the large areas and a no. 1 or no. 0 for the smaller areas. For soft, fuzzy shadows, work wet-into-wet and for crisp shadows, work wet-on-dry. If some underpainting areas need to be extra lightened, blend the paint with clean water until you are satisfied with the color.

4 Paint the Headdress

Paint a wash on the main part of the headdress with Naples Yellow and a no. 1 round, leaving horns and tassels unpainted. When dry, paint the center of the headdress with Terra Rosa. Use a no. 0 round and a mix of Naples Yellow and a bit of Burnt Sienna for the shadows on the golden trim. Apply diluted Payne's Gray for the shadows in the center. For the horns, create a very diluted wash of Burnt Sienna and Payne's Gray. Leave the edges unpainted for crisp highlights. Drybrush some tiny streaks of texture using a concentrated version of the same mixture. Paint a flat wash of diluted Payne's Gray for the tassels and allow to dry before completing the shadows with the same mixture.

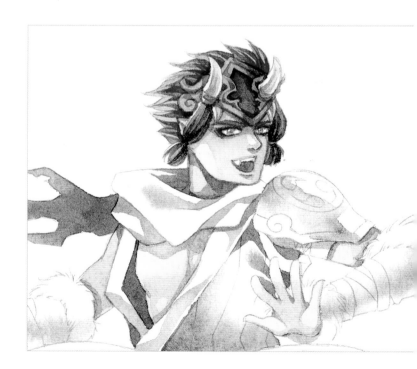

5 Paint the Scarf and Bracers

Paint a flat wash of Cadmium Yellow with a no. 2 round to depict the tiger fur of the scarf and bracers, leaving the leather straps unpainted. While the Cadmium Yellow is still damp, paint the tiger stripes wet-into-wet with concentrated Payne's Gray using a no. 0 round. This will create a hazy effect but not entirely blend. Let dry, then drybrush Payne's Gray to further define the stripes.

Paint the straps with a flat wash of Burnt Sienna. Add the fur details with a diluted mixture of Payne's Gray and Burnt Sienna using a no. 0 round. Use a no. 1 round and diluted Payne's Gray and Burnt Sienna to add shadows to the scarf and bracers.

7 Paint the Armor and Boots

Lay a flat wash of Cadmium Yellow on the decorative patterns of armor with a no. 2 round. When dry, fill the gaps of the armor with Cadmium Red and Manganese Violet. For the swirl on the shoulder armor, apply a base of diluted Raw Umber and fill the gaps with Terra Rosa. Paint the inside of the armor with a flat wash of Cerulean Blue. Define the engraved details with concentrated Raw Umber and a no. 0 round. Add a diluted mixture of Payne's Gray and Burnt Sienna for the fur. Once all the base colors are established, bring out the shadows with a diluted mixture of Manganese Violet and touch of Terra Rosa and Payne's Gray.

With a no. 2 round, paint the boots with a mixture of Payne's Gray and Raw Umber. On the caps and collars, simply paint a flat wash of diluted Naples Yellow, and diluted Terra Rosa for the trim. Use diluted Payne's Gray to complete the shadows.

8 Continue the Shadows and Paint the Drums

Refer to the completed illustration on page 106. Paint a flat wash of Cerulean Blue on the hanging ribbons with a no. 1 round. Mix Cerulean Blue with Manganese Violet to apply a layer of shadows. Paint the bells with Cadmium Yellow and add shadows with Raw Umber.

Lay a wash of Naples Yellow and Potter's Pink on the orbs with a no. 1 round. Darken the center of each orb with concentrated Payne's Gray and soften the edges with clean water. Use a no. 0 round to add the tiny strings at the waist with Cerulean Blue

Create a light mixture of Burnt Sienna, Naples Yellow and water for the drums. Spread the paint with a no. 3 round and let dry completely. Paint a flat wash of Quinacridone Rust on the swirly patterns using a no. 1 round. Apply another shadowy layer on top with diluted Burnt Sienna and a touch of Payne's Gray. Make sure to allow a few of the highlights at the corner of the drums to show through. Finish up the hoop connecting the drums with concentrated Indigo.

6 Paint the Robe and Pants

Apply a wash of Terra Rosa and Manganese Violet to the robe and pants using a no. 3 round, leaving the collars unpainted. Paint the shadowy folds of the torso with a mix of Manganese Violet and Payne's Gray. Emphasize the very thin stripes on the fabric using a no. 0 round and diluted Payne's Gray.

Paint a wash on the collars with a diluted version of the mixture from the main outfit. When dry, use the same wash to add an extra layer of shadows.

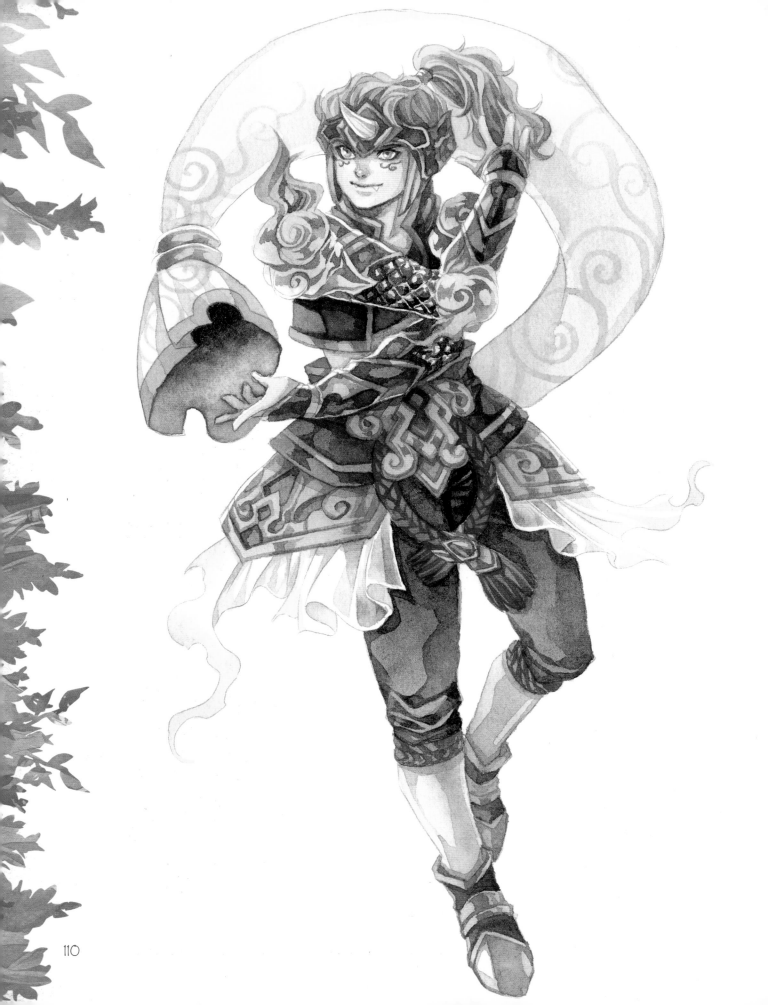

Demonstration
FUJIN

Confident and fearless, Fujin, the god of wind, is never afraid to speak his mind. He holds the unrivaled power of controlling the breeze using a windbag as his source of power. Though he is one of Raijin's close companions, Fujin frankly isn't afraid to tell Raijin how he feels, even if such conversations lead to friendly quarrels. They have a lot in common, both in their powers over the weather as well as their highly honest and virtuous natures.

MATERIALS

PAINTS
Burnt Sienna, Cadmium Red, Cadmium Yellow, Cobalt Green, Cobalt Turquoise, Green Gold, Indigo, Naples Yellow, Payne's Gray, Perylene Green, Potter's Pink, Raw Umber, Sap Green, Van Dyke Brown

OTHER TOOLS
cold-pressed watercolor paper, nos. 0, 1, 2 and 3 rounds, pencil

Color Scheme

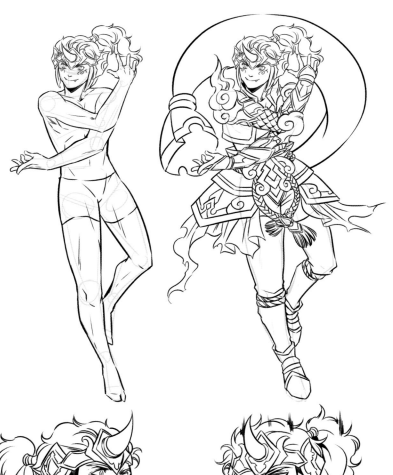

1 Plan Out the Design
Fujin's body structure is similar to Raijin's, toned but not overly muscular. His hands are wrapped around his body as he summons a strong breeze from his windbag. His armor is decorated with swirling embellishments to complement his magical powers, and a cool color scheme helps illustrate the chilly side of Mother Nature.

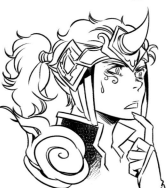

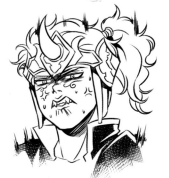

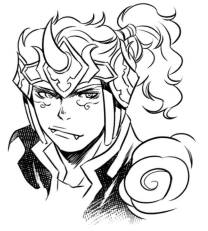

2 Sketch the Pose and Establish the Skin Tone and Hair

Sketch Fujin's pose with a pencil on watercolor paper. Create a mix of Potter's Pink and Burnt Sienna and paint the underpainting of the skin with a no. 2 round. On top of this, paint a diluted mixture of Cadmium Yellow and Cadmium Red. Refine the facial details and shadows with a concentrated version of the previous mix plus Burnt Sienna, and a no. 0 round. Let dry completely.

For the hair, lay a flat wash of diluted Green Gold with a no. 1 round. Add depth to the hair by painting a few shadowy streaks with a mix of Cobalt Green and Perylene Green using a no. 0 round.

3 Paint the Outfit's Underpainting

Establish the underpainting of the outfit with a mix of Perylene Green and Indigo using a no. 2 round. You can work both wet-into-wet and wet-on-dry. Pay attention to the shadows but don't get too detailed at this stage.

4 Paint the Headdress

Begin the headdress using a no. 1 round and Naples Yellow, leaving the horn unpainted. Paint the remaining thin gaps with a mixture of Sap Green and touch of Perylene Green. Paint the horn with a very diluted wash of Burnt Sienna, drybrushing the details and shadows. Be sure to leave some edges of the horn unpainted to indicate the highlights. Switch to a no. 0 round to pick up some shadows on the headdress. For additional shadows, apply more layers of Raw Umber on the Naples Yellow, and Perylene Green on the Sap Green.

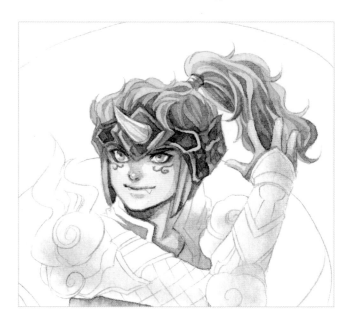

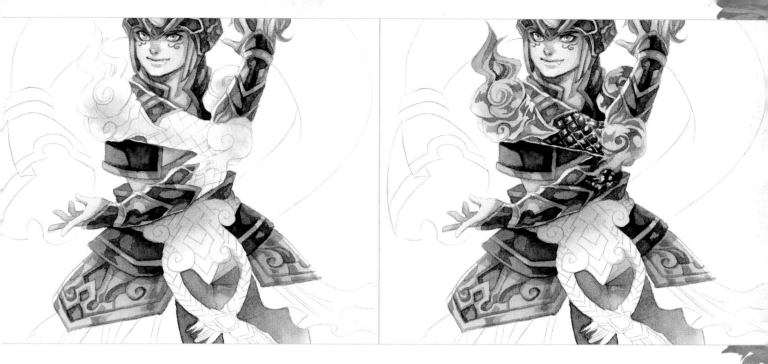

5 Paint the Armor

Paint a flat wash of Naples Yellow on the armor with a no. 2 round, leaving the shoulder and upper arms unpainted. Add a mix of Cobalt Turquoise and Perylene Green to the green areas of the armor. Use a no. 0 round and a mix of Raw Umber and Burnt Sienna to refine the outline of the armor's golden engraved patterns and shadows. Mix Perylene Green and Indigo for the shadows on the armor's green areas.

6 Complete the Armor Details

Apply a graded wash of Cobalt Turquoise to the swirling details of his elbow and shoulders using a no. 1 round. Paint the tips a bit darker. When dry, paint shadows with diluted Payne's Gray. Paint a light wash of Payne's Gray on his biceps, leaving some areas unpainted for highlights. Paint tiny shadows to indicate the crosshatched pattern using a no. 0 round. Paint the leather strap on his chest with a flat wash of Burnt Sienna.

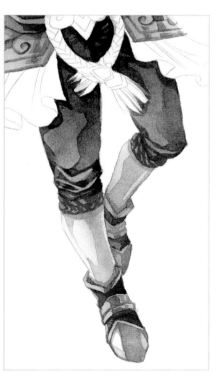

7 Work on the Pants and Boots

Paint a wash on the pants using Burnt Sienna and a no. 2 round. The underpainting from step 3 will create some depth, but add more wrinkles with Van Dyke Brown. Paint Cadmium Red on the ropes below his knees.

Paint the stocking area above the boots with a pale wash of Burnt Sienna. Refine the previous wash with a bit of Perylene Green. Add a flat wash of Naples Yellow on the gold areas of the shoes and fill the gaps with Burnt Sienna. Darken the golden areas with Raw Umber, then darken the Burnt Sienna areas with diluted Van Dyke Brown.

8 Complete the Clothing, Transparent Cloth and Windbag

Refer to the completed illustration on page 110. For the buckle and clasps, paint Naples Yellow for the base color and Raw Umber for the shadows and engraved details using a no. 2 round. Paint the ropes at his waist with Cadmium Red.

To paint the transparent cloth under the armor allow the base colors to slightly show through. Dilute Burnt Sienna until it is lighter than the original color of the pants. Use a no. 1 round and apply the wash on the cloth areas closest to the pants. Soften the edges with water and let fully dry. Mix Van Dyke Brown, Sap Green and water, then delicately paint the folds. Add a few more layers to deepen the shadows, but don't overdo it.

Spread fresh water on the windbag. Paint a pale wash of Raw Umber wet-into-wet using a no. 3 round. For the inside of the windbag, lay a wash of Cobalt Turquoise, then quickly add concentrated Indigo around the top area to create some depth. Paint Cadmium Yellow and Raw Umber on the bag's rings. Use diluted Cobalt Turquoise for the trim and create glazes of swirly patterns using a no. 0 round. Paint the windbag's shadows with a diluted wash of Perylene Green.

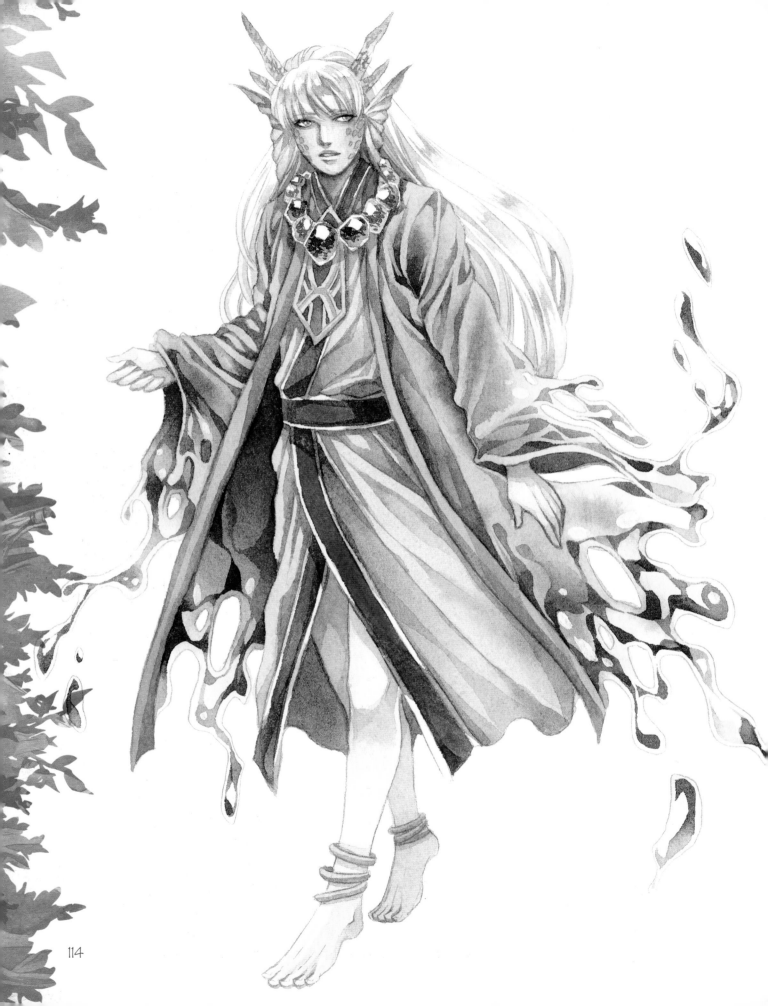

Demonstration
SUIJIN

Suijin is the Japanese god of water, who dwells in rivers and lakes. He has a reserved personality and is more comfortable hanging out with aquatic creatures than townsfolk. While the other gods take great pleasure in the never-ending stream of luxurious gifts, Suijin has no interest pampering himself with gold or other expensive things. Nature helps keep him grounded, and he chooses to focus on quietly helping others, especially his aquatic friends.

PAINTS

Burnt Sienna, Cobalt Blue, Cobalt Turquoise, Indigo, Lilac, Naples Yellow, Payne's Gray, Peacock Blue, Perylene Green, Raw Umber, Verditer Blue, Yellow Ochre

OTHER TOOLS

cold-pressed watercolor paper, nos. 0, 1, 2 and 3 rounds, pencil, white acrylic paint (optional)

MATERIALS

Color Scheme

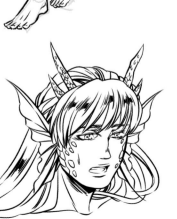

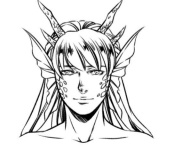

1 Plan Out the Design

Suijin is of average size and his pose is reserved just like his quiet personality. Because of his personality, it's best to play down his outfit rather than make it flamboyant. Suijin prefers to wear a simple robe with minimal colors and details, and a few simple accessories such as his gemstone necklace and ankle rings. Even though he is less exuberant than other gods, he is still quite striking because of his water-like robe.

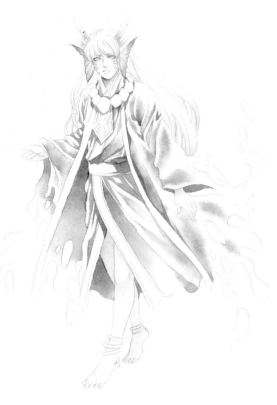

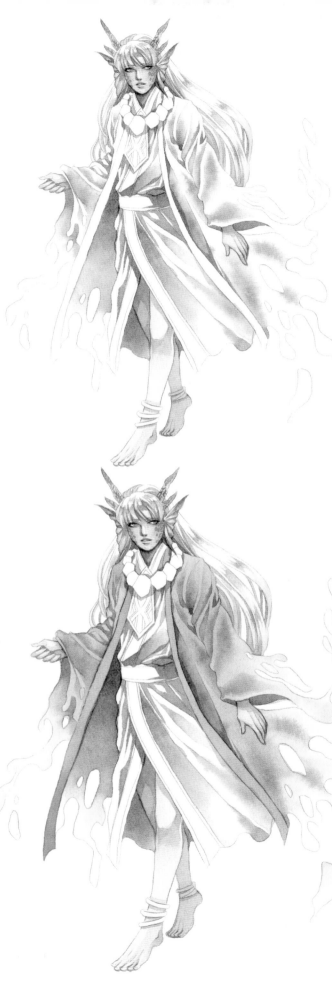

2 Sketch the Pose and Create the Blue Underpainting

Sketch Suijin with a pencil on watercolor paper. Create a light mix of Verditer Blue and water, and establish the underpainting of the legs and cheeks with a no. 1 round. Spread fresh water on his serpent horns and fins, then quickly apply concentrated Cobalt Turquoise at the base of the horns and edge of the fins. Let the paint blend gradually into the water. Dilute some Cobalt Turquoise and apply it at the tips of the hair. Use a brush to soften the color along with water. Apply Indigo for shadowy drapes and folds on the robe.

3 Paint the Skin and Horns

Create a pale skin tone mix with Naples Yellow, Lilac and water. Lay the diluted mixture on the hands, legs, feet and face with a no. 2 round. When dry, darken some areas with a concentrated version of the previous mixture. Use diluted Burnt Sienna for the darkest shadows.

Refine the subtle details with a no. 0 round. Create the scales on his face with Cobalt Turquoise while darkening the fins with diluted Indigo. Add Burnt Sienna at the tips of the horns, and soften the color so it fades toward the roots with water. To suggest tiny scale details on the horn, add a touch of diluted Indigo. The scales on the horns are very small, so you don't have to refine each one. For the hair, dilute Indigo with lots of water and paint the shadowy strands of hair. Leave some unpainted areas for the hair's highlights. Refer to the completed illustration on page 114 for a closer look at the head's details.

4 Paint the Outside of the Robe

Using a no. 3 round, spread a graded wash of Peacock Blue on the outer robe while keeping the bottom as light as possible. Switch to a smaller brush, and add Yellow Ochre to the robe's collars.

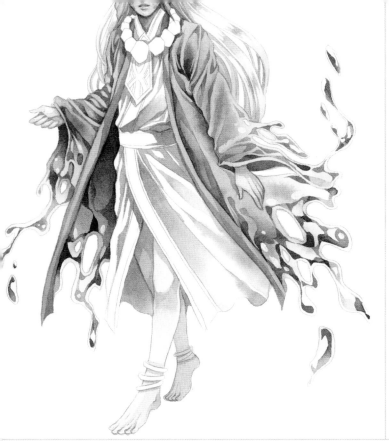

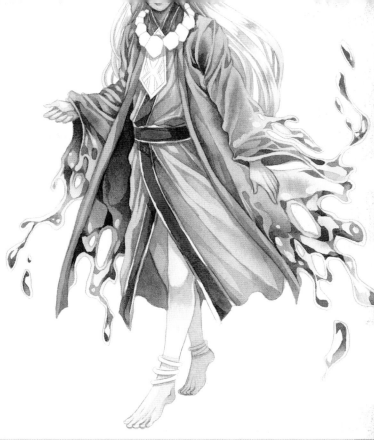

5 Add Shadows and Water Effects

Add shadows on the yellow collars with Raw Umber. Using a no. 1 round and a mix of Cobalt Blue and Indigo, refine the established folds and darken the inside of the robe. To create the water effects, work wet-on-dry and paint the bubble shapes of concentrated Peacock Blue and Indigo on the ends of the robe. Leave some space in between the paint and the very edges of the robe. Leave plenty of space for the robe's highlights, or indicate the reflections with a couple drops of white acrylic paint when the rest of the layers are dry.

6 Paint the Inner Robe

Use a no. 3 round to lay a very diluted wash of Cobalt Blue on the inner robe, and darken the folds with a more concentrated version of the mixture. Paint Cobalt Blue on the collars and sash at the waist, making sure to leave the tiny trim unpainted on both sides. Once this layer is dry, dilute Indigo with a bit of water and apply shadows of the inner robe with a no. 1 round.

7 Paint the Accessories

Opal should reflect various colors from the rest of the painting. Use a no. 0 round and a variety of colors such as Cobalt Blue, Cobalt Turquoise and Lilac to paint the gem stones on the necklace. Leave some unpainted areas for sharp highlights. Paint a flat wash of very light Payne's Gray on the chest plate, and Naples Yellow on the ankle rings.

8 Complete the Gem and Special Effects

Refer to the completed illustration on page 114. With a no. 0 round, add a cluster of tiny dots of concentrated Payne's Gray on each gemstone to create a sparkling effect. Fill the spaces within the chest plate with Perylene Green. For the final touches add shadows on the ankle rings with Raw Umber.

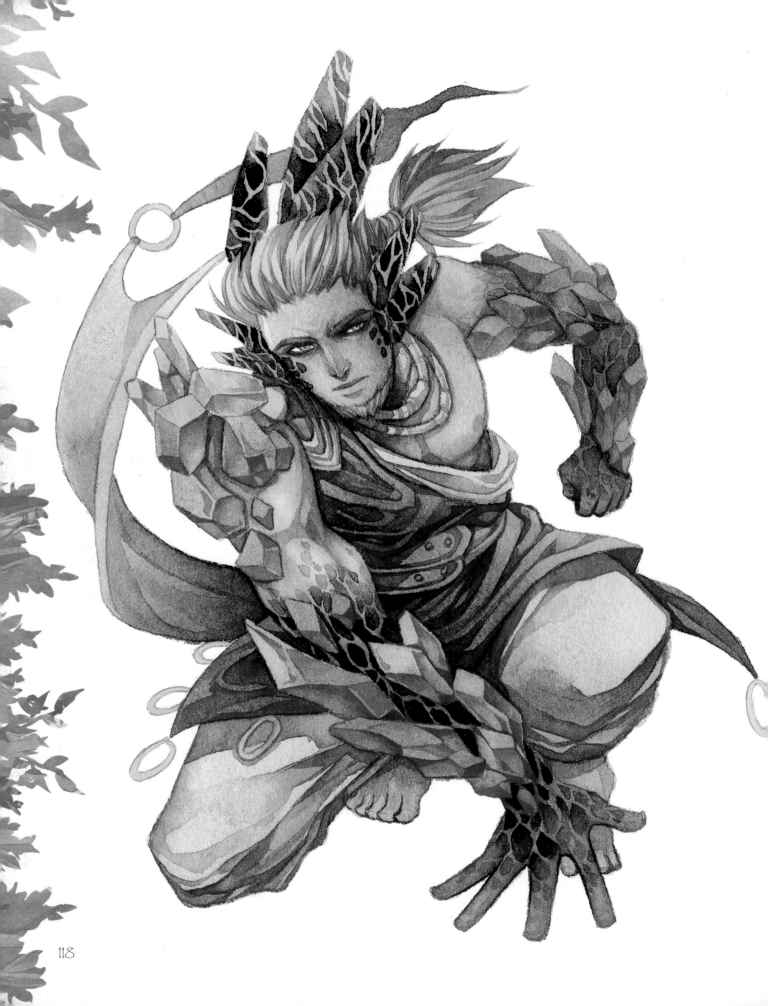

Demonstration
KOJIN

Kojin is the god of fire, strong and merciless, yet moral enough to use his blazing power only against evil deeds. He is best known for his destructive fiery power that can utterly wipe out his enemies. Everybody knows Kojin is even-tempered, but with his buff physique and magma arms, the fire god is definitely not someone you should pull a prank on. Though he isn't as talkative as Raijin or Fujin, and certainly doesn't look as amicable as other gods, Kojin has a positive reputation for being a trustworthy companion.

Color Scheme

MATERIALS

PAINTS
Burnt Sienna, Cadmium Orange, Cadmium Red, Cadmium Yellow, Cobalt Turquoise, Manganese Violet, Mauve, Payne's Gray, Peacock Blue, Perylene Maroon, Perylene Violet, Quinacridone Rust, Raw Umber, Sepia, Yellow Ochre

OTHER TOOLS
cold-pressed watercolor paper, nos. 0, 1, 2 and 3 rounds, pencil

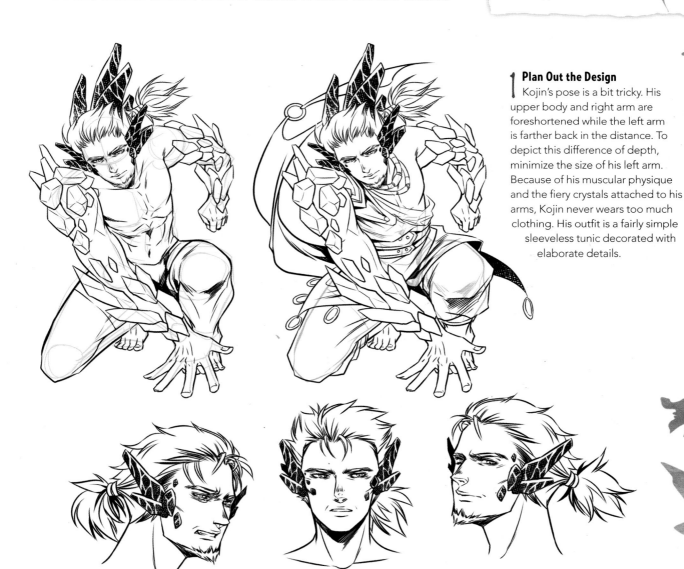

1 Plan Out the Design
Kojin's pose is a bit tricky. His upper body and right arm are foreshortened while the left arm is farther back in the distance. To depict this difference of depth, minimize the size of his left arm. Because of his muscular physique and the fiery crystals attached to his arms, Kojin never wears too much clothing. His outfit is a fairly simple sleeveless tunic decorated with elaborate details.

Visit impact-books.com/manga-magic to download free bonus materials.

119

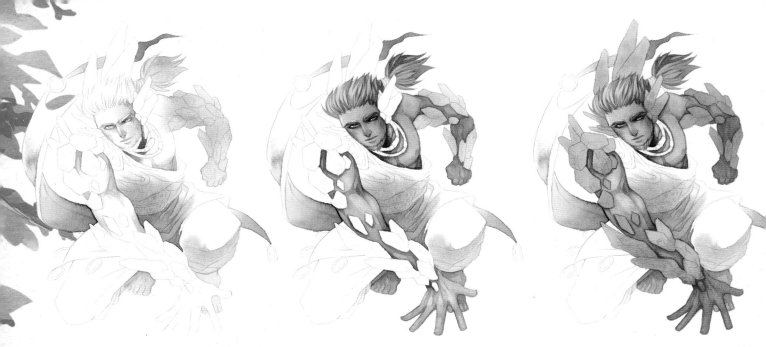

2 Sketch the Pose and Establish the Underpainting

Sketch Kojin's pose with a pencil on watercolor paper. Build up the initial shadows on the skin and outfit with Perylene Violet and a no. 3 round, especially his receded left arm and legs. Darken the layer around his neck and soften some of the paint with clean water, if desired.

3 Paint the Skin and Hair

Mix a tan skin tone mixture with Burnt Sienna, Cadmium Yellow, a bit of Manganese Violet and water and paint the skin with a no. 2 round. When dry, add a little Sepia to the mixture and refine the shadows on his face, muscles and close to the outfit. Lay Cadmium Yellow and Cadmium Orange on his hair. Switch to a no. 0 round and add subtle details of hair with Quinacridone Rust. Add extra layers with the same paint to deepen the shadowy strands.

4 Begin the Arms and Fire Crystals

Begin to build the base for his magma arms and fire crystals. With a no. 2 round, shade concentrated washes of Cadmium Orange and Cadmium Red on the forearms and crystals. Let this layer dry completely before moving to the next step.

5 Detail the Fire Crystals

Add details to the crystals on his arms. (We will render the crystals on his face and hair in the next step.) Add a layer of Cadmium Red on each facet and quickly soften with water, painting toward the edges with a no. 1 round. Leave the top facet's highlights unpainted. Continue this method for the other facets in each crystal. Add another layer of Quinacridone Rust for some extra shadows.

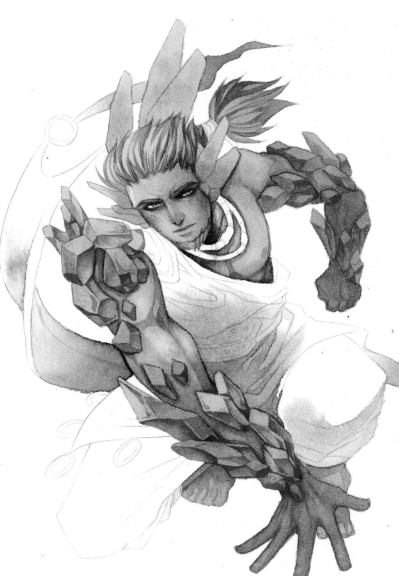

6 Paint the Molten Rocks

Use a no. 0 round and concentrated Payne's Gray to paint dark molten rocks on the forearm and face/head crystals. Make sure to leave some small spaces in between each rock to depict the hot lava beneath. To show the transition from skin to magma, dilute some of the details on the bicep of the forearm with water. Paint the molten rocks of the back arm with diluted Payne's Gray.

7 Paint the Tunic and Pants

Paint a flat wash of Cadmium Red on the tunic with a no. 3 round. Use a no. 1 round for refining small details. Darken the folds with Perylene Maroon and Mauve. Add Cadmium Yellow on the button. Spread a flat wash of Cobalt Turquoise on the inside of the tunic, and add shadows with Peacock Blue.

Allow the tunic to fully dry, then use a no. 3 round and apply a mixture of Raw Umber and a bit of Burnt Sienna on the pants. Create layers of shadows with Burnt Sienna and Perylene Maroon using a no. 1 round.

8 Paint the Sash and Accessories

Refer to the completed illustration on page 118. Paint a diluted mixture of Perylene Maroon and Mauve on the sash behind his back with a no. 2 round. Create a layer of shadows with the same mixture. Use Cobalt Turquoise on his hair ties. Apply Cadmium Yellow on the necklaces and rings, and paint a flat wash of Yellow Ochre on the shoulder pad and belt. Add details on the accessories' shadows with a mixture of Yellow Ochre and a bit of Payne's Gray.

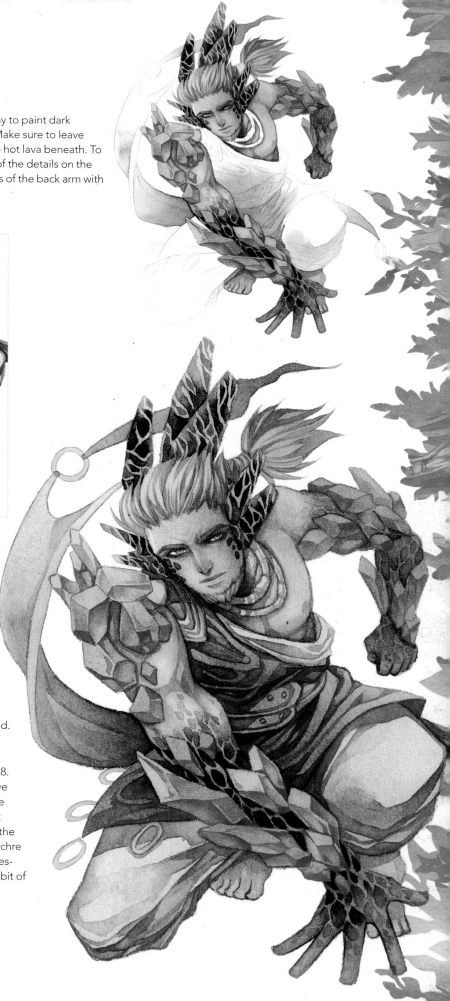

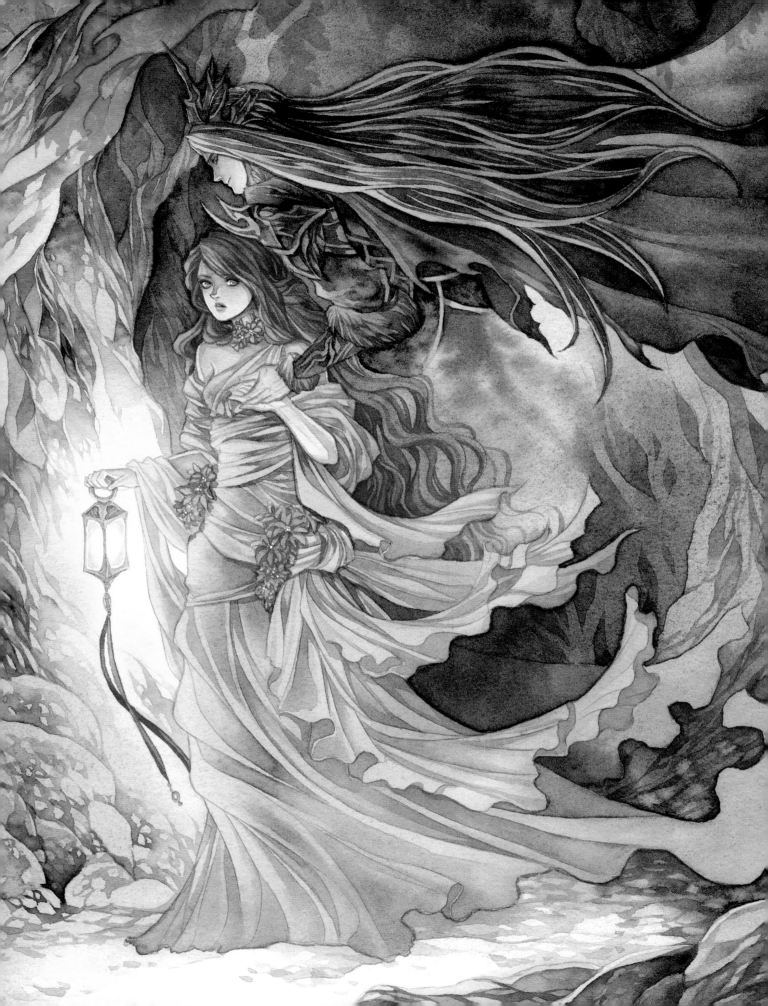

6

Backgrounds

After working so hard creating your mythological character's personality, pose and clothing, it's time to focus your efforts on the background. Great backgrounds are essential to creating fun and convincing stories. Whether real or imaginary, dark or cheery, the environment that is most natural for characters is key. Other aspects to think about are time of day, season, weather and characteristics typical of different regions: mountains, oceans, trees, snow or ice. Of course, in fantasy realms the details of your scenes are only as limited as your imagination! This section covers the basics of backgrounds—from perspective and character placement to atmosphere and composition—and shows you how to bring it all together with three complete demonstrations.

Perspective Basics

Have you ever noticed how the road merges into one point at the horizon? Or how buildings look smaller as they recede? In fundamental perspectives, grids and vanishing points are the basis for creating three-dimensional drawings. Perspective tricks your eyes with the illusion of depth and distance. Understanding perspective is essential to making your backgrounds believable.

One-Point Perspective

One-point perspective converges to a single vanishing point. It is commonly used in drawings of hallways, alleys and streets. Use both vertical and horizontal grids as your guideline for the ground and the character's setting. The placement of the vanishing point can be anywhere you choose.

Two-Point Perspective

Two-point perspective provides you with a better sense of space. Place another vanishing point on the horizon line and adjust your subjects in the background relative to the perspective grids. There are two points where the lines of the grid will merge.

worm's-eye view

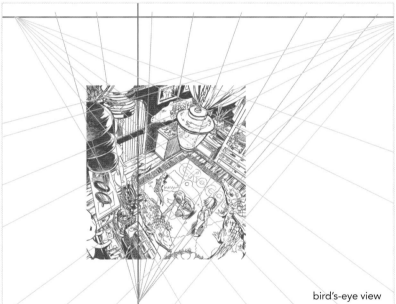

bird's-eye view

Three-Point Perspective

Three-point perspective creates a dramatic viewpoint. To accomplish this, draw a vertical line that intersects your horizontal plane, then set a third point along that vertical line. Be careful not to place the vanishing points too close to each other or your scene will look cramped. The placement of the third vanishing point can also determine the angle of your drawing. If you place it above the horizontal line, you create a worm's-eye view. Placing it under the horizontal line creates a bird's-eye view.

Align Your Characters

Unless your characters are floating in space or flying, they should each intersect the horizontal line at about the same level. If one character intersects at his chest, the rest should as well. You can make an exception if a character is in a different position such as sitting, kneeling or jumping or is of a much different height. Then the line may not cross them at the same place—or at all.

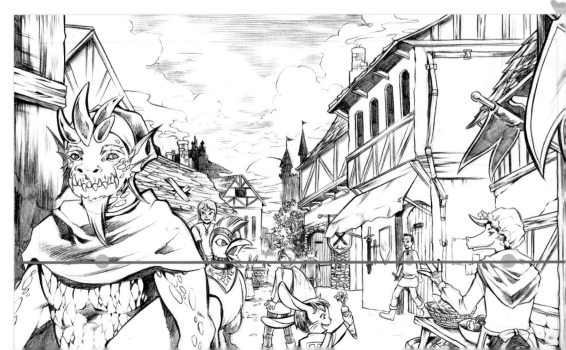

Fantasy Settings

Most mythical stories have been interpreted many times by many different cultures all over the world. The details of the stories vary as much as the unique details of the location where the story originated. Typically, the realm in which a god, deity or fantasy character dwells reveals a lot about their personality.

It can be helpful to start with a basic setting such as underwater or high in the sky, then use your imagination to build the scene's details. Here are four sample locations to help get you started brainstorming your scenery.

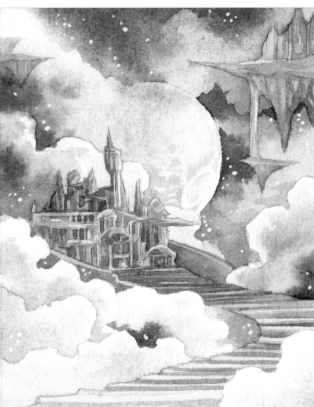

High in the Sky

The heavens make a suitable home for the immortal gods and goddesses who watch over the earth. The limited gravity is a great setting for floating palaces in and on the clouds.

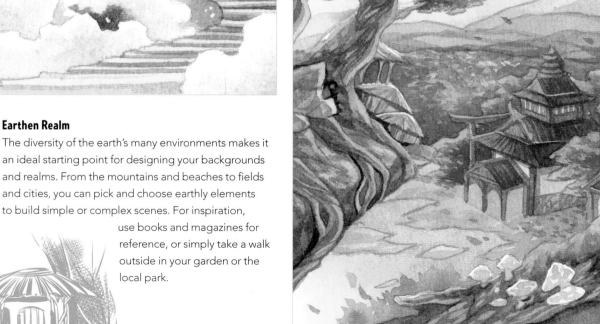

Earthen Realm

The diversity of the earth's many environments makes it an ideal starting point for designing your backgrounds and realms. From the mountains and beaches to fields and cities, you can pick and choose earthly elements to build simple or complex scenes. For inspiration, use books and magazines for reference, or simply take a walk outside in your garden or the local park.

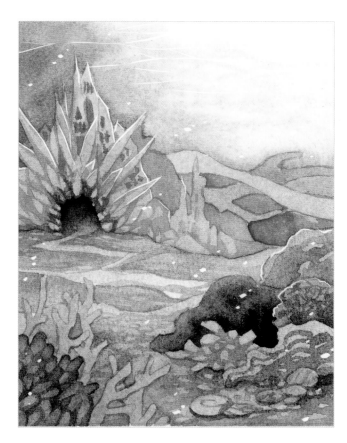

Watery Scene

Aquatic kingdoms are fun to adorn with seashells and other details of the ocean. Get creative when designing underwater realms by mixing and matching different elements. Here we have a sparkling cerulean crystal castle among a colorful field of coral. You could even add a bridge made of a sunken ship.

The Underworld

The underworld, home to the god Hades, is dark, unpleasant and lifeless. It is the land where evil souls are condemned. Tunnels, catacombs, stalactites and stalagmites are common deep beneath the earth's surface. If you aren't too frightened, add skull and bone details to create an even spookier atmosphere.

Working From Photographs

Photographs are a valuable source of inspiration. Whether you are out and about in your daily life or traveling abroad, take note of the interesting shapes and designs of the buildings and landmarks around you. Sketch them in your sketchbook or take a snapshot with your camera or smartphone. To avoid infringing on others' copyrights, I recommend you use your own photos and sketches for creating your backgrounds, though your imagination will always be the most powerful tool you can use for designing compelling scenery.

An Inspiring Vacation
When I visited Kyoto, Japan, I took photos of the famous landmarks Osaka Castle (top right) and Fushimi Inari-taisha (bottom right). The fascinating shapes and subtle details of the structures later inspired my own unique creations.

Weathered Features

A perfect setting doesn't mean everything has to be in mint condition. Ancient, abandoned structures are covered in cracks, stains, dried vines and moss. Though these details may not be appealing in real life, applying them in your mythical settings will make everything more convincing.

Dried Leaf

Sketch a simple dried leaf and apply a wash of Green Gold at the tip. Lay a wash of Burnt Sienna on the entire area and blend at the green tip with water. When dry, use a small brush and a dark mix of Burnt Sienna and Sepia to refine the veins.

Moss

Moss often grows near brooks and streams and can be depicted carpet-like or in clumps. To paint moss, lay a wash of concentrated green paint such as Cobalt Green, Green Gold, Sap Green, Olive Green, Viridian or Perylene Green. Use a dry-brush technique or sprinkle salt over the damp washes to create unique textures.

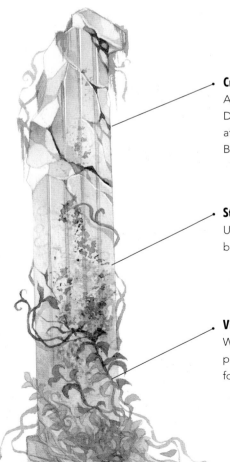

Crack

As time passes, structures will show their age through decay and cracking. Depict the severity of the cracks by the intensity of the crack's color. To create cracks, apply concentrated mixtures of Payne's Gray, Van Dyke Brown or Burnt Umber using a small brush.

Stain

Use a sponge or paper towel to randomly dab stains on a surface. Dry brushing is another great technique for this.

Vine

Whether wilted, dry or living, vines wrap naturally around pillars. Green paints are a good choice for fresh, lively vines while earthy browns are better for dried or dead ones.

Creating Contrast

You can distinguish the foreground and middle ground subjects from the background by playing with contrast. Adjusting the intensity level of the color values can help the viewer tell each element apart and also suggest depth and distance. Here are two methods for building contrast in your backgrounds.

Dark Subjects and Light Background

1 Lay a diluted flat wash of Cadmium Yellow with a large round or a flat brush.

2 Apply a diluted wash of Sap Green and Green Gold to the farthest subjects in the middle ground. Add more color to build depth.

3 Build up the subjects and add details to the trees in the foreground with Green Gold and Viridian.

Light Subjects and Dark Background

1 Lay a diluted flat wash of Cobalt Blue with a large round or a flat brush. Let dry.

2 Apply another wash of Cobalt Blue over the middleground and background leaving the foreground subject alone.

3 Fill in the background with Indigo. Rough in details on the middle ground subjects, then refine the foreground subjects.

Demonstration
AERIAL PERSPECTIVE

Aerial perspective is the technique of establishing the illusion of depth by adjusting colors to appear weaker in the distance. It's important to control the color intensity in your paintings to avoid distracting the viewer. Farther subjects such as distant hills should be less pronounced and lighter in color as they are being viewed through the atmosphere. Closer objects will have more details and greater color intensity.

MATERIALS

PAINTS
Cerulean Blue, Green Gold, Raw Umber, Sap Green, Viridian

OTHER TOOLS
cold-pressed watercolor paper, nos. 1, 2 and 3 rounds, pencil

1 Sketch the Scene
Plan out a bird's-eye view landscape in three-point perspective by placing the third vanishing point under the horizontal line. With a pencil, sketch the picture and add some clouds above the landscape to enhance the dramatic view.

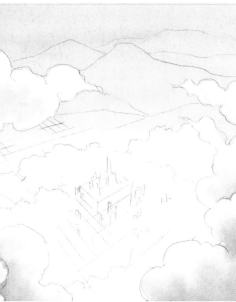

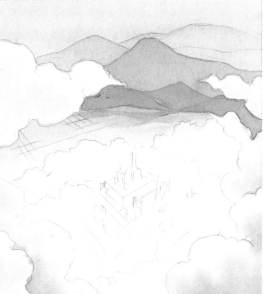

2 Paint the Clouds
Lay a graded wash of Cerulean Blue from top to bottom with a no. 3 round. Work with wet-into-wet by laying down water, then quickly applying Cerulean Blue at the bottom of the clouds. Deepen the shadows by adding more of the same color.

3 Build Up the Hills
Establish the distant hills with a light wash of diluted Sap Green using a no. 2 round. Let fully dry, then apply another layer on top. Build up the intensity of the pigments by applying more layers of the same wash on the other hills closer in the foreground.

4 Paint the Forest
With a no. 2 round, lay a wash of concentrated Green Gold on the forest area. Let dry, then switch to a no. 1 round and paint the forest's shadows with Viridian and Green Gold. Add a touch of Raw Umber on the building in the center of the trees.

Composition

Choosing the right composition can be a challenge. You can have a simple setup of just a few elements or many elements in a limited space. Here are some basic compositions to help you get started designing your settings.

Static Composition

A static composition is one where the gridlines mostly run vertical and horizontal without any major angle adjustments. It gives the scene a balanced, tranquil or steady feel.

Dynamic Composition

A dynamic composition is more exciting and interesting. You can begin with a static composition, then simply tilt the overall angle of the picture. But be careful. If you tilt the angle too much it may look flipped over and unnatural.

Balanced Composition

A balanced composition has an equal number of features on each side of the picture—whether this is the number of elements, the size or scale of the objects or the level of color intensity. One side should not feel heavier than the other.

Unbalanced Composition

An unbalanced composition may contain randomly placed subjects where one side of the picture is heavier than the other and the other contains more negative space. The eye will naturally focus on the heavy side. It's okay to use this type of composition, just make sure not to overdo it and confuse the viewer unnecessarily.

Rule of Thirds

The rule of thirds is a useful trick for establishing an interesting focal point. Divide your scene horizontally and vertically into nine equal parts. For a more interesting scene, place the most important compositional element (i.e. your focal point) at one of the four areas where the lines intersect. This will lead to a much more interesting picture than if you simply place your subject in the center of your painting.

Easy Fixes to Improve the Design

Spending some time making simple adjustments can really improve your scenes. Play around with the poses, angles, colors and sizes of your subjects to see what works best for the painting.

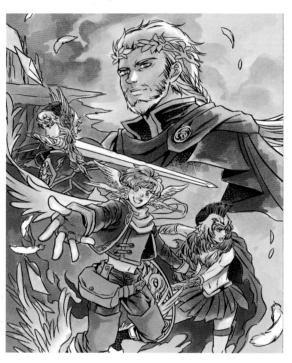 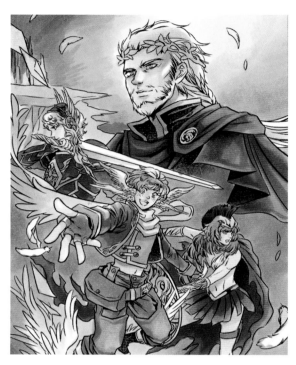

Color Test
A color test helps you visualize the final outcome. When you finish a sketch, rough in a couple different color schemes to help you choose which direction to go.

Adjust the Size of the Subjects
Instead of having the same sized characters gathered in the picture, adjust the size of each character to make the composition more interesting. Scale the size of the most important character to be bigger than the others, or add more details to the closer characters.

Change the Camera Angle

Simply adjust the camera angle to get a different feel or level of intensity from the character interactions. Experiment with a few angles until you find the one that works best.

before

after

Adjust the Pose and Background Elements

Once you've sketched out the composition, check for small details that distract you and don't be afraid to make some adjustments. In this example, instead of having the sword point awkwardly at the head of Hermes, I modified the pose and the sword's direction. To make Hermes the focal point and improve the flow of the composition, I shrunk the nearby Athena character and foreshortened Hermes's arm toward the viewer. Lastly, I fixed the cliff in the background so it wasn't touching Zeus's face, helping it to appear farther in the background.

UNDERWATER REALM

Deep down under the rippling waves and bubbles, Suijin the water god resides peacefully in his sacred aquatic shrine. He is content to dwell quietly under water with his aquatic friends. In this demonstration, we will establish the subjects and details, then slightly shift the composition to make it more dynamic.

MATERIALS

PAINTS
Burnt Sienna, Cadmium Red, Cerulean Blue, Cobalt Blue, Cobalt Turquoise, Indigo, Lilac, Mauve, Naples Yellow, Payne's Gray, Peacock Blue, Perylene Green, Quinacridone Rust, Raw Umber, Sap Green, Sepia, Verditer Blue, Viridian

OTHER TOOLS
cold-pressed watercolor paper, ¾-inch (19mm) flat, nos. 0, 1, 2, 3, 5 and 7 rounds, pencil, salt, white acrylic paint

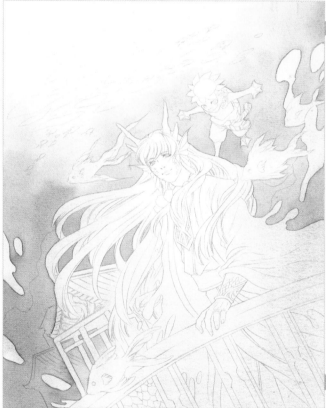

1 Lay In the Blue Underpainting
Sketch the scene with a pencil. Lay water over the entire surface with a ¾-inch (19mm) flat, then quickly paint a wash of Cobalt Turquoise wet-into-wet with a no. 7 round. Since the light source is coming from above, keep the top of the scene and the area around Suijin a bit lighter. Let dry completely.

2 Darken the Background
Deepen the background with a wash of Cobalt Blue and Cerulean Blue using a no. 5 round. Soften the wash at the top of the paper with fresh water. Switch to smaller brushes for the tiny spaces between the characters.

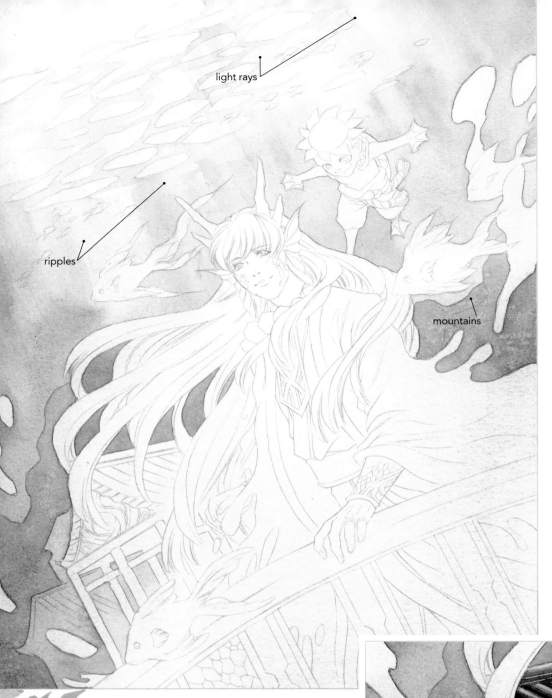

light rays

ripples

mountains

3 Create the Light Rays and Establish the Mountains

To create the ripples, paint diluted Cerulean Blue at the top of the paper with a no. 1 round but leave some ripples unpainted where light will shine through. Dilute the mixture with even more water and paint the glowing rays of light with a no. 2 round. Paint each streak from the top to the middle of the page. Soften the paint as needed with touches of clean water. Continue layering streaks of diluted Cerulean Blue, allowing plenty of time for each layer to dry.

Create a mix of Cobalt Blue and Viridian and paint a flat wash for the hills in the background using a no. 3 round. While the surface is damp, sprinkle a bit of salt on the mountains. Let dry, then brush the salt off with your hand.

4 Paint the Shrine

Mix Payne's Gray with a bit of Sepia and paint the roof of the larger foreground shrine with a no. 1 round. Deepen the shadows and details with a more intense version of the same mixture. Paint the pillars with Cadmium Red, adding a bit of Sepia to the mix to paint the shadows. Paint the swirling pattern of the attic with Indigo. Lay a flat wash of diluted Sepia on the rocky basement. When dry, apply the shadows in between each rock with diluted Indigo and Sepia.

For the smaller background building, use the same mixtures as above, but more diluted. The background building should have fewer details than the foreground building.

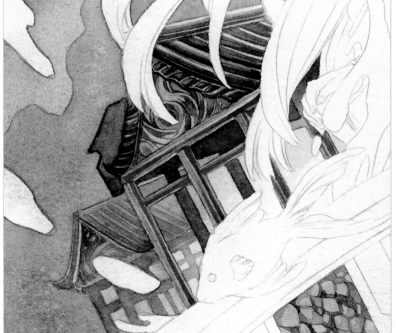

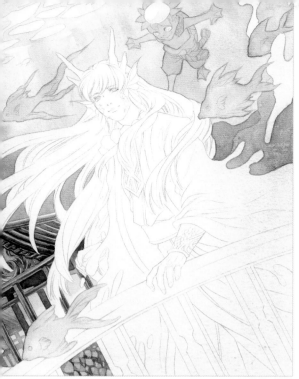

5 Begin the Fish and the Kappa
Lay clean water on the three fish, then quickly add Cobalt Blue and Viridian with a no. 2 round allowing the colors to blend. For the Kappa, paint a wash of light Sap Green on his skin and leafy hair. Dilute the mixture with water and paint the cap on his head. Use a diluted wash of Perylene Green to paint his turtle shell and outfit.

6 Complete the Fish and the Kappa
Apply the details of the fish with concentrated Cobalt Blue and a no. 0 round, softening a few of the edges with water. Suggest the groups of fish in the distance with random brushmarks of Cobalt Blue. Paint a flat wash of Raw Umber on the Kappa's pants and mix in Indigo for the shadows. Paint the rope around his waist with Cadmium Red. Add the shadows of the Kappa's skin and leafy hair with Viridian, but leave the webbing between his fingers unpainted. Deepen the shadows around his neck and under his leafy hair with more layers.

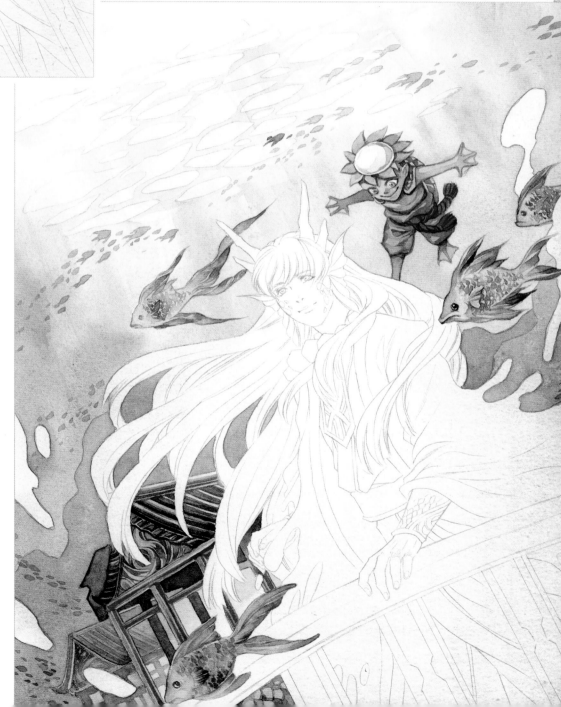

7 Paint the First Layer of Suijin

Apply a Verditer Blue underpainting on the hands and face with a no. 2 round. Use a no. 0 round for the small details like the lips and under the chin. Paint Cobalt Turquoise on the fins, serpent horns and tips of hair, and soften with clean water. Use Indigo for the underpainting of the inner and outer robe.

8 Paint the Face and Hair

Mix Naples Yellow, Lilac and water to paint Suijin's pale skin with a no. 2 round. Allow this layer to dry, then add the skin's shadows with a concentrated version of the previous mixture. Add Mauve to the mixture for the deepest shadows under his chin and bangs. Paint the scales on his face with Cobalt Turquoise.

Emphasize details on his ear fins with diluted Indigo. Lay Burnt Sienna on his serpent horns and add tiny scales with a bit of Indigo. Use a no. 0 round to subtly refine the hair strands. Complete the remaining details by layering more of the diluted mixture of Indigo and Cobalt Turquoise.

9 Paint the Robe

Lay a wash of Peacock Blue on the outer robe with a no. 3 round, keeping the edges as light as possible. Use Naples Yellow for the collar. For the inner robe, paint a flat wash of diluted Cobalt Blue, using a more concentrated version for the collars and sash. When the layers dry, mix concentrated Cobalt Blue and Payne's Gray to deepen the folds and shadows of the robe. Switch to a no. 1 round to depict the details. Continue painting the robe's details working wet-on-dry, smoothing some of the edges with water. Use the same mixture to refine the shadows on the inner collars and sash. To complete the shadows of the yellow collars of the outer robe, mix Naples Yellow, Burnt Sienna, and a bit of Indigo.

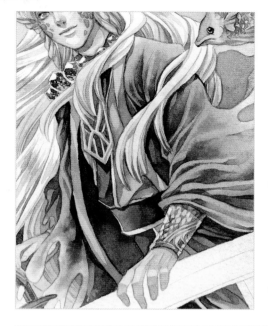

10 Paint the Jewelry and Bracer

Paint the bracer with diluted Payne's Gray and a no. 1 round. To deepen the shadows, allow each layer to dry completely. Lay a flat wash of diluted Payne's Gray on the chest plate, and fill in the engraved pattern with Perylene Green. For the gemstone necklace, add Cobalt Turquoise and Lilac as the base of the stones. Let dry, then fill in the tiny spots with Payne's Gray and a no. 0 round.

11 Paint the Bridge

Create a mix of Quinacridone Rust and Cadmium Red, and lay a wash of this mixture on the bridge areas with a no. 3 round. Add a touch of Mauve into the mixture, and use it to darken the shadows. For small details, work with smaller brushes.

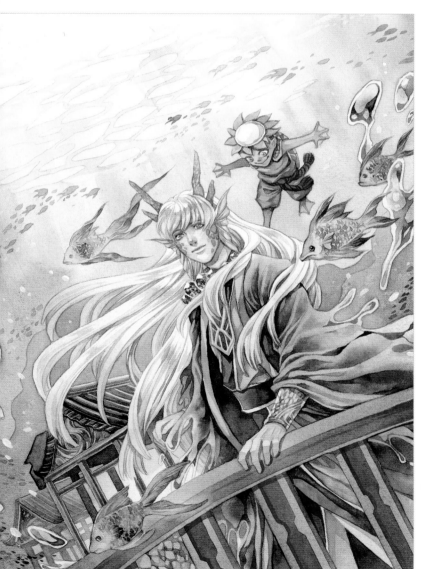

12 Add Details to the Bubbles and Complete the Painting

Refer to the completed illustration on page 136. Working wet-into-wet, paint a wash of Cobalt Turquoise at the center of the bubbles on the right and left sides of the paper using a no. 2 round. Soften the paint with water. Allow the layer to dry, then add the bubbles' shadows with a concentrated mix of Peacock Blue and Indigo. Use this mix for the shadows on the outer robe's edges as well. Finally, use a tiny bit of white acrylic to add a few extra bubbles.

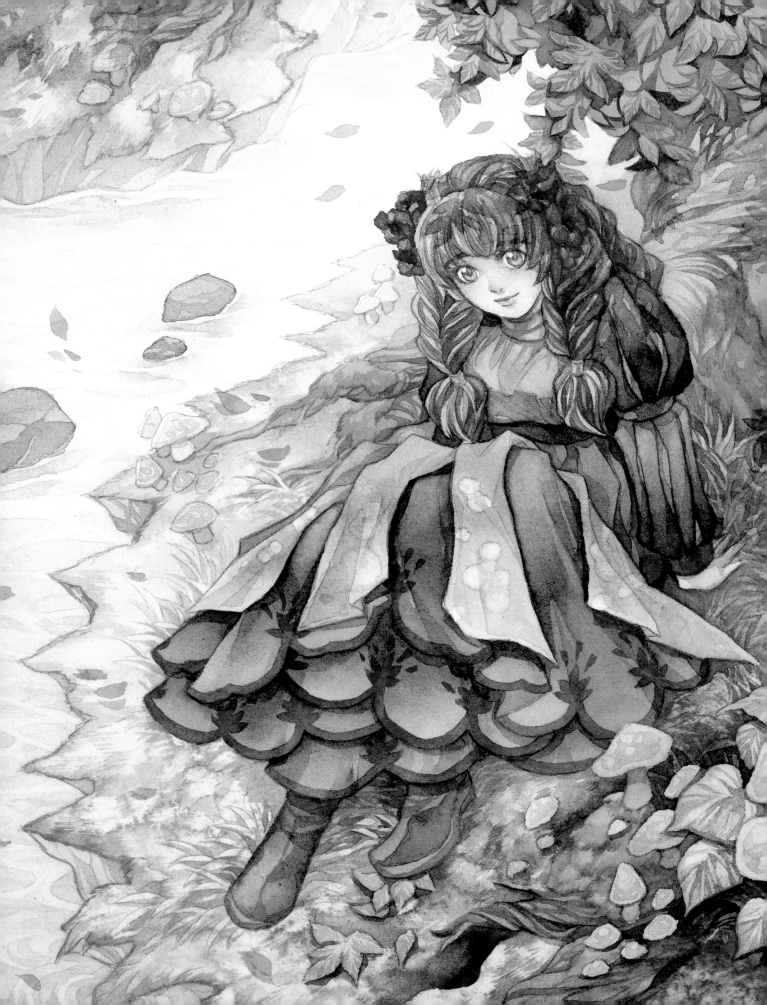

Demonstration
AUTUMN SCENE

A prefect breeze, the rustle of falling leaves and the faint whispers of wood nymphs ... these are the signs of summer changing to fall. This is Demeter's favorite time of year, and she loves to indulge in the serenity of the changing foliage. In this demonstration we will bring together all we've practiced to paint a lush forest scene in autumn.

MATERIALS

PAINTS
Burnt Sienna, Cadmium Orange, Cadmium Red, Cadmium Yellow, Cerulean, Blue, Compose Green, Green Gold, Indigo, Lilac, Naples Yellow, Olive Green, Payne's Gray, Perylene Green, Quinacridone Rust, Raw Umber, Sap Green, Sepia, Viridian

OTHER TOOLS
cold-pressed watercolor paper, ¾-inch flat (19mm) , nos. 0, 1, 2, 3, 5 and 7 rounds, eraser, masking fluid, pencil, rubbing alcohol, salt

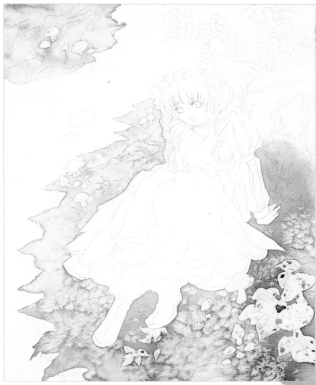

1 Lay In the Background
Sketch the design with a pencil. Lay a flat wash of water with a ¾-inch (19mm) flat over the entire paper. Working wet-into-wet, establish the background with a diluted mixture of Compose Green and a touch of Cadmium Yellow using a no. 7 round. Don't worry if the wash spreads into the character areas at this step. Let fully dry before moving to the next step.

2 Begin the Ground
Before layering more paint on the background, cover the mushrooms and foreground leaves in the lower right corner with masking fluid. Wet the ground area with water using a no. 5 round, then working wet-into-wet, paint a wash of Green Gold and Perylene Green. Keep the lower right corner darker than the rest of the ground area. While the surface is still wet, add Naples Yellow around the edges of the stream. Sprinkle some salt for unique textures. Let dry, then brush the salt off with your hand.

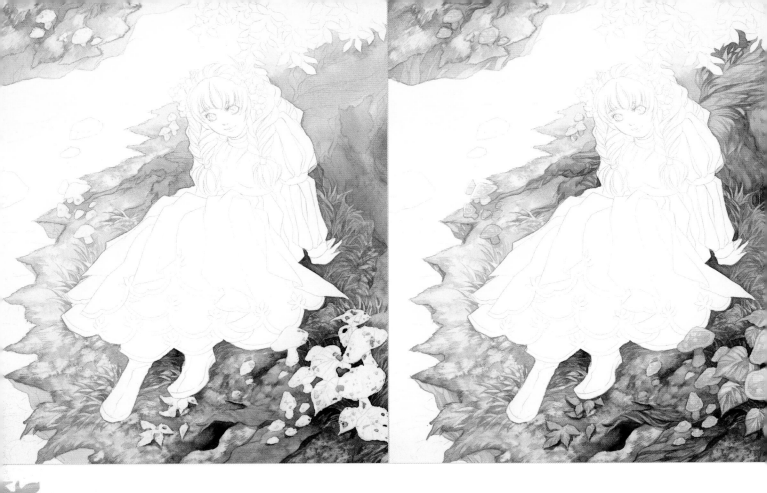

3 **Add the Ground Details and Begin the Tree**
Paint the small details of the ground with a no. 1 round with diluted layers of Viridian and Perylene Green. Gradually build the shadows of individual leaves and grasses around Demeter, and under the mushrooms. Use this mixture and a dry-brush technique to establish some of the grass texture. Mix Raw Umber and a touch of Viridian and paint a light wash on the terrain underneath the grass.

For the bark, create a mix of Burnt Sienna, a bit of Green Gold and water. Paint an underpainting on all of the tree bark including the roots. Paint the moss on the bark with Green Gold and a no. 3 round.

4 **Refine the Terrain and Tree Bark**
Add more shadows to the terrain with the underpainting mixture from step 3 using a no. 1 round. Mix Burnt Sienna and Perylene Green for the darker shadows on the bark and build texture by applying layers of shadows. Work with a dry-brush technique and soften some of the brushstrokes with water. Add shadows on the moss with Sap Green.

Allow the surface to dry completely, then use an eraser to remove the masking fluid applied in step 2. Paint the foreground leaves in the lower right corner with a wash of Compose Green and a no. 1 round. Quickly add a touch of Cadmium Orange at the edges of the leaves, letting the colors bleed into each other. Let dry, then paint the veins with layers of Viridian. Paint the leaves near Demeter's feet with Cadmium Yellow and Cadmium Orange. Paint the mushrooms with a mix of Lilac and a bit of Cadmium Yellow. Darken the shadows with the same paint mixture.

5 Paint the Stream

Lay a graded wash of Cerulean Blue on the stream with a no. 5 round. Keep the bottom area of the stream darker than the top. Dilute the mixture and paint the ripples with a no. 2 round. Paint the rocks with diluted Burnt Sienna, and add layers of shadows on top with the same paint mixture. Add some Raw Umber to suggest the green reflections in the bottom left corner. Soften the paint with a bit of water as needed.

6 Begin the Foliage

Use Cadmium Yellow, Cadmium Orange and Sap Green to paint the base layer of the fall foliage. Work wet-into-wet and use a no. 2 round. Let the areas dry completely before moving to the next step.

7 Finish the Foliage

Use a no. 2 round and Perylene Green to add shadows underneath the overlapping leaves. Soften the shadows of water in some areas. Switch to a no. 0 round and use Quinacridone Rust to paint the small veins on the leaves.

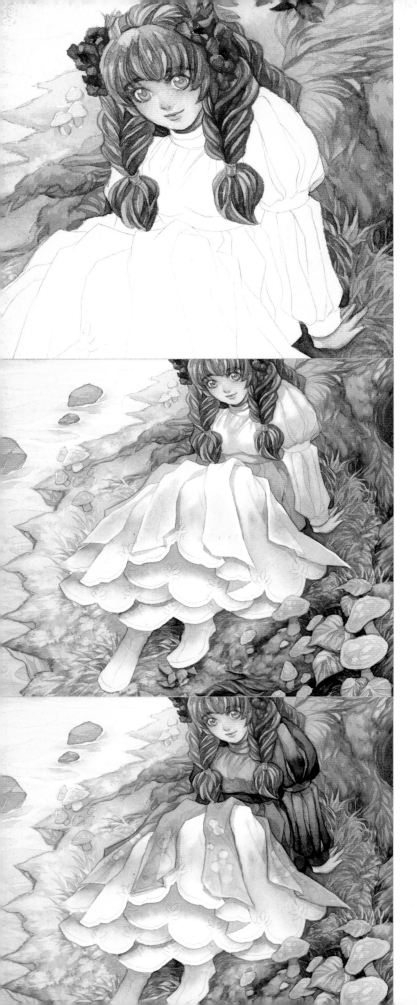

8 Paint the Skin and Hair

Dilute Cadmium Red with water and paint her rosy cheeks and lips using a no. 2 round. For the skin tone, mix Cadmium Yellow and a touch of Cadmium Red. Darken the shadows under the bangs and chin with diluted Burnt Sienna with a no. 1 round. Paint the eyes with Lilac.

Create a mix of Cadmium Yellow and Burnt Sienna and paint the hair with a no. 2 round. Paint the shadowy strands with Burnt Sienna and diluted Sepia. When the hair is completed, mix Cadmium Red and Cadmium Yellow for the flowers and apply shadows with diluted Sepia. Paint the hair's ring with Cadmium Yellow.

9 Begin the Dress

On the dress, lay an underpainting of Viridian using a no. 2 round. Emphasize the shadows under her chest and sleeve areas. Layer more color on the overlapping layers of the dress and soften the paint with water toward the bottom of the dress.

10 Paint the Top of the Dress

Lay a wash of Olive Green from the top of the dress to the bottom of the top layer of fabric. Quickly add Compose Green at the tips with a no. 2 round. While the surface is still fairly damp, sprinkle a few drops of rubbing alcohol to create a bubbly texture. Paint the individual stripes on the sleeves with concentrated Indigo and Olive Green. Paint the shadowy gaps between the stripes with Raw Umber, and the cuffs and strap beneath her breast with Cadmium Red. Paint the rings on her neck with Cadmium Yellow. When the surface is dry, paint the neck rings' shadows with a layer of diluted Indigo.

11 Paint the Bottom of the Dress

Paint the bottom layer of the dress with a wash of Burnt Sienna and a no. 3 round. Quickly add Gold Green using a wet-into-wet technique. Make sure to let the surface of each layer dry before working on the next one. Add a flat wash of Raw Umber on the boots.

12 Complete the Dress Details

After the surface is dry, switch to a no. 1 round and paint the patterns at the bottom of the dress with concentrated Quinacridone Rust. Paint the shadowy folds with layers of diluted Indigo and Viridian. Emphasize the fabric that is overlapped by other layers. Create a mixture of Indigo and Raw Umber to refine the shadows on the boots.

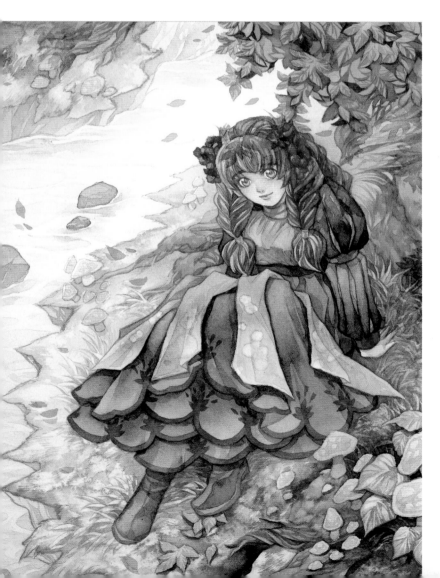

13 Add Shading to the Tree

Refer to the completed illustration on page 142. Paint random leaves falling from the tree with Cadmium Orange and a no. 1 round. Dilute Payne's Gray and paint the shade beneath the orange foliage and the leafy shadows on Demeter's head.

Demonstration
THE MESSENGER CHAMBER

It takes a lot of hard work for Hermes to sort through and organize all the messages in the delivery chamber, though he has some angels to help him. Though he always keeps to the schedule, it can still be quite stressful. There are many elements to establish in this scene, so it may help to focus on the background, middle ground and foreground one at a time.

MATERIALS

PAINTS

Blue Apatite Genuine, Burnt Sienna, Cadmium Orange, Cadmium Red, Cadmium Yellow, Cobalt Blue, Cobalt Turquoise, Lilac, Manganese Violet, Mauve, Olive Green, Payne's Gray, Perylene Green, Perylene Violet, Raw Umber, Sap Green, Sepia, Yellow Ochre

OTHER TOOLS

cold-pressed watercolor paper, ¾-inch (19mm) flat, nos. 0, 1, 2, 3 and 5 rounds, masking fluid (optional), paper towel, pencil, white acrylic paint

48

1 Design and Sketch the Composition

Sketch the drawing. Here the three-point perspective gives us a dynamic composition. If you apply the rule of thirds, you see that Hermes and the little angel make strong focal points as they are placed at two of the intersections.

2 Establish the Base Color

Lay a flat wash of Cadmium Yellow with a ¾-inch (19mm) flat over the entire paper. Use a dry no. 1 round to lift some paint from the figures and some floating envelopes. When you lift the paint, don't worry too much about making it perfect.

3 Begin the Sky
Make sure the paper is completely dry, then apply some fresh water to the sky area. Working wet-into-wet, paint a dark wash of Cadmium Orange with a no. 5 round. Allow the paint to spread and try to keep the right side lighter to indicate where the light source is coming from. Use a dry paper towel to dab around the torch area at the top of the chamber building to lift some color out. Fill in the gaps of the building with Cadmium Orange and a no. 0 brush.

4 Darken the Sky
Create a mix of Mauve and Cadmium Red to deepen the shadows of the clouds with a no. 2 round. I recommend working wet-on-dry to define the crisp edges of the clouds, but you can also work wet-into-wet. Soften some of the shadows with clean water while continuing to keep the right side as light as possible.

5 Paint the Chamber's Domes
Create a mixture of Yellow Ochre and Manganese Violet and paint an even wash on the distant domes of the chamber with a no. 2 round. The purple shade in Manganese Violet will complement the colorful sunset background.

6 Paint the Middle Ground Foliage

Create the base tone mixture for the foliage on the right with Yellow Ochre and Olive Green, then lay a wash with a no. 2 round. Paint the foliage on the left using the same mixture plus a touch of Sap Green. Allow the first layers to dry, then build up the shadowy leaves with diluted Olive Green. Leave a few white areas open for the highlights.

7 Refine the Foliage

Since the main light source is coming from the right side, the foliage on the left should be a bit darker. Use a no. 1 round to refine the leaves' shadows with Perylene Green, painting the bottom of the foliage a bit darker. Add subtle branches on top with concentrated Mauve.

8 Lay the Initial Shadows on the Chamber

With a no. 2 round, add a layer of diluted Perylene Violet on the left side of the main chamber. Darken some of the area under the platform and the left corner with more layers of the same wash. Don't worry if the colors appear a little blotchy at this stage; we will refine the details later.

9 Create the Marble Texture

To create the marble texture on the building, we can use cauliflower marks to our advantage. Mix Raw Umber, a bit of Payne's Gray and water and lay a light wash over the building with a no. 3 round. Let the surface dry until it's just slightly damp and add the same wash or clean water over the previous layer, allowing the colors to randomly mix. When dry, use the dry-brush technique to add some more texture with diluted Payne's Gray.

10 Refine the Shadows and Emphasize the Cracks

Paint a flat wash of diluted Raw Umber on the base of the pillars and interior hallway door trim with a no. 2 round. Use diluted Blue Apatite Genuine with a no. 1 round to refine the shadows on the building. Paint more layers of diluted Payne's Gray to emphasize the cracks and engraved patterns on the pillars. Deepen the interior of the building and corner shadows with a concentrated wash of Payne's Gray.

11 Complete the Chamber Details

Paint a wash of Cadmium Yellow on the pediment, cornices and torch with a no. 1 round. Refine the shadows with Burnt Sienna and a touch of Payne's Gray. Use Cadmium Orange and diluted Cadmium Yellow to create the flame. Spread a flat wash of Cobalt Turquoise on the dome, and lift some paint out near the wings with a dry brush. Paint the dome's window frame with Cadmium Yellow and fill in the window panes with Mauve and Cobalt Turquoise. (You could also add masking fluid to the window frame before painting the panes, then paint the frame second.) Paint Yellow Ochre on the hanging bridge, adding a bit of Burnt Sienna for the shadows.

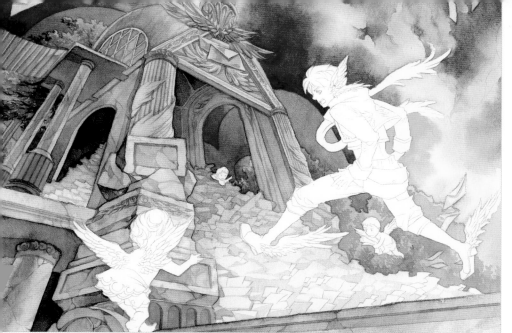

12 Paint the Pile of Letters

Paint a graded wash of diluted Blue Apatite Genuine on the pile of letters with a no. 3 round. Paint the top area darker than the bottom area. Switch to a no. 0 round and the same mix to paint the shadows, varying their intensity. For the floating letters, apply a diluted wash of Cobalt Turquoise.

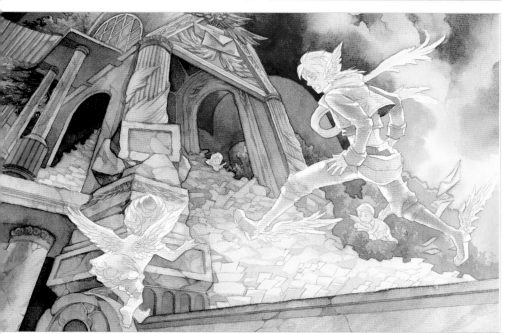

13 Paint the Underpainting of the Figures

Paint a wash of Lilac on the figures' skin, hair, wings, outfits and Hermes's scarf with a no. 1 round. Add a few shadows with Mauve and leave a few areas unpainted for highlights.

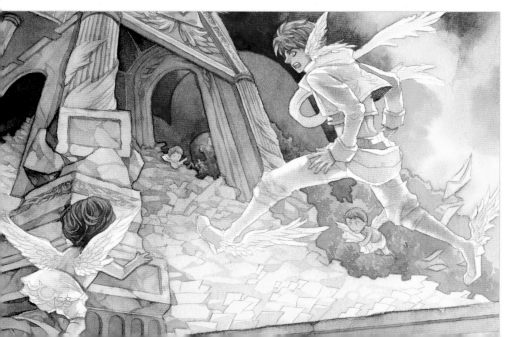

14 Paint the Skin and Hair

Create a light mixture of Cadmium Yellow, Cadmium Red and water and paint the skin with a no. 1 round. When dry, add Burnt Sienna to the previous mixture and refine the skin's shadows with no. 0 round.

Paint the details of Hermes's hair with light Cadmium Yellow and a no. 0 round. Add some shadowy strands with diluted Burnt Sienna and Payne's Gray. Paint a wash of diluted Burnt Sienna on the angels' hair, then add details with Perylene Violet and Burnt Sienna. The angels farther in the distance don't need as many details as the main angel in the foreground.

15 Complete the Angel Details

Add the shadows under each overlapping feather on the wings with diluted Cobalt Turquoise. Lay a wash of Cobalt Turquoise on the cloth at the foreground angel's waist with a no. 1 round. Add a touch of Cadmium Yellow on the left edge and let the colors gradually blend. Use Blue Apatite Genuine for the shadows on the cloth and Cadmium Yellow for the trim. Paint Yellow Ochre on his pants and add details with Burnt Sienna. Use diluted versions of the previous mixtures for the angels in the background.

16 Paint Hermes's Outfit

Lay very diluted Cadmium Yellow on the scarf and quickly paint the tips with Cobalt Turquoise using a no. 1 round. Paint Cobalt Blue on the jacket and Raw Umber on his vest. Use Cobalt Turquoise to paint the cuffs and vest trim. Dilute this paint for the wings. Paint the jacket trim and wing logo with Cadmium Yellow. Refine the shadows with a mixture of Mauve and Blue Apatite Genuine on the darkest areas and diluted Blue Apatite Genuine on the lighter areas such as the scarf and wings.

17 Paint the Pants and Boots

Paint a flat wash of Cobalt Turquoise on the inner pants and Raw Umber on the outer pants using a no. 1 round. Lay Burnt Sienna on the bag and Sepia on the boots except the toe caps. When dry, emphasize the shadows with Mauve and Blue Apatite Genuine.

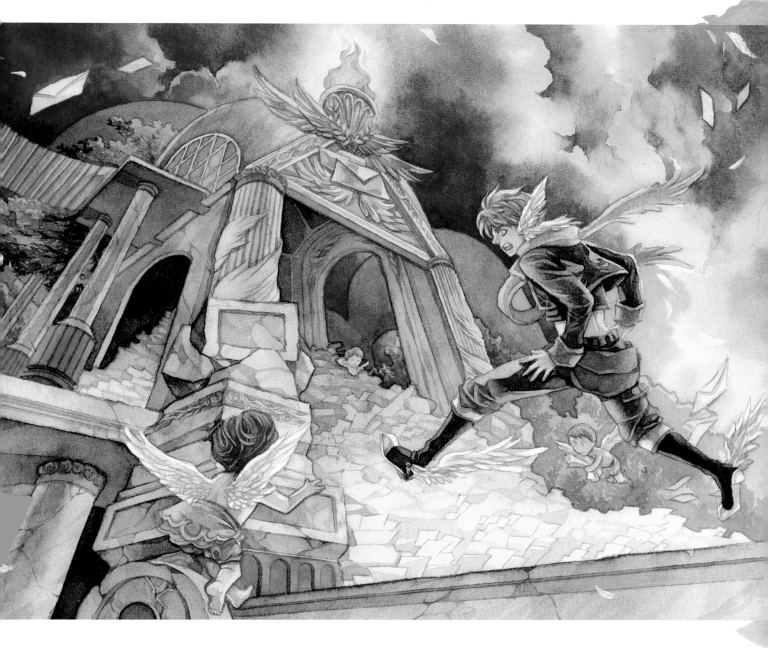

18 Complete the Details

Use a no. 0 round and white acrylic to refine the highlights. Add some extra strands on the hair and a few feathers floating randomly around the scene.

Index

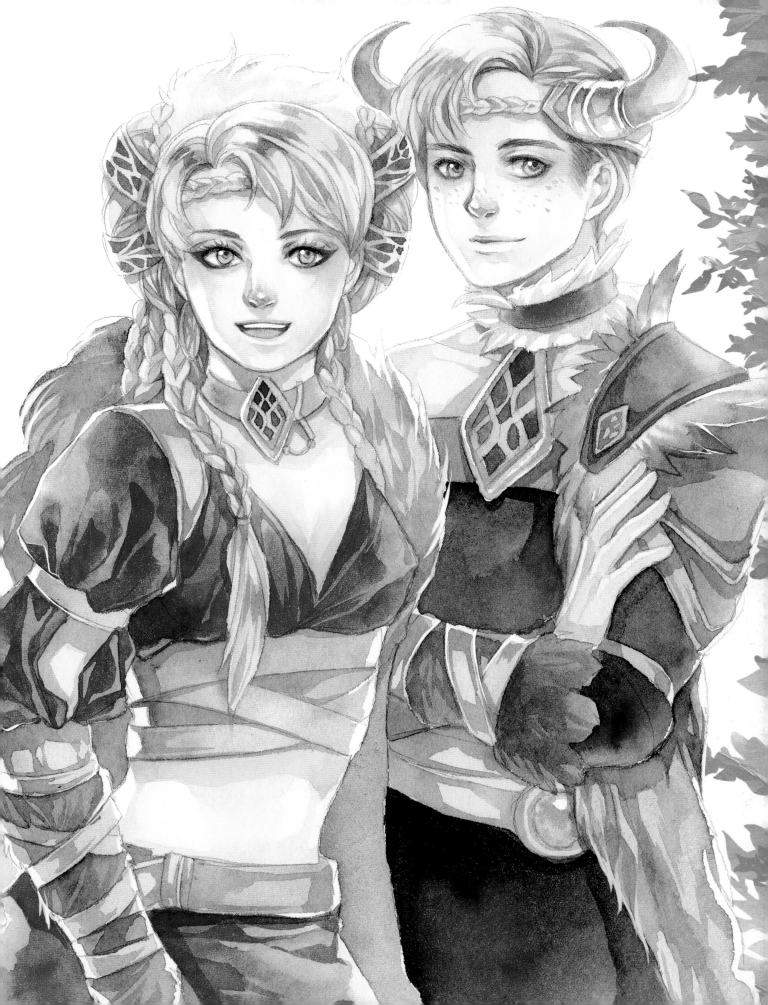

Metric Conversion Chart

To convert	to	multiply by
Inches	Centimeters	2.54
Centimeters	Inches	0.4
Feet	Centimeters	30.5
Centimeters	Feet	0.03
Yards	Meters	0.9
Meters	Yards	1.1

a content + ecommerce company

19 18 17 16 15 5 4 3 2 1

DISTRIBUTED IN CANADA BY FRASER DIRECT
100 Armstrong Avenue
Georgetown, ON, Canada L7G 5S4
Tel: (905) 877-4411

DISTRIBUTED IN THE U.K. AND EUROPE
BY F&W MEDIA INTERNATIONAL LTD
Brunel House, Forde Close, Newton Abbot, TQ12 4PU, UK
Tel: (+44) 1626 323200, Fax: (+44) 1626 323319
Email: enquiries@fwmedia.com

DISTRIBUTED IN AUSTRALIA BY CAPRICORN LINK
P.O. Box 704, S. Windsor NSW, 2756 Australia
Tel: (02) 4560-1600; Fax: (02) 4577 5288
Email: books@capricornlink.com.au

ISBN 13: 978-1-4403-3970-7

Edited by Sarah Laichas
Designed by Laura Kagemann
Production coordinated by Mark Griffin

Dedication

To my supportive family, who have encouraged me to do what I believe and are always there when I need true advice. To my aunt, Dr. Chantrapa, who enabled me to earn the education of a lifetime. And to my belated grandparents, you are always missed.

Acknowledgments

To Sarah Laichas, my wonderful editor and partner in crime. Thank you for this opportunity and for keeping up with my hectic schedule. To my junior, Kade, for your adorable character in the book. And lastly, to Ming Zhang, my best friend, coworker and life savior who is patient enough to deal with all the craziness and always supports me through the entire process of creating a book. I can't thank each of you enough!

About the Author

Supittha "Annie" Bunyapen is a proflic young manga artist and author of the best-selling *Shojo Wonder Manga* (IMPACT, 2011). Known as Ecthelian on deviantART since February 2004, her site has received more than 2.6 million pageviews and counting. She earned her BFA in sequential art from Savannah College of Art and Design, and currently works in the game industry for Kiz Studios (kizstudios.com). Bunyapen's influences include the Japanese manga and Konami game artists Ayami Kojima and Fumi Ishikawa; Taiwanese manga, comic book and video game artist Jo Chen; and writers J.R.R. Tolkien and the Brothers Grimm. When not busy working at Kiz Studios or on personal commissions, she spends her free time taking photos, listening to music and traveling. She divides her time between her home in South Carolina and Bangkok, Thailand. Visit her at **ecthelian.deviantart.com** and **facebook.com/ecthelian**.

Bonus Materials

Visit impact-books.com/manga-magic for a downloadable PDF of line drawings from the demonstrations throughout the book!

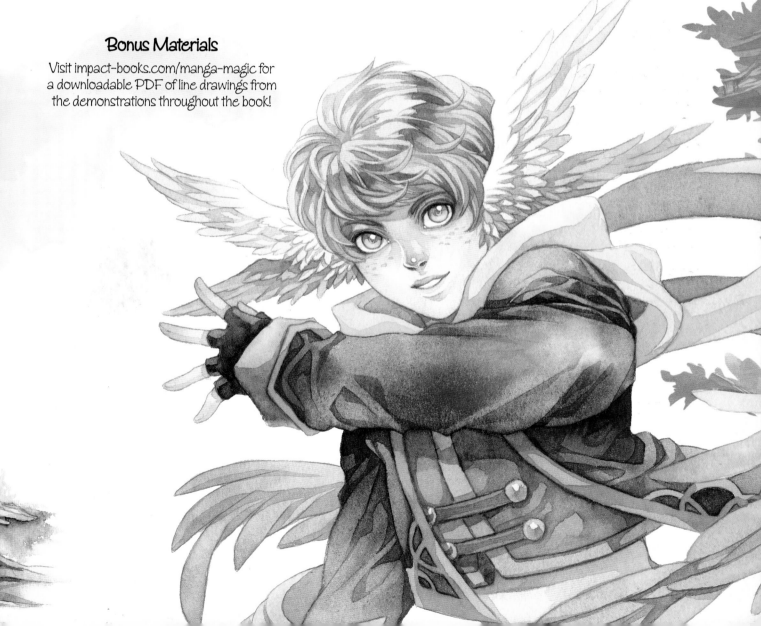

Ideas. Instruction. Inspiration.

Download a FREE bonus gallery of Annie's work at impact-books.com/manga-magic.

Check out these *IMPACT* titles at impact-books.com!

IMPACT-BOOKS.COM

- Connect with your favorite art
- Get the latest in manga, fantasy, comic and sci-fi art instruction, tips and techniques
- Be the first to get special deals on the products you need to improve your art

Follow *IMPACT* for the latest news, free wallpapers, free demos and chances to win FREE BOOKS!